How to Make
a Watercolor
Paint Itself

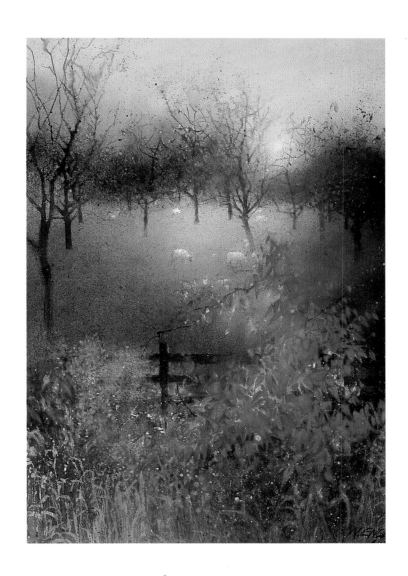

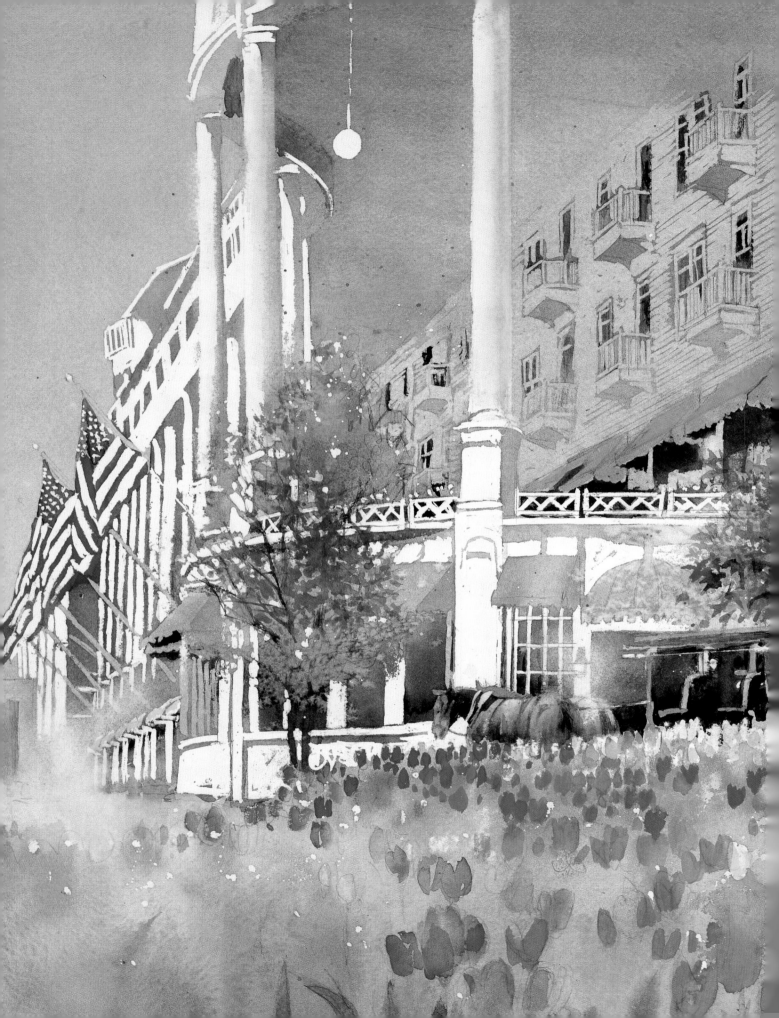

How to Make a Watercolor Paint Itself

Experimental Techniques for Achieving Realistic Effects

NITA ENGLE

Watson-Guptill Publications
New York

ACKNOWLEDGMENTS

My sincere thanks and appreciation to the staff at Watson-Guptill, especially to Marian Appellof, who managed with sensitivity to fit the material for two books into one; to my long-suffering photographer and collaborator Patricia Winton, who complied successfully when I demanded action shots of paint flying through the air and landing on the paper; to my other long-suffering collaborator, Patty Ryan at Manpower, for her ideas on organizing the material and her unfailing happy spirit in typing endless manuscripts; to so many people who helped shape a career—Kirkland Advertising, Reader's Digest, American Artist, Mill Pond Press, and especially the American Watercolor Society; to my collectors through the years; and to my students, who always teach me more than I teach them.

This book is dedicated to my family and friends, who have always been ready with help and support; to my brother and his wife, Jim and Grace Engle; to my best critic, Maggie Linn; to my very first collectors, Alice Hunter and Ed and Edith Nelson; and to my cousin Nona, who taught me to draw in the first place; to the memory of my mother and father, for providing a childhood of freedom, love, and beauty; and finally, to the land itself, the Upper Peninsula of Michigan, still an unspoiled wilderness, its people still pioneers. Thank you, God, for creating it all.

Frontispiece:

EVENING ORCHARD
Watercolor on Arches 140-lb. cold-pressed paper, 28 x 20" (71 x 51 cm). Collection of Alice Hunter.

Title page:

VICTORIAN SPRING—GRAND HOTEL
Watercolor on Arches 140-lb. cold-pressed paper, 20 x 27½" (51 x 70 cm). Collection of Peter Hendricksen.

The photographs on the following pages are courtesy of Mill Pond Press, Inc., Venice, Florida: pp. 2–3; 6–7; 12–13; 39 bottom; 41 bottom; 43 bottom; 49; 50; 57; 58 top; 59; 60–61; 65 top; 67 bottom; 68 right; 72; 73; 80; 87; 89 top and bottom; 93 bottom; 94–95; 97 right; 99 right; 102 right; 105; 109; 111; 113; 114–15; 119 top; 120; 121 top; 123 bottom; 124–25; 132–33; 142.

All other photography by Patricia Winton.

First published in 1999 in the United States by Watson-Guptill Publications, a division of BPI Communications, Inc., 770 Broadway, New York, NY 10003

Library of Congress Cataloging-in-Publication Data for this title can be obtained by writing to the Library of Congress, Washington, D.C. 20540

Manufactured in Malaysia

ISBN 0-8230-5708-9

4 5 6 7 8 / 06 05 04 03 02 01

CONTENTS

INTRODUCTION
Concepts, Principles, and Goals

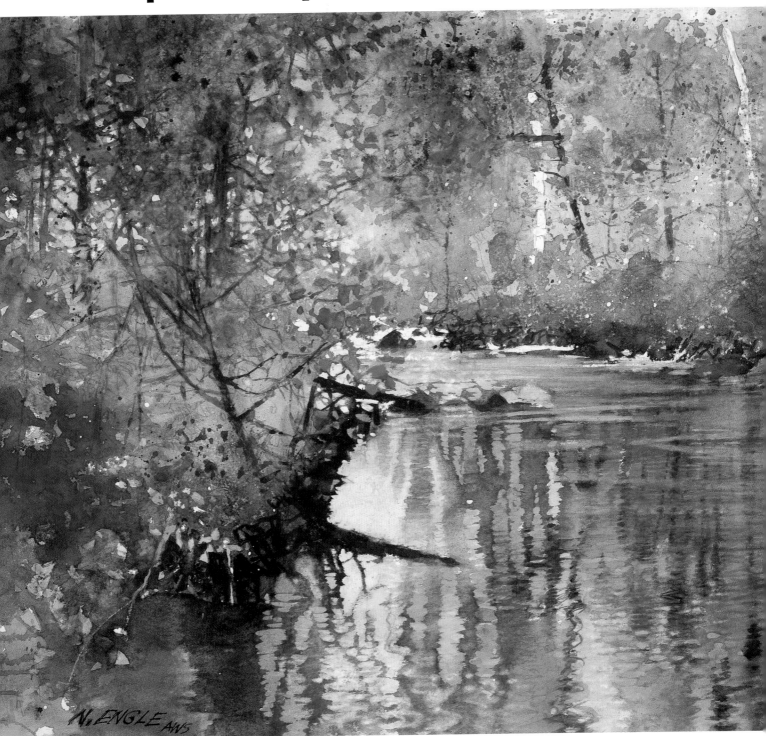

SUMMER RIVER
Watercolor on Arches 140-lb. cold-pressed paper, 19¾ x 28" (50 x 71 cm). Private collection.

IF YOU ARE FASCINATED with watercolor, you can make fascinating watercolor paintings. If you are excited by the very act of painting, the brushstrokes, the water and color flowing on the paper, you can make exciting paintings.

Whether your desire is to paint people or flowers or kitchens, or your motivation is a love of trees and sky, or you are smitten with abstract design, you will make paintings that touch, excite, and fascinate other people— and yourself. You need only be passionate about something for your work to have life.

While planning this book, I wondered how I could best help readers, whatever their stage of development. So much of watercolor painting, in spite of all attempts to analyze it, is done by instinct. Many artists paint intuitively, in response to some stimulus in their environment, and don't know themselves why they do what they do. There is a kind of mystery about the process that defies teaching it, and properly so. How can you explain why, for instance, in the midst of painting, you suddenly think, "I need some red right here, now." There is no formula.

Rather than teach you the basics of composition, color theory, and the like—information you can readily find elsewhere—I will tell you how I discovered my own identity in painting, how I found out why I do what I do, and help you find your own answers so you can turn the techniques I present to your own use.

The essence of my painting is a blend of spontaneity and control, but first there must be freedom! If you are relaxed and having fun, you will be more open to ideas and will work more creatively. I believe in a carefree, unstructured approach to painting, one without limits. Watercolor often requires a bold and daring attack. And if you lose, it's only a piece of paper! I love what Winston Churchill said about learning to paint with "audacity." He was very timid in his first attempts, till a friend began to "hurl slashes of paint on an absolutely cowering canvas. Anyone could see that it could not hit back!"

FINDING A GUIDING PRINCIPLE

What would happen if, with a bolt of lightning, as in the movies, you were suddenly given the ability to paint every watercolor just as you envision it, to make the paint and the drawing and the design all happen exactly as you want? But what way is that? How do you want it? You see?

You would still have to know what you want!

Nothing else really matters; you are the factor directing everything. If you want to be an original, the only differences possible in paintings are the differences among people. Paint is paint.

Is it possible to find a tool no one has ever used in a million years, or a new way of applying paint, or an original way to break up the space in a rectangle? I suppose it is. But the only original in this whole equation is you.

My purpose is to help you find and project your own unique qualities on paper and to offer practical solutions for painting your own vision more clearly. Only by being true to your own way can you be successful in art.

How many times have students attended classes and workshops, in a state of excitement and hope, only to return to their studios in confusion? How can they use what they have learned? They don't know how the demonstrator did it all; the actual painting seemed to appear magically. Well, no one can ever really know how the demonstrator does it, because he is following his own inner voice, which constantly gives him direction. He is following his own principles, his own integrity, which he doesn't violate. He is listening to his own vision. Demonstrations and books and workshops are very valuable for teaching methods and insights, but don't be seduced by another artist's work. Without understanding his reasons, his inner concepts, you would just be repeating his surface mannerisms.

My students have endless, and specific, questions: "How do you know when a painting is finished?" "Sometimes you use more colors than are there at the scene; what determines your use of colors?" "How do you determine light and dark values?" "Do you have a rule for a focal point or center of interest?" I have come to think my answers to such queries won't help very much, because they pertain specifically to my work. Really, the answers should be not mine but yours, because this is the very essence of style.

What it all boils down to is one major question, the answer to which will be in your own, unique voice. The one question you must ask yourself is this: "What is my underlying, guiding principle?"

Answer this and I will show you how it answers all your other questions. This is the first of two ingredients I think are necessary for growth as a painter.

The best way I can explain this is to tell you about my own experiences. I had been painting mostly by instinct, and fairly successfully; I was already doing watercolor landscapes for Reader's Digest (Condensed Books and magazine.) My paintings at that time were just a response to nature. I was also involved in graphic design and book illustration, working in every medium imaginable.

Several things happened at this point that were very enlightening and very influential on my growth as a painter. I was asked to write articles here and there about my work, so was forced to articulate verbally what I had been doing instinctively. In other words, I had to think. I also began to teach workshops, which required the same ability—to explain what I do. Therefore I became more alert to the ramifications of my work, how to define it, and what it was really about.

Then living in New York, I often visited galleries, where I became aware of the kinds of questions art dealers would ask: "What are your goals for your work? How will it grow?"

I was illustrating a book at the time in which a character in the story, an art critic, said, "A painting should take you into its own existence." There can be many interpretations of that, but it made me realize that's what I had been trying to do with my work—not to be a photorealist, not to record my impression of a scene, not to make an abstraction—but to try to invite the viewer to enter the painting.

At that same time, fortunately, someone told me that one of the editors had said of my work, "I could just fall into that painting." My thoughts at the time? I know when you are engrossed in a book, you are no longer aware of sitting in a chair reading; you are wherever the writer takes you. I wanted to create some of that feeling with my work. (Be aware of people's reactions to your work; they are probably responding to the strongest part, and that can be helpful to you.)

Because I want the viewer to enter the scene itself, I can have no reminders that say, "This is a painting you are looking at." That means no calligraphy, no unnatural colors, no mixed media, no obvious brushstrokes; as soon as you see a brushstroke, you are snapped back to reality. I want you to suspend disbelief, to be one with the scene. So this one concept is a principle that guides all of my work. I rely on it daily.

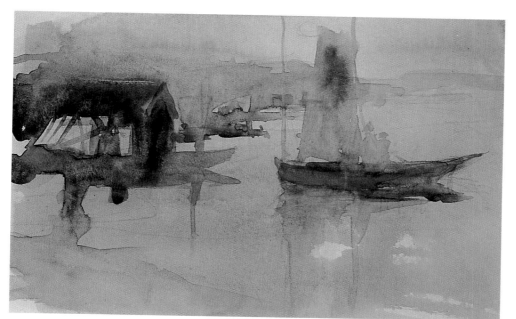

WATERCOLOR DAWN
Watercolor on Crescent cold-pressed illustration board, 8½ x 11" (21.6 x 28 cm). Collection of the artist.

I did this painting of a harbor scene when I was still working in many styles. I loved the feel of direct painting, emotionally dashing in the rigging, giving my impression of the scene.

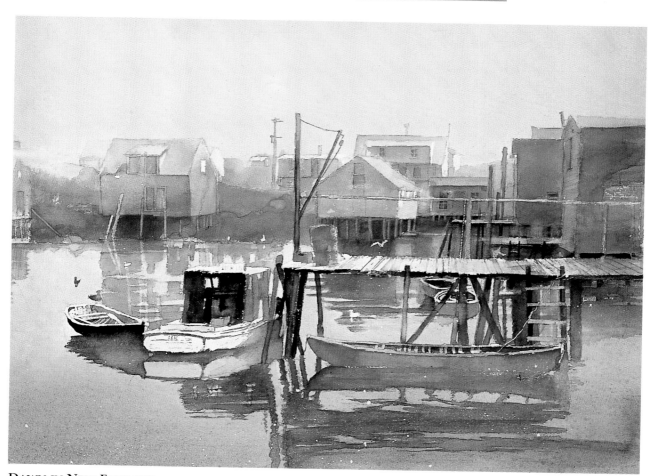

DAWN IN NEW ENGLAND
Watercolor on Arches 140-lb. cold-pressed paper, 13½ x 21" (34 x 53 cm). Private collection.

This is from the same period, except here I drew and masked and planned more carefully. In the end, this is the direction I had to take; something inner dictated it. However, I try to incorporate the feeling of *Watercolor Dawn* whenever I can in my work.

This time in my career was so important to me that I remembered not only the editor's comment, but the actual painting as well: *Once upon an Island,* reproduced below.

How do you find your underlying intent? What "look" for your work are you in love with? At this point I am not discussing what moves you to paint; that is a separate thing. I am talking about how you want your painting to look physically, what you want to accomplish. The answer will be composed of your taste, what you like, your feelings, your unique experiences.

Do you like subtle paintings, part suggestion, part lost? Do you like paintings that say more by what they leave out? Do you like minimalist art or hard-edged art? Do you like paintings that tell a story or make a statement? Do you think of watercolor as a vehicle for ideas or as an end in itself? Do you just like the look of moving paint or abstract textures? Your temperament is important, too. Do you like to paint every blade of grass (and have the patience)? Or make broad, gestural strokes to dash off grass in one fell swoop? Or paint it abstractly?

Or, like me, paint six blades of grass and create an illusion for the rest? What do you love? Your concept will be built from the inside, from your emotional response to the external. When you really isolate and think about your intent, you will see that in being true to it, your secondary questions will be answered. It will tell you what to do. And when you are aware of this intent, you will have a direction, and you will paint consistently, whatever the subject.

With direction, you have a goal. If you don't have a goal, how can you ever *arrive* there? Giving some real thought to all of this may help you to sharpen and shape your work.

I suggest that you write a short explanation of your goals for painting in watercolor—not a career goal, not a philosophy, but how you want your paintings to look, what kind of painter you are. Write it as though an art dealer asked you this.

About the importance of having an underlying concept, consider what Winston Churchill once said to a waiter: "Take away this pudding—it has no *theme!*"

ONCE UPON AN ISLAND
Watercolor on Arches 140-lb. cold-pressed paper, 16 ½ x 12" (42 x 30.5 cm). Collection of Reader's Digest.

I painted this as an illustration for a Reader's Digest condensed book by the same title.

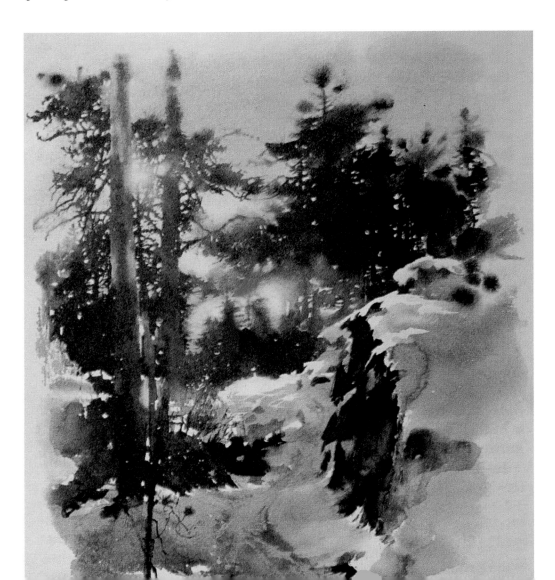

DISCOVERING WHAT MOTIVATES YOU

The second ingredient I find necessary for growth as a painter is something you must have, or you will never produce anything of value: desire. I used to think success was the result of 99 percent perspiration, that you needed to be determined to stick it out for the long haul, because making a success as an artist *is* a long haul, and even making a success of a single painting can be agony.

But now I don't think that it is work and determination that see me through; it's desire. If you desire to do something, and desire it enough, you don't need perseverance, you don't need discipline to do what you want to do anyway! But the desire must be strong enough to make you go to any lengths necessary to get what you want—the success of a painting, the success of a career. I myself (and I know other artists who feel the same) sometimes border on the obsessive about a painting. Compare the experience of doing battle with a painting to pursuing a love object: Are there no limits to what you will do to win? Including doing crazy things?

It's probably wise sometime in your career to stop looking for a while at the work of other people and concentrate on your own and what you want to do. Try not to fall in love with another artist's work! Look not just at your paintings but at your sources. For example, look at the material you have gathered for a painting. Are you enough in love, is the desire strong enough for you to paint it? Your response to a subject is uniquely you, and you can depend on it. You must find what your deepest passion is and focus on that. But, of course, all of this advice will be useful only after you have exposed yourself as broadly as you can to everything.

You may have heard these same ideas expressed by other artists. It is at the same time disquieting, and yet rather a comfort, to find that many artists have arrived at the same truths, just expressed them in different words. Whenever you have an inspired thought about painting, you find that someone has already thought it and written about it. Perhaps it means we are all on the right track.

What *can* be original? Not what you say but what you do—how you proceed with these theories. My happiest times in teaching are when I introduce some discovery to the class and they take off in fifty directions with the idea, applying and exploring it in their own unique ways. The connection your imagination makes with *my* discovery, and what *you* do with it, will always be new, because you are not copying my discovery, you are inventing new ways to use it.

To sum up my own artistic approach: The underlying principle that guides my work is to take the viewer into the painting. My motivation for painting, my real passion, is my love of the natural world.

Desire is your driving force, your motivation; *guiding principle* is what directs you toward attaining your goal.

THE BASIC MATERIALS
My Choices and Yours

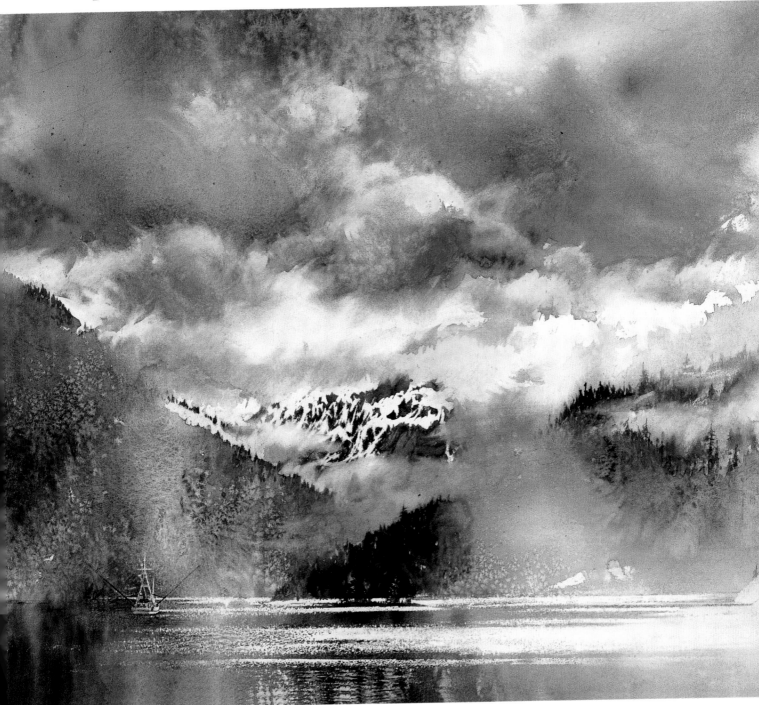

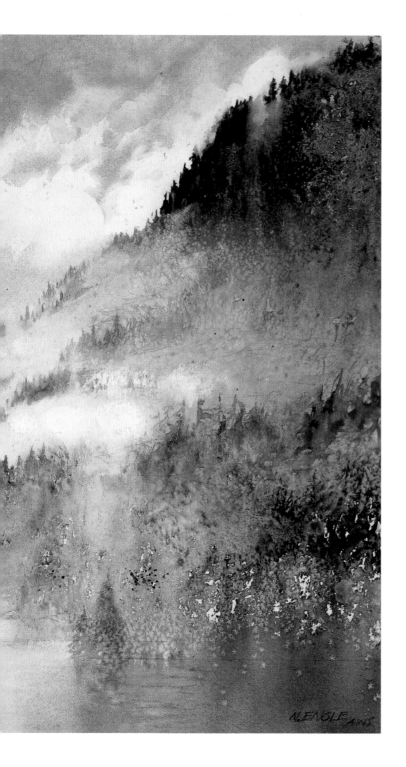

MY CHOICE OF MATERIALS has evolved as my painting style has evolved. The limitations and advantages of the materials I have tried have made their own suggestions, while my response to nature made its own requirements, and in the end, the goals I defined for my work dictated to me which materials would let me achieve those aims. As an illustrator, I had used designers' colors (gouache); in art school, casein and oil. I used mixed media. All of these were gradually discarded as I began to realize where I was going with my work.

I will tell you my reasons for working with the materials I now use, but you must determine your own preferences, based on your own goals for your paintings, your own likes and dislikes. If your goal is, like mine, to paint representational landscapes, then my materials will suit you fairly well.

GREAT PASSAGE
Watercolor on Arches 140-lb. cold-pressed paper, 24 1/4 x 35" (62 x 89 cm).
Private collection.

WATERCOLOR PAINTS

There are numerous brands of watercolor paint available; I've tried many of them over the years and have come to prefer Winsor & Newton (the manufacturer of all of the paints shown here). Try different kinds yourself to discover which ones you like.

Color Selection

It took me about fifteen years to develop my color palette; when I was a beginning artist I used every color made. I tried all combinations, different brands, all opaque and all transparent colors. Eventually I settled on a palette consisting of only the primary colors, mainly because using the same hues throughout a painting gives it an overall unity that suits my style.

I use two basic groups of primary colors. The first triad (and for me, the more important) consists of Winsor red, Winsor yellow, and cobalt blue. I call this the "air" triad, because when used in the right combinations these colors make it possible to paint a sky you can see through! The second triad, which I call the "sea" triad because it yields mixtures that resemble the jewellike colors of the sea, is heavier, containing an opaque red—cadmium scarlet—plus aureolin yellow and Antwerp blue. In addition to these I use Payne's gray, brown madder alizarin, cerulean blue, and French ultramarine blue. I am not rigid about how I work with these triads; all the colors in my palette can be used in any combination. That's the reason I chose them—as a team!

My four blues range from the blue-green of cerulean (which I call my troubleshooter, because it has a lot of body and can add this quality to other colors when mixed with them), to the almost pure blue of cobalt, to the deeper red-blue of French ultramarine, to the darker blue-green of Antwerp blue. Of my two reds, cadmium scarlet is orangy, while Winsor red is a pure red. Of my two yellows, Winsor yellow is a pure yellow, while aureolin leans a bit toward red. Payne's gray, used for darks, and brown madder alizarin, for rich browns, add depth to the palette.

This limited palette offers a lot of flexibility in creating a range of colors by mixing. For instance, with my Antwerp blue triad, I can make fifty different kinds of green just by varying the proportions of these colors in the mixture. I can create a blue-green by adding more blue, or an olive green by adding some cadmium scarlet, or a very deep greeny dark by adding Payne's gray. There is no need to squeeze some made-up color such as sap green into the mix. This simplifies things for me. I know I have eight transparents and two opaques (the latter being cerulean blue and cadmium scarlet). The same colors are in everything, giving a painting unity.

I have recently added a new color when I am painting in the tropics, since my basic palette doesn't allow me to paint tropical flowers: Holbein's opera, a bright, "hot" pink. I love it because

This is my palette, a porcelain butcher's tray, with my colors arranged in four rows.

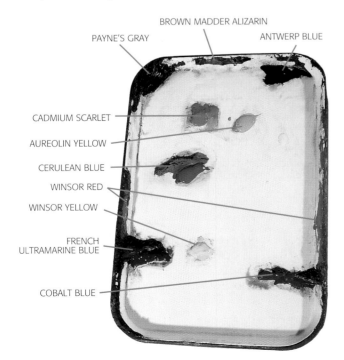

BROWN MADDER ALIZARIN
PAYNE'S GRAY
ANTWERP BLUE
CADMIUM SCARLET
AUREOLIN YELLOW
CERULEAN BLUE
WINSOR RED
WINSOR YELLOW
FRENCH ULTRAMARINE BLUE
COBALT BLUE

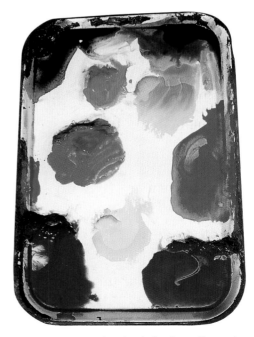

Here the paints are dissolved—"activated"— and ready.

it mixes well with my other colors and can be lifted (removed from the paper after it has dried). Try it with cobalt blue for violet, and with Winsor yellow for a Day-Glo orange.

As my palette evolved, the first colors to be eliminated were all the staining pigments, such as Hooker's green and alizarin crimson, since they can't be lifted from the paper. This is because one aspect of my approach to painting calls for simplifying the work after it's dry, removing anything that isn't relevant (I call this my "rewrite" process). Next to go were the earth colors, such as ochre, which was hard because I love some of those hues. But most of them can result in a dead, chalky, muddy look, and I was beginning to fall in love with the transparent approach to watercolor—or actually, with the white paper!

Palette Arrangement

For a palette I have always used a white porcelain butcher's tray with no divisions. The arrangement of colors on the tray is very important to me. If you look at the photograph opposite, you'll see that the colors are positioned as follows, beginning at the top left and continuing left to right in each consecutive row: Payne's gray, brown madder alizarin, Antwerp blue; cadmium scarlet, aureolin yellow; Winsor red, cerulean blue, Winsor red; French ultramarine blue, Winsor yellow, cobalt blue. The bottom fifth of the tray is left empty for mixing.

Notice that there is Winsor red on both sides of the tray. On the left side I use it for deeper color mixtures, and on the right side as part of a triad. It is squeezed along the inside walls of the tray because it is such a strong color that it could take over the entire palette.

Note also how the cobalt blue and French ultramarine blue spread out to form a dam. This works effectively at keeping other colors out of their area, giving me the bottom fifth of the tray for activating these blues. They are placed there because I use greater amounts of these colors.

PAPER

I work on basically two kinds of surfaces: Arches 140-lb. cold-pressed paper and Crescent medium-weight cold-pressed illustration board. Both of these choices were determined by my emerging style. Arches is a tough, sturdy paper that lets you lift colors and make major changes without falling apart. It never disintegrates into layers, no matter how you scrub it.

I evolved from working on a very textured surface—Fabriano rough paper—to cold-pressed, which has a medium texture, and hot-pressed, which is very smooth. The reason I abandoned rough paper was that I had been discovering new ways to make my own textures and didn't want a paper surface at war with me, its inherent texture destroying my illusions.

I also evolved from working on 300-lb. paper to the 140-lb. weight for three reasons. First, I was beginning to float and flow colors, using great amounts of water, and even 300-lb. paper began to warp. Second, stretching paper of that weight can be a pain. I remember what happened once when I tried to stretch a 300-lb. sheet at our summer cottage. In the middle of the night there was a tremendous noise, a crack like a gun—everyone woke in a blind panic. It was the sound of my support board breaking under the strength of the drying paper! The third reason I gave up on this heavier paper is that it has a blotterlike surface that proved to be incompatible with my methods for creating textures. It is possible to get some marvelous effects while the work is still in progress, but no one will ever see them, because as the paint dries, the paper absorbs it in a "creepy-crawly" way, so that color fills in all the white spaces, thus eliminating textural passages.

I began to use illustration board after watching how colors behaved on the smooth white surface of my butcher's tray—how they merged and made patterns and textures when they dried. I now use illustration board when I want a lot of surface excitement—textures and so forth. When I know I'm going to use a lot of glazes in a painting, I work on paper instead of board.

Stretching Paper

After many years of using gummed brown paper tape to adhere the sheet of paper to my support board, I found it was no longer efficient enough for my purposes, so I reluctantly turned to staples. This was not a good answer, because I use so much water. As the paper dries, it makes a little tear at every staple, slackening the surface just enough to cause hills and valleys the minute you start to paint on it. My methods require an absolutely flat paper surface, for many reasons.

One day I found a student painting strong glue on the tape! So now my troubles are all in the past. I use tape along with staples and have not had a buckled painting since.

To stretch a sheet of 140-lb. cold-pressed paper:

- Soak a sheet of watercolor paper in the bathtub for about half an hour, drip it off until it's safe to walk through the house with it, and place it on a plywood board. I use ⅜-inch-thick best-grade board; ¼-inch board will warp, and ½-inch is too heavy.

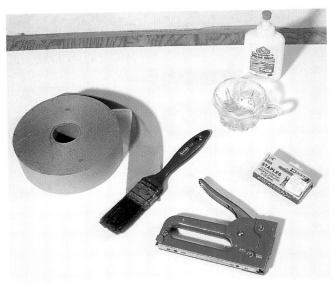

Here is what I use to stretch a sheet of watercolor paper: gummed brown paper tape, an old varnish brush, a staple gun and staples, and carpenter's glue and water in a mixing cup.

- In a cup, mix carpenter's glue with water, using about one part water to four parts glue. Have ready an old varnish brush and old newspaper. Tear off four strips of brown paper tape in lengths appropriate to the size of your paper.

- Spread the tape out on the newspaper and paint the carpenter's glue on the gummed side of one strip. Place this strip along the top edge of the watercolor paper on the long side; the tape should be half on the paper and half on the plywood.

- Staple through the tape and paper to attach this edge to the board, spacing the staples about two inches apart from each other. Pick up the bottom edge of the watercolor paper, pull it firmly, and tack it to the board with a staple on each bottom corner.

- Proceed from there by applying the next strip of tape (with glue painted on the gummed side) to the bottom edge of the paper and stapling it to the board; then do the same on the other two edges. Remember, you always staple through the tape.

- Dry flat, preferably overnight.

Before painting, I cover the brown paper tape with two-inch white masking tape. This covers the staples and prevents water from lifting the paper tape. The white border acts like a mat, as it can be wiped clean. I also try my colors on it.

BRUSHES AND OTHER TOOLS

As you'll see, I will use anything that makes a mark on the paper. My brushes are several good Winsor & Newton series 7 rounds: a #14, two #12s, and a #10, along with smaller brushes in synthetic and sable, some long riggers and sign-painters, and a sky-flow (from Cheap Joe's, a mail-order art materials supplier). I use a lot of Chinese and Japanese brushes, too; the longer the hairs or bristles, the better their flexibility. Besides being valuable for making strokes like those used in *sumi-e,* they are very good for "throwing" paint—flinging it onto the paper— because they seem to hold more paint and release it more readily than many Western brushes. I have gravitated away from flat brushes because they make their own statement—obvious brushstrokes—instead of mine. Also, when you use a flat brush to lay in a large wash, there is a danger of accidentally catching a corner of the brush in an unwanted color on the palette and transferring it to your painting.

I also use bamboo pens, which have a scooped-out point on each end. The bamboo is hollow and acts as a reservoir for the paint, and so functions as a sort of primitive fountain pen. They make wonderful free linear effects.

Still another tool I use is a painting knife—actually, a palette knife, the kind with a flat blade rather than a blade that bends below the handle. Palette knives are more commonly used in oil painting, but also work with watercolor when you want to move areas of wet paint around for hard-edged effects, for example, in depicting rocks, tree trunks, or ice.

Tools for Lifting Paint

I have many tools for removing color from a painting, and all of them are important to me because they are necessary for the simplifying phase of my work. To lift paint from larger areas in a painting, I use toothbrushes. I have a potter's brush that's especially good for softening hard edges that surround areas that have been masked, like the ripples on a lake, or for lifting color to create reflections. I couldn't complete a painting without it.

Another tool I use for lifting is the Incredible Nib, which is made of the same fibrous material used in felt-tip writing pens but contains no ink. With a point on one end and a chisel edge on the other, it is used for precision lifting of paint, softening edges, applying masking liquid, or even applying paint.

An electric eraser is great because it lets you remove paint without having to wet the paper first. I prefer the kind with a short nib; nibs are color-coded, and the one that's dark gray works best for lifting watercolor. Electric erasers are available in drafting supply stores; the one I use is an Apollo. Cotton swabs (such as Q-tips) and sponges are good for gently lifting paint from smooth surfaces like hot-pressed paper and illustration board. And I use razor blades to remove paint that is dry to create fine, precise lines.

Sometimes when you're trying to scrub away "mistakes" with a toothbrush, the brush flattens when pressure is applied and has no scrubbing power or accuracy. Here is a cure. Select a hard toothbrush and cut off the tip at an angle—in other words, bevel the bristles so they slant from the tip, with the shorter bristles on the end. The short hairs will be stronger, and you will be able to see what you are removing. This also works on flat oil brushes, the stiffer the better—cut off one corner at a slant.

Spray Bottles and Squirt Bottles

Among other treasures in my collection of painting implements is the spray bottle, the kind Windex comes in, with a plunger-type spray mechanism. Filled with water, this tool is not only handy for wetting the paper, it is also vital for my methods of creating textures and getting the paint to move. What I value about a Windex bottle specifically is that it delivers a coarse pattern of water droplets. This is what makes it a texturing tool, as you will

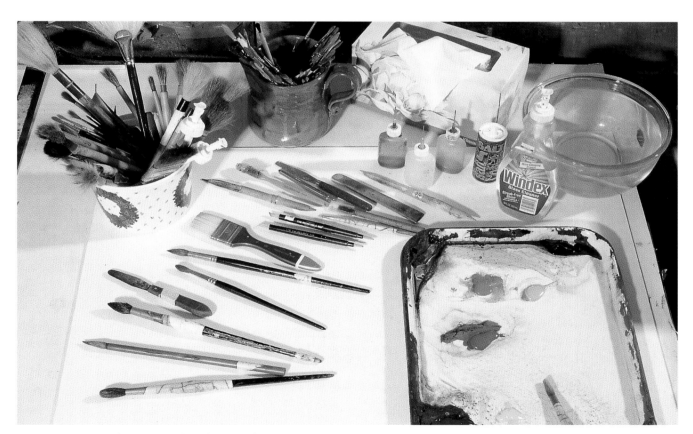

Various painting implements: in the background, containers holding Chinese, Japanese, rigger, and sign-painting brushes; in the foreground, from the bottom, a series 7 Winsor & Newton #12 round brush; my favorite Chinese brush for throwing (flinging or spattering) paint; a Winsor & Newton series 7 #14 round; a painting knife (a flat one, the only kind I use); two smaller round brushes; a large flat brush for washes; and some bamboo pens. Adjacent are an orange toothbrush and, just below it, a little potter's brush (the one completely wrapped in tape); if I ever lost either of these, I think I would have to quit painting. On the palette is an old round brush I use for activating my paints and general mixing. Also shown, in the background, are squirt bottles, Kleenex, a Windex spray bottle containing water, a salt shaker, and a bowl of clean water for painting.

learn. I don't buy the first one I see—I try them out in the store. Make sure the plunger doesn't get stuck! Don't buy a bottle with a trigger mechanism, because it delivers too forceful a spray—it could wash all the paint off your painting.

I have also become very attached to plastic bottles with hollow needles, which I use for squirting plain water or colors onto paintings. I have seen them only in Cheap Joe's art supply catalog, where they are called Oiler-boilers. The needles come in two sizes: OB-1 Hypo 200, a fine needle used for squirting water, and OB-2 Hypo 490, a thicker needle used for squirting paint.

Masking Materials

In my work I often mask out areas on the paper where I don't want paint to go, for which I use frisket, a liquid latex resist. After trying every brand on the market, I found Pebeo to be the best for me. It is very thin, which allows delicate detail work, and it has a gray tint that I like because it lets me see what I'm doing. Its only fault is that you can't leave it on your paper for months, as it sinks into the fibers and won't come off. Also, you shouldn't use it if it's very old, because it will leave a gray film on the paper after you remove it.

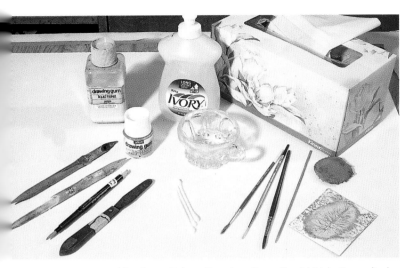

For masking I use Pebeo Drawing Gum (liquid frisket), applied with small synthetic brushes that I clean in a solution of dish soap and water. In the foreground at left are some of my other masking tools: bamboo pens, a palette knife, and cotton swabs.

In the past I used old, worn brushes for applying mask, but found that to be frustrating because I needed better detail. So I now use new synthetic brushes in smaller sizes. The problem is always the same: The hardened resist collects in the heel of the brush, which splays out the tip so a point is no longer possible. Using a rigger brush helps—the longer hairs keep the mask out of the heel. I have tried every kind of solvent for cleaning mask out of brushes but found that nothing works very well, so I just use the easiest—dishwashing liquid mixed with an equal amount of water.

STUDIO SETUP

The photographs shown opposite give you an overall view of part of my studio. There is a sitting area around the fireplace, divided from the work area by a large counter with vertical hanging file cabinets underneath, plus a large, five-drawer steel horizontal chest. This entire filing system opens opposite my work area.

I do all my major painting standing up and moving around, then sit down when I'm working on fine details. I have two drafting tables that can be adjusted to different angles, and a two-level taboret I designed myself that has drawers for everything and is made of pine and Formica. The whole wall to my left is windows. Unfortunately, this affords me east light, but then, in the cold north woods you won't find many houses with windows facing north! I also have color-corrected lights for night work, plus a wonderful light box. When the daylight goes, turning it on is like turning on the sun.

The two walls you can't see in the photos are lined with bookshelves, mostly for reference books and magazines filled with images of flowers, birds, deer, moose, and other nature subjects. I have books about the sea, the wilderness, mountains, deserts—everything. All of these reference images are photographs, not paintings. When I want to know exactly what a heron looks like, I don't want to rely on another artist's idea of its appearance— I want just the facts!

I also have special shelves to display paintings I'm working on. One wall has waist-high vertical files with plywood spacers; above them are rows of small plastic boxes for my reference slides, labeled according to subject. These are pictures I have taken myself through the years to record, say, how a lilac bush grows, how birch bark looks up close, how olives grow in Italy and flame trees in Africa. If you haven't already begun to collect such reference material, begin now!

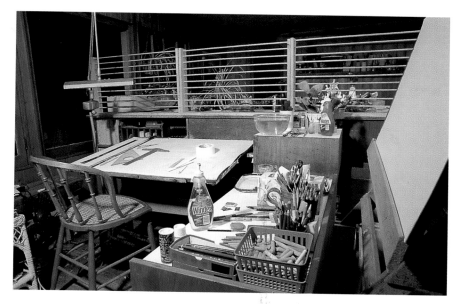

Part of my studio: drafting table and two-level taboret. The structure with the wooden dowels? It's a sort of fence: My two cats used to sleep on the counter and decided that the easiest way down was to walk across my paintings, wet or dry, on the drafting table (and take a drink of the painting water along the way)!

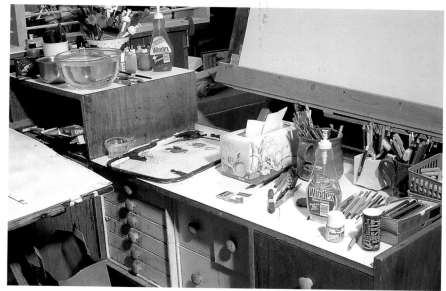

All of my supplies are arranged on the taboret for easy access. From left: a bowl of clean painting water, some squirt bottles, a Windex bottle containing diluted color, my butcher's-tray palette, a pop-up box of Kleenex, kneaded eraser, razor blades, various brushes and paint-lifting tools, a Windex bottle containing clean water, masking fluid, salt (used for texturing; more on this later), and, in the background at right, pencils of various kinds (drawing, watercolor, and chalk) and chalk. Other tools I use that aren't shown are a hair dryer, electric eraser, heat gun, and Craftsman sander, and something I couldn't paint without: a roll of 2" white masking tape.

Words of Advice

Make things easy for yourself. Let your materials evolve until you are entirely comfortable with them, yet always be on the lookout for new tools. I have noticed that whenever a group of artists are engaged in an intense conversation, it's never about esoteric theory—it's all about supplies!

When I am preparing to paint, I know all of my supplies must be at the ready, because once the first out-of-control stage of the painting is under way, I have to give it my full attention. I compare it with Chinese cooking—all of the food must be cut up and ready in little dishes before you heat up the wok.

Before you begin painting, be sure you activate all the colors you plan to use. In other words,

dilute them with water. I do this by filling a #6 or #8 round brush with water and mixing it with the piles of paint on the palette one at a time until there is a pool of color around each. I do not activate the entire pile of paint—it's important to leave some intact, in reserve. Also, have tissues nearby—the kind that come in a pop-up box that gives you one at a time—because when you are coping with water running wild on your painting, you can't be groping blindly for tissues. (You may be sure a lot of my choices have been made because of disasters happening!)

Above all, remember the priority: whatever is happening on the painting! If something tips over on the rug, forget it! The painting is the thing.

WARM-UP EXERCISES
No Drawing, No Censors, No Rules

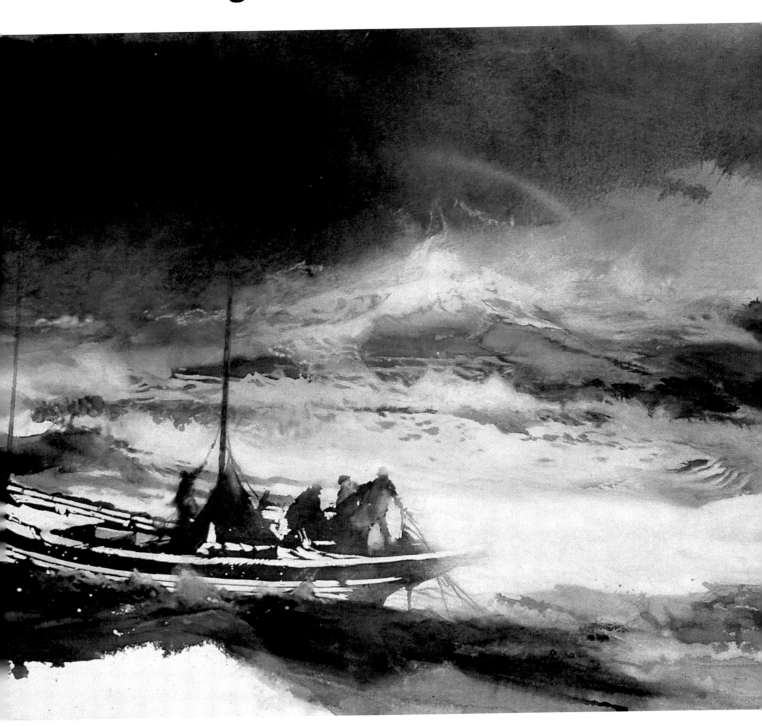

LIFTING NETS, LAKE SUPERIOR
Watercolor on Crescent cold-pressed illustration board, 24 x 36" (61 x 91.5 cm); one of nine panels. Total size: 6 x 9' (18.3 x 27.4 m). Collection of Marquette General Hospital.

THERE IS NO GREATER freedom than play, and I believe it is essential to the making of a watercolor painting. Thus, in the first half of this chapter, I want to create an atmosphere that is free and easy. Look in a thesaurus for synonyms for freedom—they are wonderful words: *unchained, unshackled, independent, ungoverned, unobstructed, wanton, loose!* We will put these words into action with a few exercises, for which there are no rules, no drawings, no censors. My intention is to make you so familiar with the behavior of paint and water on illustration board or paper that you will become totally proficient at using these techniques in any situation, whatever your subject matter. So, arm yourself with lots of paper and board, lots of paint, a water bottle, and a carefree spirit! Get the water moving, get the paint moving, and watch what it can do!

In the second half of the chapter we will attempt to combine the looseness of abstract painting with the realism of landscape painting. This will involve preparation—studying reference material, drawing, thinking through the composition —finding ways to turn your abstract beginnings into a believable, well-designed watercolor painting.

MY BASIC APPROACH

My method of working consists of two parts: a wild, spontaneous phase, in which I aim to create a field of texture that will give the illusion of, say, water, a daisy field, trees, or whatever; and a realism phase, in which I select small areas, usually in the foreground, and add careful detail so the viewer's eye will read the rest as reality.

In the first phase I apply the water and paint and follow it wherever it leads, with no censoring. This is not a time for thinking; it is a time for reacting to the paint, being ready to take action for any possibility. I let all the mistakes happen in this stage, because I know I can get rid of them later.

After the paint is dry, the thinking phase begins. I stare at my painting, study it, and decide what to keep and what to lift out. At this point, I collect all the material I might need for reference, and use this research to add details to my painting. Anything that doesn't contribute to the overall image, I remove.

Doing the Exercises

I have chosen the sea as subject matter for these exercises because it lends itself to manipulation of water and paint. The object is to learn to control the water, and therefore the paint. It's not a time to be fearful; as the ski instructor says, if you're not falling on your head, you're not learning anything! Incidentally, I use these warm-up exercises in all my classes—even advanced master classes. They are based on the theory that water follows its own path and on taking advantage of that fact. If you make a pattern of wet and dry areas on your paper, the paint will more or less stay out of the dry areas. This will create a unique texture that can be used for any subject matter and is one of the basic ingredients of my methods. To see how it works, pick up a piece of scrap paper and your Windex bottle filled with water. Hold the bottle close to the paper, about six inches away, and depress the plunger only halfway so that you get a sprinkle instead of a spray. This produces a coarse texture pattern of water droplets on your paper. When you apply paint to it—not with brushstrokes, but by "throwing" it, flinging it at the paper from a loaded brush (the action is kind of like a tennis chop or like shaking down a thermometer)—the paint will flow into the wet areas and stay out of the dry ones. Practice this technique—which I call the "half-stroke sprinkle"—until you feel you're comfortable with it.

To begin, tape a sheet of cold-pressed illustration board to a support (such as Gator board or plywood) with white masking tape. You will need at least two squirt bottles: one for paint, the other (with a thinner needle) for clean water. Also be sure to have a Windex spray bottle filled with clean water, along with a ready supply of clean water in other containers at hand. Make sure all the colors you are going to use are thoroughly dissolved on the palette and ready to work with. You must be ready to paint as soon as water is applied to the board. Your full attention must be on the painting, because the action moves quickly.

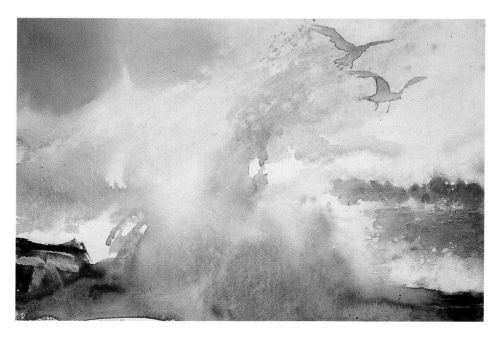

PERCUSSION WITH GULLS
Watercolor on cold-pressed illustration board,
12 x 14" (30.5 x 14 cm). Collection of the artist.

Painting Wave Patterns

In this demonstration, a painting based on the wave action of the sea, I introduce you to most of the techniques I regularly use in the first phase of my painting process: squirting paint, spraying it with water to move it around, texture spraying, and using a painting knife. When you try these techniques yourself, be sure to have enough paint on your palette, because you will be using water as a vehicle for moving it around on your painting surface, meaning that the color will become diluted. Also, avoid having too much water on your painting surface to begin with, because you will want some areas to remain dry so that you get a texture pattern.

In preparation, I squeeze some of my colors into a cup to get a fairly dark blue mixture, adding water and stirring to dissolve the paint thoroughly so it has a consistency that's about like regular milk. I pour this mixture into a squeeze bottle (the one with the bigger needle).

First I decide which direction I want the waves to go in. The waves are established by water running from one side of the painting surface to the other, which involves tilting the board accordingly.

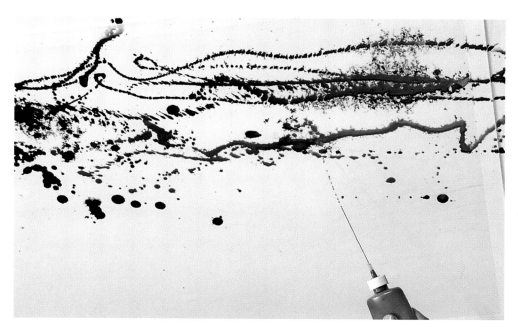

To begin, I lightly spray the surface of my illustration board with water, then squirt the dark blue paint mixture in the squirt bottle in a free wave pattern across the top of the board. The waves in the distance, near the horizon, should appear small, becoming larger as they move into the middle ground. Here I'm squirting a second, different blue mixture just below the darker color already applied.

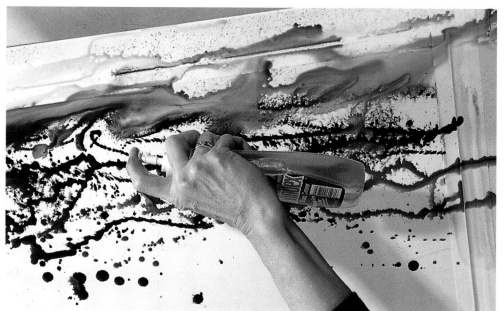

I choose my horizon line and spray water from there *upward,* right off the top of the painting. This area will fill with color and become the sky. I'm careful to keep some white dry areas on the horizon, as these will become whitecaps. I briefly tip my board to run water off the top, then keep it tipped toward the right, the direction I want the waves to go in.

Keeping my board tilted in the same direction (to the right), I spray water into the linear area, letting the waves form themselves. I add more paint as needed. I continue working from side to side until I'm about a third of the way down the painting, taking care not to drown everything as I spray!

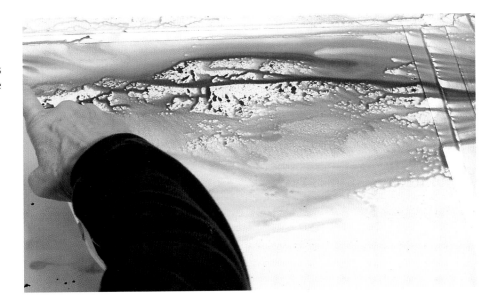

With a large brush, I paint rocks conventionally in the foreground with dark colors—Payne's gray, brown madder alizarin, plus the "sea" triad of cadmium scarlet, aureolin yellow, and Antwerp blue. I also use accents of cad scarlet and cerulean blue. Using the drybrush technique, I drag a brush that's only partially loaded with paint and very little water across the dry surface of the tops of the rocks at an angle, and then partly fuse this into the wet area. This will happen naturally because the board is both wet and dry. I paint the bottom of the rocks with blues and greens, where I will be making foam against them.

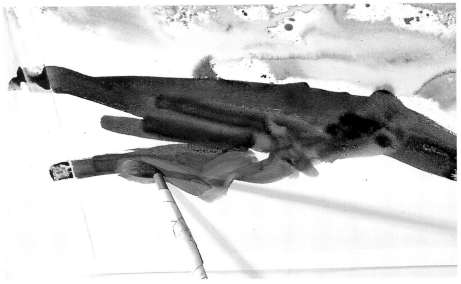

You can see by this picture how wet the painting is at this stage—still viable, still able to go in any direction.

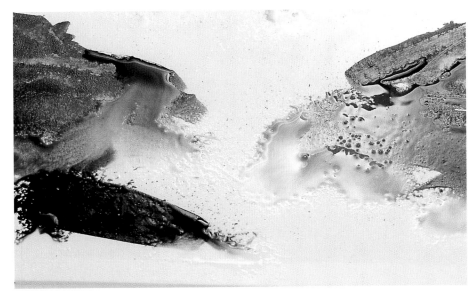

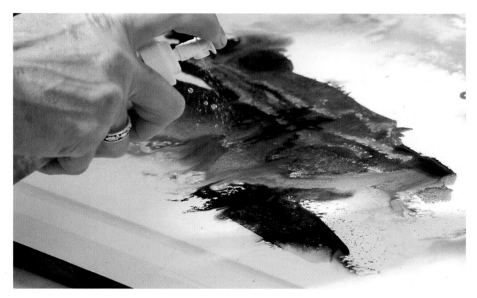

Working close to the painting, I use the half-stroke sprinkle technique described above, directing a gentle spray of water along the bottom of the rocks to create the illusion of foam. I am careful not to allow any red near the waterline, as I don't want the foam to be red. I keep the board tilted toward the right to establish a flow of water and paint between the rocks. The purpose of this step is not only to create foam, but also to soften the bottom edge of rocks at the waterline.

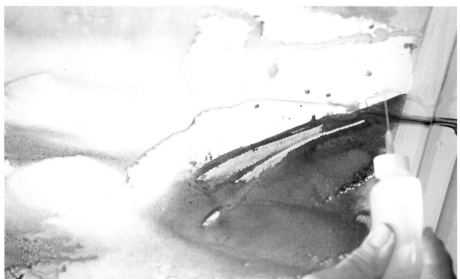

It's safe now to rest the board normally (slanting top to bottom instead of sideways) or move it as needed.

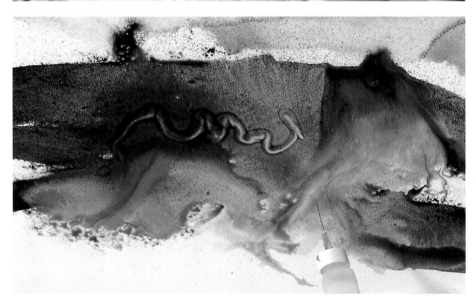

At this point I steer the paint delicately with a fine-needle squirt bottle filled with water. I keep playing with the water.

Here I make large, free strokes with my painting knife to establish the shape, sharpness, and highlights of the rocks. The paint should be about one-third dry when you do this—in other words, when the shine of the wet paint is just beginning to disappear. You actually sculpt the rocks with the knife, moving around the paint that's already on the surface and knifing on more paint if needed. Hold the knife at an angle, as if you were frosting a cake; this usually prevents marring the paper, although some digging and scraping might add to the effect. I paint with the knife fairly vigorously because I know the paper and illustration board I use can take a beating. One great thing about knife painting is that if you don't like the strokes you make, you can cover them with paint and use the knife again!

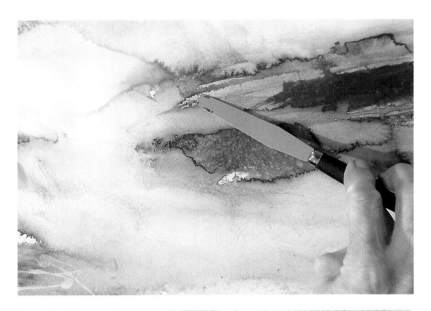

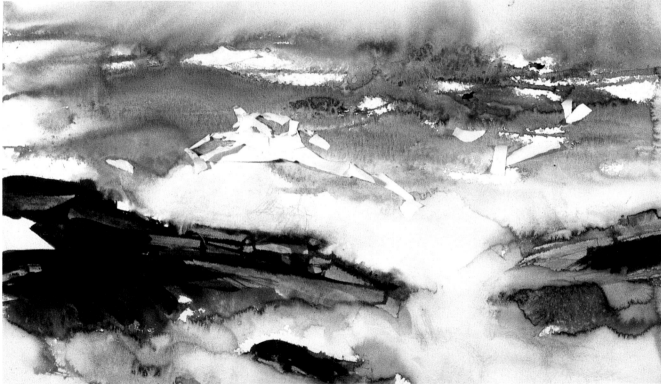

Now comes the thinking time, when I study my painting and make decisions about where I want it to go. After the paint has totally dried, I prop the painting up, stand back, and first check for emotional impact and whether it has the all-important illusion of reality. I also look at the big shapes to see if the design works and if I have led the viewer's eye into the painting. Sometimes I leave it for a few days and come back with fresh eyes. In this case, I decided to adjust some shapes. To visualize how the waves should look, I tore pieces of masking tape into various shapes and tried them right on the painting. I felt here that the foreground was not connected to the background; the eye needed to be led more efficiently. When it looked right to me, I drew around the tape, removed it, and removed the paint from within my pencil line so now I had the white paper back, in a redesigned shape, for the foam.

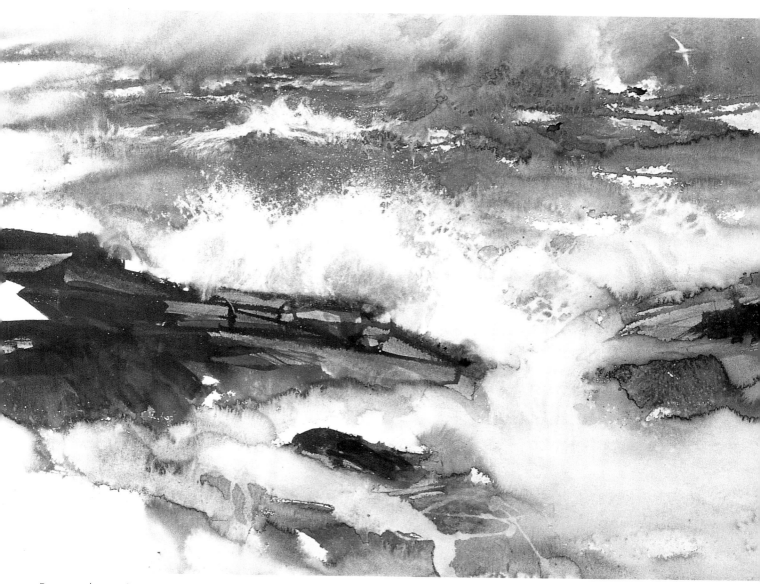

Between the previous step and this one—the finished painting—I revised certain areas, including the wave smashing in the foreground; what initially looked like foliage in the middle ground I modified to look more like spray; and I made sense of the white areas, using the whites that happened spontaneously on the painting either as whitecaps on the waves or as places light was gleaming on. I note what the watercolor itself has done, then enhance it, rendering details with a #3 or #4 brush. I have no magic techniques for painting details or finishing paintings; it's just hard work!

Related Examples

On these two pages are some examples of other sea-painting exercises that are the result of teaching my classes to be free with watercolor. They all have a similar composition because I want my students to experiment with sea and rocks. If you follow the preceding step-by-step demonstration, you will have a free, intriguing start, with many happenings and possibilities. Your next step is to make a painting out of what you have.

In the beginning, *Headland* (below) was very similar to the preceding demonstration, but as I continued working on it, I lost my original concept and the painting became shapeless. Fortunately, it started to resemble a headland jutting into the water. I added a house in the distance, enhanced what looked like a stone bridge, and transformed a small white area into a shining sea on the horizon.

From the Top (opposite, top) is an example of a sea exercise gone wrong. The painting action included spraying, tilting my board to make the water and paint behave like a real wave, and knifing rocks in the foreground. However, after the paint was dry and my thinking phase had begun, I realized I had lost any real feeling of moving water. Thanks to an accent of light here and there, I began to see mountains, and finished the painting accordingly. I established a new, very high horizon line for the sea, added a lone tree atop the land at right, and removed paint for distant sea. I also filled foreground hollows—previously waves—with trees and rock. Last but not least, I gave the painting its title!

What do you do when a painting seems to be a failure but has passages that are really worth saving? When it has areas of happy accidents that you could never do again? I couldn't throw away what eventually became *Harbor 1890* (opposite, below), so I turned it upside down and the sea became the sky. I added details of the town, docks, and sailboats, and suggested the seagulls to give the composition a foreground. And because the schooner-like shape was accidentally there, the painting became a scene from 1890.

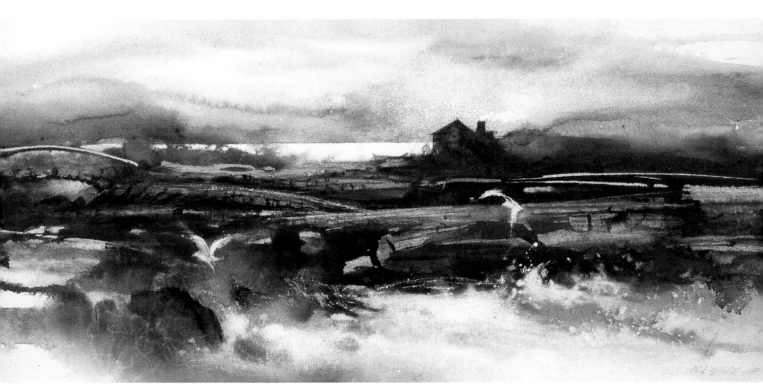

HEADLAND
Watercolor on cold-pressed illustration board,
10½ x 20" (27 x 51 cm). Collection of the artist.

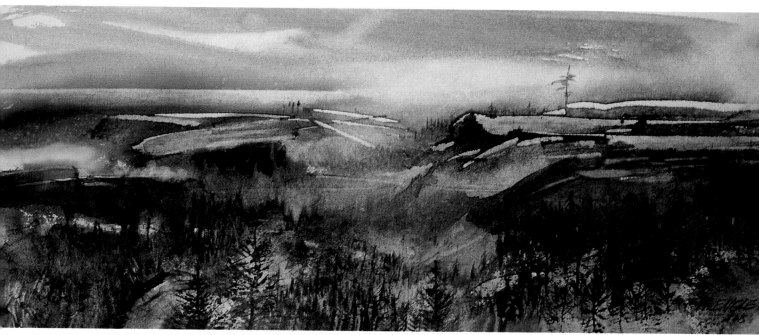

FROM THE TOP
Watercolor on cold-pressed illustration board, 9⅜ x 22" (24 x 56 cm). Collection of the artist.

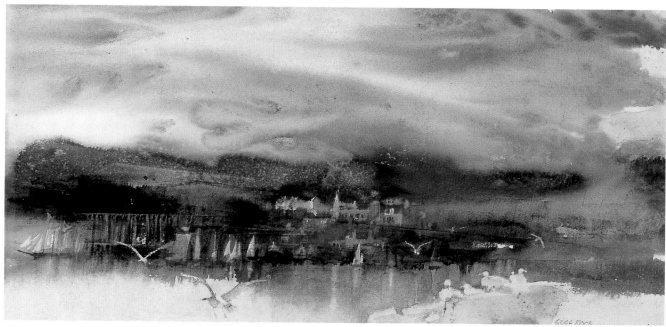

HARBOR 1890
Watercolor on cold-pressed illustration board,
9¾ x 19" (25 x 48 cm). Collection of the artist.

Painting a Cresting Wave

Informally I call this little painting "wave coming at you." I discovered that if you apply paint and water in certain ways, you can sit back and watch while, just as in nature, the wave breaks and crests all on its own. This example was painted on illustration board, which works better here because it has a slicker surface than regular watercolor paper.

To begin, I taped a piece of illustration board (15 x 20" or smaller is good) to my support board. I have ready a squirt bottle filled with water and another with a mixture of dark marinelike colors, diluted with water to the consistency of milk. This exercise may require some practice before you can expect a rewarding result, but it's such fun!

I tilt the board toward myself at a moderate angle and spray it lightly with water, starting about a third of the way down and continuing to the bottom, so that when the paint is introduced, some areas will be softened by the water, creating texture. I then paint a wave shape across the surface at about where the spray started, using deep marine colors consisting of the "sea" triad, plus French ultramarine mixed with Winsor red for a purple blue, yellows used to make green, and maybe some Payne's gray for darks.

Immediately after I paint in the wave shape, I squirt clean water about an inch or so beneath the top of the wave.

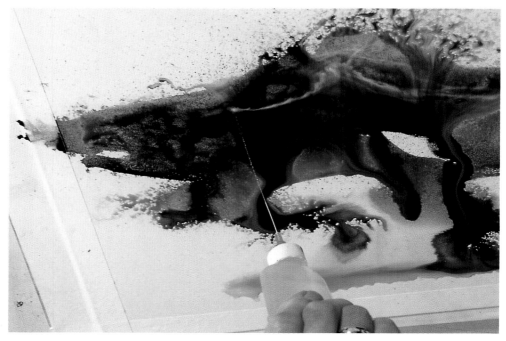

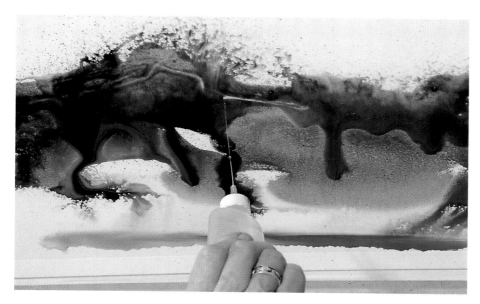

I continue across the surface, tilting the board more vertically toward myself. The wave begins to create a lip on top and spill over toward me, the way a wave behaves in real life. The more water you squirt, the more the wave will crest.

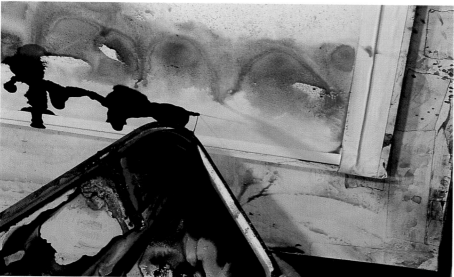

Here I see that the foreground has become too light, so I pour on some dark, diluted colors from my palette.

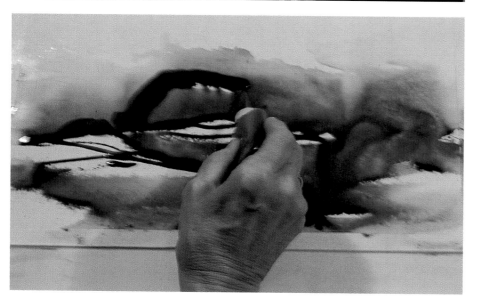

In this photo, from a different but similar demonstration, I show what you can do if you lose too much darkness under the lip of the wave: You can poke it back in with dark paint from your squirt bottle.

I squirt with water once more, and again watch as the lip of the wave spills over on itself.

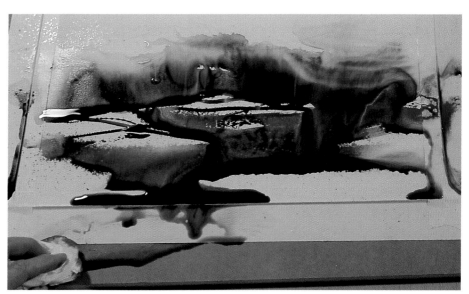

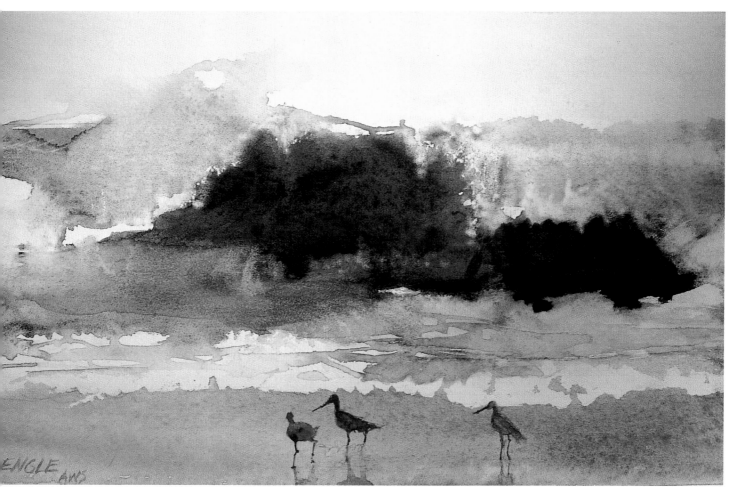

This is the finish of one such demonstration. I cleaned up the edges of the spill, aiming not to spoil the effect of the water's free movement.

LEARNING FROM THE MEDIUM

Saying that we learn from our mistakes is so trite, but everything I have learned about watercolor has been from disasters happening. This medium teaches me more every day; there is no end to its possibilities.

There is enjoyment as well as fear in giving a painting demonstration; valuable work can result from that experience, because one's adrenaline is doubled in front of an audience. The teaching artist is committed because there is no escape! He or she must follow the watercolor no matter where it leads—even into failure—and then use his or her wits to win in the end.

I write this because I know that painting in watercolor before an audience has increased my artistic abilities—the old gain-by-pain theory! If you don't teach workshops, you might try putting on your own demonstration for friends, family, or art club to see for yourself what it's like.

Starting to Work with Reference Material

This section is a continuation of the experiments with paint and water, still with no preparatory drawing or masking, but maybe just a bit of censoring. The difference here is to have some reference material at hand before beginning. Do not draw from it—just refer to it as you paint, and follow it loosely. The painting procedure is exactly the same as previously. Finish your work by applying the details your references show you. That's how I pro-

ceeded in creating these next few paintings: I used no drawing or masking, but consulted my visual sources for any necessary factual information.

My reference material for *Sea Studies—Bonaventure Island* (below) was gathered firsthand. This watercolor was part of a two-month painting trip along the eastern coast of the U.S. and Canada. We experienced this tremendous sea on a boat ride around Bonaventure Island, a bird sanctuary just off the coast of Quebec's Gaspé Peninsula. I wish paint could also express sound, because the waves were booming and echoing.

I did this painting on illustration board, which, with its smooth surface, allowed me to "float in" many colors for the rock and also lift out color later to depict the foam and sea birds. To "float in" color, you flood an area with water, then drop in the paint—the colors should be fairly intense—and tilt the board to make some of the hues merge and others half-merge. I did a lot of spraying with my Windex bottle as the rock color drifted downward, and all of the water was then directed off to the right side of the painting. It's interesting to note that in real life, a wave rolls in and then smashes on the rock, while in a painting, the smash comes first—the blast of water sprayed onto the paper—and then the wave runs out!

Sea Studies—Foam (next page) is more to me than a rendition of gulls and foam; it could instead be

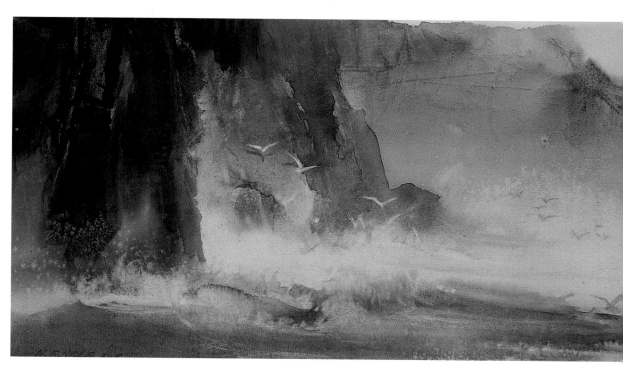

**SEA STUDIES—
BONAVENTURE
ISLAND**
Watercolor on Crescent cold-pressed illustration board, 18 x 26" (46 x 66 cm). Private collection.

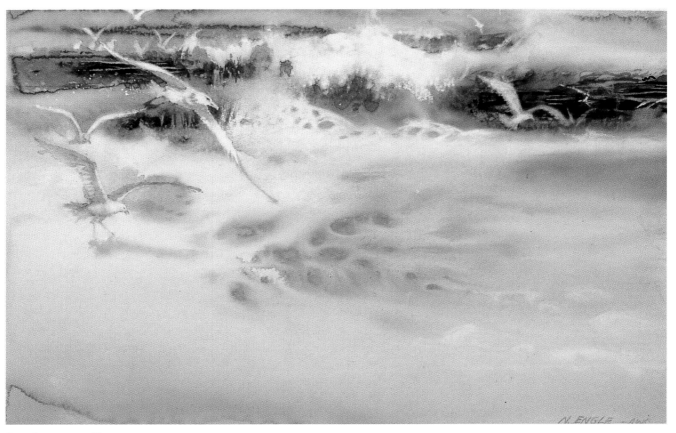

SEA STUDIES—FOAM
Watercolor on Crescent cold-pressed illustration board, 11 x 19" (28 x 48 cm). Collection of Linda McManus.

called "Watercolor, What a Wonderful Medium," because it really did paint itself, and because in watercolor, perseverance is rewarded. I learned never to despair—if you can't solve a painting problem, let the watercolor solve it!

Again I worked on illustration board, which has marvelous characteristics and offers many advantages. However, it has a down side: If you apply too much water, there comes a point when it won't take any more! I painted the very top part of the work but then couldn't make up my mind about the bottom half. I kept applying paint and spraying it off till finally the board would not accept any more paint. In desperation, I mixed cerulean blue, which has a lot of body, with some sea colors and, with a brush, flung it onto the painting in big globs. Instead of dispersing over the whole surface, it just stuck there in lumps. So I tried spraying it gently with water to get it to move. What happened next was entirely the watercolor's idea. When the water slid into the lumps of blue, it went *around* them, the way water goes around rocks in a stream! So suddenly I knew how to paint not only rocks in a stream or in foam, but rocks in fog, or any other instance where moving water meets immovable rock!

Sometimes a painting can prove to be an example of the importance of just doing it, day after day, year after year. Just painting. Nothing—not study and reading, not museums or workshops—is more essential to your growth than experience, working by yourself, in your own studio, because once in a great while, after what seems like a lifetime, a painting can be completed in ten minutes, or as the saying goes, "Twenty years and ten minutes." This happened to me with *Sea Studies—Wave* (opposite, top). I lightly sprayed my painting surface with water, applied the paint, sprayed more water on it and tilted my board to move the color around, adjusted the values (lights and darks), and it was finished. I knew before beginning where I wanted the light source to be and the direction I wanted the wave to follow, but that's all. The rest was luck and watercolor. And seizing opportunities!

Still another painting for which I did no drawing or mask preparation is *Sea Studies—Sea Power* (opposite, below). I knew I wanted to depict a swelling sea smashing against a large landmass, because when working on another painting, I had made some small sketches of this idea and was thinking of exploring it further. As I was spraying

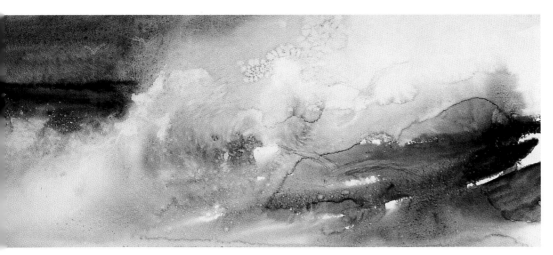

Sea Studies—Wave
Watercolor on Crescent cold-pressed
illustration board, 8 x 18½" (20 x 48 cm).
Collection of the artist.

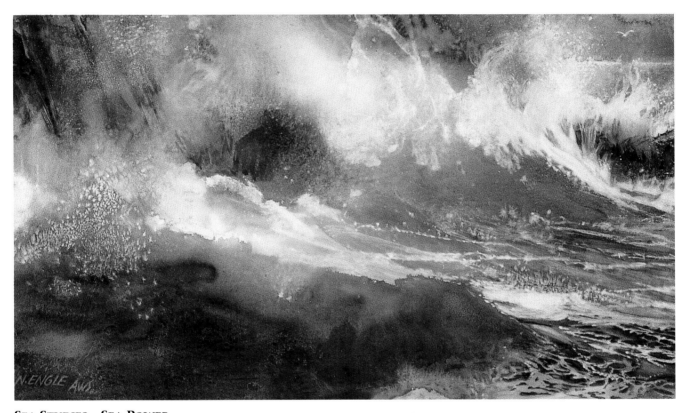

Sea Studies—Sea Power
Watercolor on Crescent cold-pressed illustration board, 17⅜ x 29" (44 x 74 cm). Collection of the artist.

water on the board and tilting it, I could see a natural run-off of water and paint occurring in the middle area, so I exaggerated this flow. It had direction but not enough value (dark vs. light) contrast. There was an overall blue-green tint, so I retrieved whites by lifting color with Q-tips and a toothbrush. I also extended the length of the water's flow into the right foreground.

I found images of some typical foam patterns in my reference files and, when the painting had dried, drew the patterns on the right foreground with white chalk. Then, following the chalk lines, I used my electric eraser to lift paint from those areas to create the foam pattern. An electric eraser is a great tool, because you can keep the painting dry; no water is needed for paint removal.

HARNESSING FREEDOM

If you are a realist painter, there is a down side to working totally freely, with no drawing, no preparation, and only a vague idea of what kind of composition you're after, what light source you will establish, and so on. After all of the great watercolor "happenings" dry, you still must develop the painting and decide how best to do that. What should be added and what removed to make the image believable? How will you make the design work? These are the kinds of questions we ignored while having fun! There is a price to pay for freedom, and of course, there is more to making a painting than creating watercolor "happenings."

Taking control of your work means answering all the questions of drawing, value, design, composition—determining all the elements of a painting before you actually begin to paint. I had to devise methods for my own work that would let me keep total freedom and still have control of the painting. I wanted all of the great watercolor effects to happen, but still wanted to retain my composition, my drawing, my realism. I wanted the watercolor to magically delineate barns and trees and rivers and all the elements in nature, and still be free enough to do its own thing.

The better we prepare beforehand, the faster we are on our feet when we paint. As is true for any endeavor in life, "chance favors the prepared mind." What do I mean by preparation, in practical terms?

1. Study the material you are working from—your source material. If you are a realist, you need to have the facts.

2. Make a careful drawing on the watercolor paper, and apply mask to the areas where you know you want to reserve white.

It is supposed to be an accepted truth that a tight drawing makes for a tight painting, but I think the opposite is true. A careful drawing, selectively masked, means you can always be working outward, freely and loosely with the paint, without concern for detail, because it is already there, protected by the mask. If, on the other hand, you have no drawing, you tend to work inward with the paint, trying to delineate all the detail. This makes the painting lose power and become scruffy-looking rather than free.

So here we will use exactly the same ways of applying the paint as before, with one difference—preparing the paper first with drawing and mask. All of the color gradations, all of the watercolor effects in every example that follows is made possible by this preparation. A word, however: Mask is only one way to control watercolor; as you will see in subsequent chapters, there are other methods.

Masking

I have one primary rule about mask—do not use it unless there is absolutely no other way to control the whites. I have spent my painting career in a search for ways to avoid using mask, for ways to achieve fine detail and free washes at the same time. Still, I regard it as a positive tool, just as legitimate as the white paint an artist working in acrylic or oil would use. I feel I am still painting, even though it's with mask; in some cases when I'm applying it, I feel that I am painting with light.

One of the most important things to keep in mind about masking fluid is that even though it is only the first step of the painting, it is really the final details you are applying, so you must be accurate and delicate. Otherwise you may go on to paint what appears to be a successful watercolor, only to find, when you remove the mask, that your painting is ruined because you were sloppy and crude about applying the resist.

I do not recommend that you use mask to the extent I sometimes do unless you are sure you know how to alter its effect at the finish. In other words, you must be able to soften the hard edges, the raw look you are sometimes confronted with when you peel the mask off the dried painting. When an area to be softened isn't very big, I sometimes use a small, stiff, chisel-edged brush dampened with water; if the area is large, I use a wet toothbrush for this. When precision and delicate handling are called for, I soften the paint with an Incredible Nib. For example, after removing mask from areas in a painting that are to become ripples on a lake, I use the nib to soften the ends of these shapes so they become part of the body of water.

Creating Hard-Edged Shapes with Mask

Around the same time I'd been exploring the shore of Lake Superior and photographing its impressive cliffs, I was reading about the early commercial fishermen of this area, much of which is wilderness, and about how they had to venture out in all kinds of weather because their nets had to be hauled in within three days or all would be lost. This all came together in a painting for a competition by a local philanthropist to furnish the high school with a permanent art gallery.

I knew I wanted a powerful design; I wanted nature to be overpowering, people small in scale. I knew I had to be careful not to lose that feeling of power with a weak painting. But I also wanted the painting to be atmospheric. As I thought about how to accomplish these goals, I decided on a dramatic winter scene, the mighty cliffs along the shore craggy and snow-covered and the water rough, with a menacing, hard-edged chop. I knew masking would help me achieve these effects.

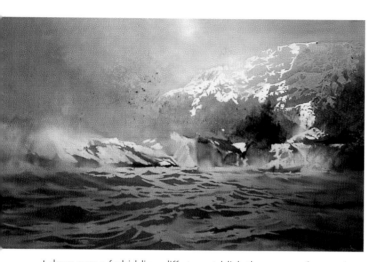

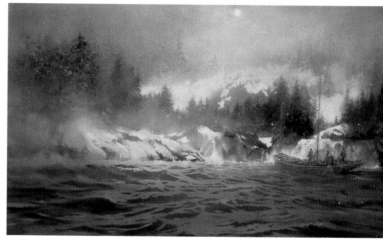

I drew some forbidding cliffs to establish the sense of nature's power, and placed the small boat right at the shore's edge, next to the cliffs, for contrast, with a lot of waves in between to convey drama and action. I applied mask to the water to preserve the hard-edged light shapes of the wave pattern. This enabled me to wash in the darkest values first, then remove the mask on the waves and apply a light toning wash to the whole area. This also meant I could control the path of the light across the water to heighten the drama of the scene. On the cliffs, mask still covers some of the snow areas (the yellowish patches), while in other areas I've already removed it and painted in some dark fir trees to establish my value range. I also decided at this point to add a winter sun by lifting paint in a fuzzy circle with a toothbrush.

IN CLOSE FOR HERRING
Watercolor on Arches 140-lb. cold-pressed paper,
18 ½ x 30" (47 x 76 cm). The Fredeen Collection.

After doing research on commercial fishing circa 1890, I changed the boat with the help of old photos from the Marquette Maritime Museum, provided by Frank Smith. The cliff immediately behind the boat was made lighter and softer to showcase the fishermen. This was done by first carefully wetting the area and then lifting color with a soft toothbrush. I removed the rest of the mask from the cliffs and designed the whole area as bands of trees and snow, each plane receding more and more into the background snow fog. This was accomplished in two ways—by making some of the hard-edged cliffs soft with a toothbrush to push them back, and by painting trees of a much darker value in the foreground. The trees were painted conventionally, with a brush, although I am never content to just leave them this way; I also sprinkled them with water to blend them into the scene.

Preserving Intricate Detail with Mask

The blustery weather of autumn on Lake Superior is a great time to be on the beach, dodging the thundering waves after a storm, running from the flying spray, sun bright overhead, intense blue sky—it is tremendously exciting. The air coming from the lake, blown over hundreds of miles of forest, is incredibly fresh and alive, charged with pure energy. The conditions on such a day determined the methods I decided to use for this painting.

This survivor of a tree—a maple the wind had stripped of most of its leaves—was wet all over from the crashing waves and spray. I knew if I painted the foliage with a brush or a sponge, or by my usual means (throwing paint and sprinkling water to form the foliage), I would create a texture of individual leaves that would make the tree look too dry. It required a really different approach to paint the feeling of this October day.

I wanted to capture the look of the tree's drenching-wet leaves, so I decided to paint all the foliage as a wet running wash. To do this and still keep the definite, delicate edges, I painted mask around the fairly complicated mass of foliage, because I thought I would lose control if I used another method of defining the leaves. Here you can see the gray mask around the outside of the leaves. (When using mask, draw carefully first so you'll know where to put it.) I then started applying many colors—reds and yellows—without restriction. Prior to this, I'd washed in the light blue-gray color of the sky in the background, visible at the top of this photo.

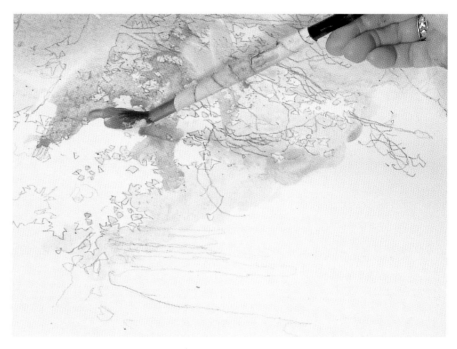

Here I added more color to merge on the paper; you can see the profile of the maple leaves on the edges, defined by the mask. Because of this careful preparation, I could be free with the wash.

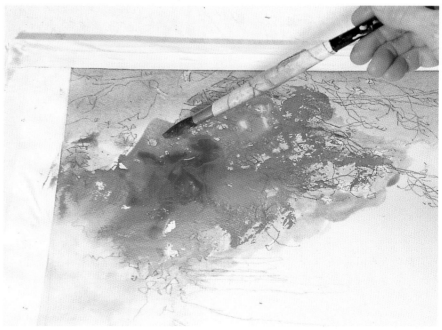

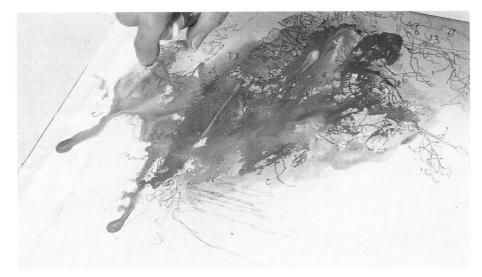

To simulate how wet the tree and its foliage were and how wet the air around it seemed to be, I sprayed the color with my water bottle freely. As you see, some of the paint escaped its boundaries, but I just sprayed it down to merge with what would become the tree's undergrowth.

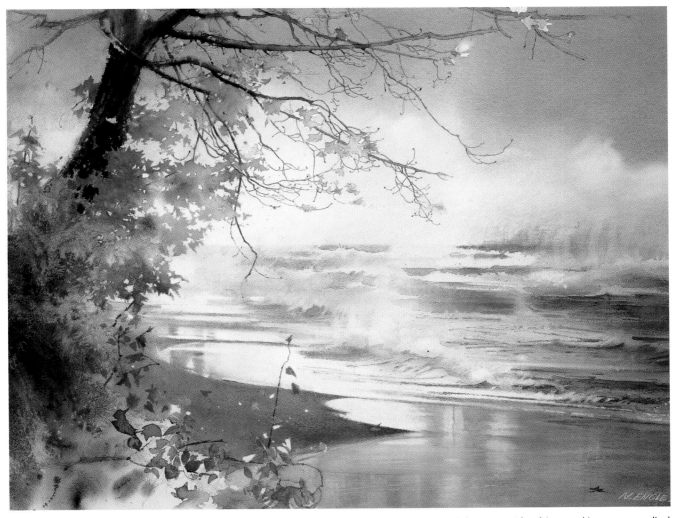

WILD OCTOBER
Watercolor on Arches 140-lb. cold-pressed paper, 17½ x 22⅛" (44.5 x 56 cm).
Collection of Dr. and Mrs. D. Elzinga.

After I peeled off the mask around the leaves, I shielded the area with white masking tape, applied masking fluid to the shining wet patch of sand and some of the wave detail, and then painted the lake with some of the techniques used in the sea exercises—brushing on color, spraying with water, tilting my board, and so on. I painted the twigs and branches last, using a rigger brush, and added the other details in the foreground as well.

Using Mask to Best Advantage

Masking fluid can be used for all kinds of purposes, not just hard edges or as protection from big glazes; it's also a means for creating textures. I've used it to depict such things as ice, architectural elements (like clapboard), reflections, and rushing white water. Sometimes I paint it on carefully, following the details of my drawing, but other times I fling it onto the surface to get random textural effects. The next few paintings should give you a good idea of the different ways I've used mask in my own work, and perhaps inspire you to explore its possibilities.

My painting *Beachy Head* (below), an image of the English Channel, is a good example of how you can use mask to create textures. Here I wanted to capture the sun's sharp glitter on the water, which called for hard-edged white areas. How to do this? There is Chinese white, an opaque white watercolor, but I never use it because it makes a painting look chalky, not even white. And retrieving the whites in an area this large by scraping the paint with a razor blade is impractical. The best solution was masking fluid, which also let me control the lovely foam creeping over the gravel beach.

After drawing the image on my paper and carefully painting mask on the detailed areas I wanted to keep light, I liberally flung dots of masking fluid onto the surface for added sparkle. I was able to recreate the color of the day using my "air" triad of Winsor red, Winsor yellow, and cobalt blue, colors that, because they ultimately complement one another, gave me mixtures of cool and warm grays. I used the rest of my palette for the dark values.

Flowing River (opposite, top) illustrates how I literally harnessed a free wash. I masked the foam pattern first, then contained and confined this river by creating masks for the gravel, the sandbar, and the twig, logs, and stump so I could have fun with the painting. I actually ran all the color down as the river flows, guiding it from bank to bank, knifing it over the falls.

Wild Roses by the Sea (opposite, below) always reminds me of what an individual thing human preference is. As a wedding present, I promised my brother and sister-in-law first choice of any painting I made. But it took them about ten years to agree on one they both liked! Finally, they felt mutual enthusiasm about this painting and so chose it.

I was very motivated by this subject—the sea, the sun, wild roses—what's not to like? As I squinted through the brambles and rose canes into the sun, watching it sparkle on the water, I knew I would have to depict the scene with a lot of hard edges. The sun's reflection on the water had a very sharp glitter, and the foliage was stiff and prickly; for me, mask was the only way to capture these effects. I drew a lot of tangled brush and applied the mask to preserve the detail. I was determined to show the exact effect of the sparkles of light and the profile of where foliage met water, so I relied on my photos of the scene to place almost every dot of mask in the crucial area. I did the same with the reflection of the sun on the water at right and on the horizon.

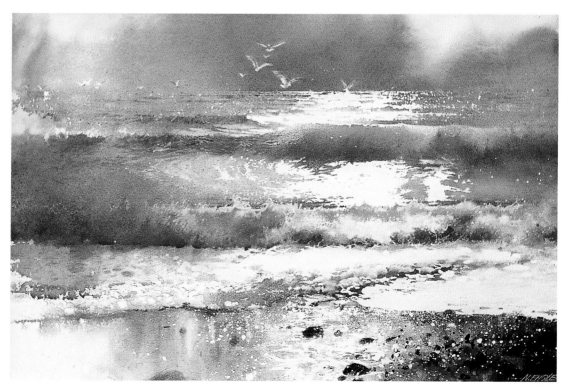

BEACHY HEAD
Watercolor on Arches
140-lb. cold-pressed paper,
19 1/2 x 27" (49.5 x 68.6 cm).
Collection of John Armstrong.

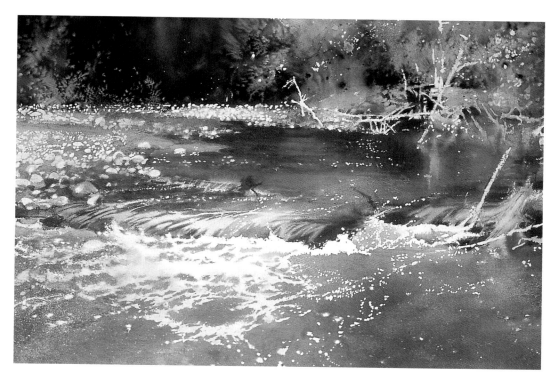

FLOWING RIVER
Watercolor on Arches 140-lb. cold-pressed paper, 20 x 27" (51 x 68.6 cm). Collection of Peg and Ray Hirvonen.

WILD ROSES BY THE SEA
Watercolor on Arches 140-lb. cold-pressed paper, 21 1/4 x 28 1/2" (54 x 72 cm). Collection of Grace Engle.

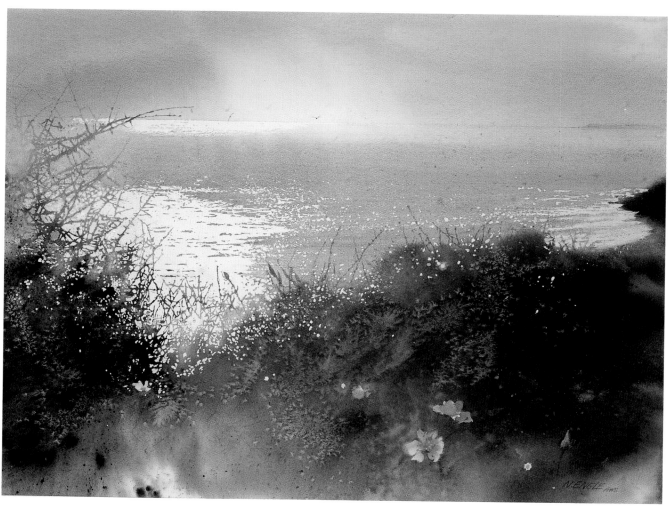

The rest of the mask was flung on. Then the real work was done; it just remained to have fun painting the scene. I used Winsor red, Winsor yellow, and cobalt blue for the sky and sea, and most of the colors on my palette for the foreground. Note the water-bottle spray at work, especially at left.

After all was dry, I emphasized the light in the brambles. First, with the support board flat, I carefully wet the area with a spray of water, then softly removed some of the paint with a toothbrush, continually blotting the area and rinsing it with clean water. This procedure gives the effect of the sun washing out some of the color as it shines through.

When I was on the scene of *After the Rain, Whitby* (below), I remember a sense of elation—the feeling you get when a thunder shower suddenly moves on and everything is refreshed. The clouds lifted, I thought, like a veil, a watercolor veil. The whole scene was a watercolor—that unique brightness after a summer rain, the thunder still rumbling in the distance, dramatic value contrasts, strong shapes, the old, wet wharf, and the feeble artificial lights against the tremendous light of the universe.

I worked on illustration board, mainly because there is a softness to the running edges of the paint (you can see this in the edges of the clouds lifting) that is not possible on paper with any kind of tooth. I masked the water and had good luck with the sky wash, and after it was dry, I applied about a two-inch band of mask along the roofline of all the buildings. I was then able to freely wash in all the dark values, flow in colors, spray water (for example, I misted the area around the lights on the boat), and tilt the board back and forth without fear, because the mask stopped the paint from bleeding into the sky. The sky was so bright in the

area of the mask that when I removed it after all was dry, you couldn't tell where it had been. Usually when you put mask on top of paint, you lose a small percentage of the color when you remove the resist. First I painted the washed-out rigging on the foreground boat with water, then floated in color.

In *Open Waters, Ducks* (opposite, top), I used mask for edge control and texture. After I applied it, I washed the whole area first with very wet and pale warm colors, then with cool complements. Dark values were blended in while the initial washes were still wet; when all was dry, I added trees using the drybrush technique. After removing all the mask, I applied more to the ice, where you see the whitest whites. I then washed a tone over the ice, and when it was dry, removed the mask. I could have painted all the brittle edges of ice with a brush instead, but I didn't want to violate my underlying principle—I didn't want any obvious brushwork. This is why it is so important to establish your own guiding principle early on, so you can make such decisions and remain consistent in your style.

At times I've needed increased control while painting—times when failure could have greater consequences, as with assignments for major publishers or a private commission, like the portrait of the sailing ship *Sea Cloud* (opposite, below). This is when preparing beforehand can really help. I had to be very careful with this drawing; these people knew their ship! But by the time I was ready to paint it, I could do so with exuberance because of all the preliminary work I'd done. I masked the sails, the details of the ship, the sun area of the sky, and some details in the sea. The rest was squirting, spraying, tilting, and running water—in short, action painting.

AFTER THE RAIN, WHITBY
Watercolor on Crescent cold-pressed illustration board, 18½ x 28¾" (47 x 73 cm). Collection of the artist.

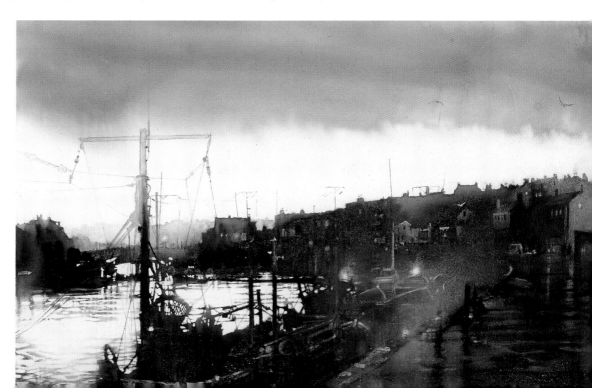

OPEN WATERS, DUCKS
Watercolor on Arches 140-lb. cold-pressed paper,
19½ x 28" (49.5 x 71 cm). Collection of Reader's Digest.

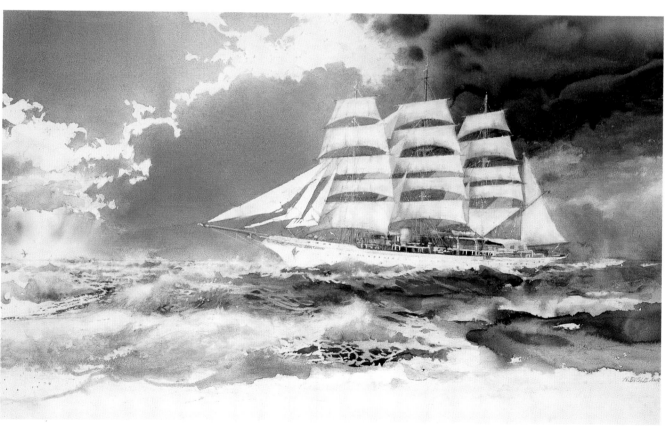

BREAKING INTO THE SUN—*SEA CLOUD*
Watercolor on Crescent cold-pressed illustration board, 20 x 30" (51 x 76 cm). Collection of Lindblad Travel.

WASHES OF LIGHT
Luminosity and the Importance of White Paper

COMING HOME
Watercolor on Arches 140-lb. cold-pressed paper, 20 x 28"
(51 x 71 cm). Collection of Clyde and Dorothy Zerbel.

WE SEE LIGHT (and therefore color) through the atmosphere, which, like a prism, both contains and breaks up colors. An object viewed up close not only appears sharper and darker than it would when seen from a distance, but also displays its real, or "local," color. In the middle distance, no matter what light is there, that same object appears lighter and fuzzier, and its color somewhat bluer than its true hue, thanks to the intervening atmosphere. And we almost never see the real color of a distant object, because it is totally influenced by atmosphere. It is important to study this carefully for each new painting, as every situation is different.

As the artist Rachel Wolf said, "Light is everything . . . light reveals beauty, and the inherent emotions of joy and wonder, the foundations of creativity" (*Splash 1,* North Light, 1997). When I was an illustrator, my main purpose was to enlighten readers and enhance their experience of a particular story. Thus, I began to understand the power of light. In my struggle to literally illuminate subjects I realized, as countless artists have, that it was light itself that attracted me. As a result, all my efforts became concentrated on how to achieve the effect of light in watercolor—and still are!

How does one create the illusion of light with only paint and paper? Artists have devised many ways to accomplish this: through value and color contrasts, lost and found edges, and more. I explored every method, but finally rejected the obvious solutions—not because they didn't work, but because they did not give me the feeling of light I was after.

I made many discoveries by experimenting with colored glazes—very thin, transparent applications of paint, usually laid over another, already dry layer of color. It is fascinating to watch what one glaze over another will do, and another over that, and still another . . . but eventually I saw that each new glaze was just one more layer of paint separating me from the white paper, the source of the glow, until the light, the transparency, the magic seemed to disappear.

Ultimately, it is the white paper that is the source of all light in watercolor and makes the colors glow. In this chapter, I'll show you where my explorations led.

THE SIX-WAY WASH

In searching for a way to use the glazing technique that would let me preserve the light source of the white paper, I decided to try applying as many glazes as I could handle at once in a single wash. This is how I developed what I call the "six-way wash"—which doesn't necessarily mean using six different *colors*, but rather, six *applications* of paint in one fell swoop. Basically, it is a multicolor wash.

Once I discovered how to do this, I saw how it could help me not only with solving light problems, but also with establishing my whole style.

I began to float thin, transparent paint over fresh white paper, using many colors at once and letting them blend together in their own unifying way, controlling the wash from all directions. This differs from the traditional method of applying one color at a time and carrying the "bead" of wet paint down the paper in a single direction. My approach is really a form of action painting, in which all of the judgment, emotion, and skill needed to make a watercolor work have to be operating at once, in a nerve-racking twenty minutes!

Achieving Luminescence with the Six-Way Wash

For this demonstration I used Winsor red, Winsor yellow, and cobalt blue. The transparency of these colors was essential to my idea. If you try this technique, be sure to use these transparent hues, because sometimes substituting another color results in a muddy look. Also be sure to completely dissolve and dilute the red so you don't get ugly red streaks of this powerful color on your work.

My initial paint application was done in a bull's-eye format; this was because it was crucial that the colors come from all sides. A student once asked me, "How come all that color, that blue and yellow, doesn't turn green?" Because before the blue can get to the yellow, it has to run through the band of red, which turns it lavender, which is the complement of yellow!

The key to success with this technique is to have enough paint dissolved and available, because once

the action starts, you will have no time for this. A multicolor wash is dependent on a lot of water and a lot of color; it requires large amounts of paint to remain vibrant, since the color gets diluted as you move it around with water. And nothing can be allowed to ever begin to dry; you must keep the painting constantly wet while maneuvering the color. You can spray water with abandon, because if the painting turns out to be too pale, you can repeat the process after it dries.

For this painting I worked on Arches 140-lb. cold-pressed paper, stretched and dried overnight. Before beginning to paint, I made my drawing and applied the first small areas of mask. I made sure to have my colors dissolved and ready. With this technique, we are setting the color loose on the paper to charge in every direction. Don't be afraid of wildly running paint and water!

First, I flooded the paper all over with water. After running the excess water off the surface, I kept the board flat for the application of paint at my light source—here, a hanging light in the left foreground. I began by laying in Winsor yellow in a circle, surrounding it with a wide band of Winsor red, and then around the red, a band of cobalt blue. Everything was kept very wet, and the paint was applied quickly.

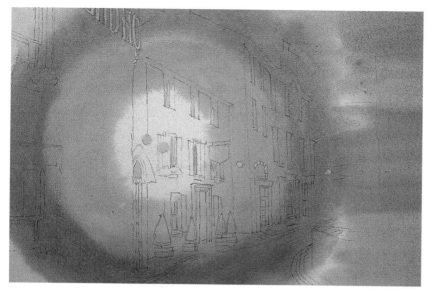

I made sure my paper was still wet, then quickly added the next three colors down the right side of the painting in horizontal bands of roughly equal size. The top third is cerulean blue, a relatively warm blue used because I wanted the sky to be warmed by the distant lights in the village. The middle third is cobalt blue, and the bottom one a mixture of Winsor red and cobalt to make a lavender, which will represent the street fog in the finished painting.

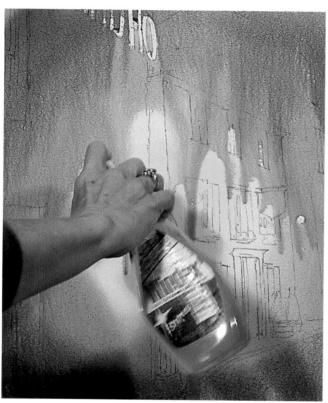

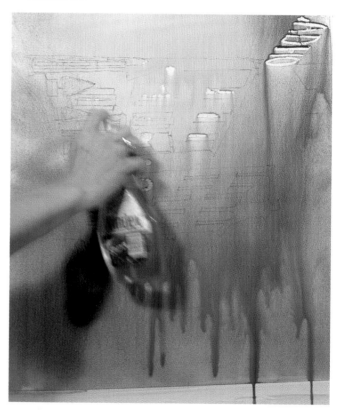

Immediately after applying all the colors, I picked up the painting and, holding it almost vertically, began spraying with water to make the paint move. I then rapidly turned the board—one quarter turn at a time—and as I did so, kept spraying water toward the center of the painting. I let all of the colors run through the yellow middle, and out again.

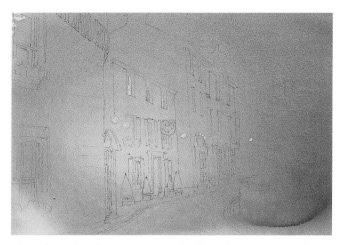

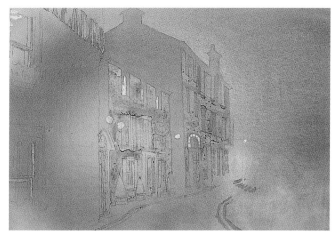

When the colors began to be less lively and run more slowly, I kept turning the board and wiping the edges until I could see the bull's-eye disappear and the painting magically turn into a foggy, predawn village street, lit by streetlights and the sky.

When the paint was dry (right), I applied mask on the face of the buildings, then flowed in large, loose washes, still working freely but controlling the paint to keep it within the rooflines. I did this by first painting with water all of the rooflines and down the edges of the building on the right, then saturating this shape with water, keeping the sky and the right side of the paper dry. I floated the yellow, red, and blue into the space and literally

steered it: I tilted the board on end and watched as gravity made the colors run up the chimneys, then tilted the board sideways and then down, and watched the colors all run down again. Water can be added if there is not enough paint running around; I usually add it near the bottom, then run it up to the top. The paint really does go where you have painted with water, and stays out of the dry areas; it's quite dramatic. When the colors had settled to my satisfaction, I let the painting dry flat.

Floating the colors in rather than just painting them on in a wash gives you gradations you can't achieve with traditional brushwork. More importantly, when all the color settles and dries, the resulting "look" conveys reality better than brushed-on paint.

To complete this workshop painting (the original is privately owned), I added richer color to the building in the left foreground, floating in Antwerp blue, aureolin yellow, and Payne's gray near the top, cadmium scarlet near the brightly lit lamp, and a mixture of French ultramarine and Winsor red at street level. Then I added a darker wash across the bottom of the painting to connect the wall with the building at left and emphasize the light spilling out onto the street. It was fun to remove the mask and see the buildings recede into the fog; this happens because their façades and the sky were all created from the same wash, graduating both in value and color toward the light source. I then softened the streetlights with water and a stiff brush, lifted some color to accentuate the light, and added and refined the details.

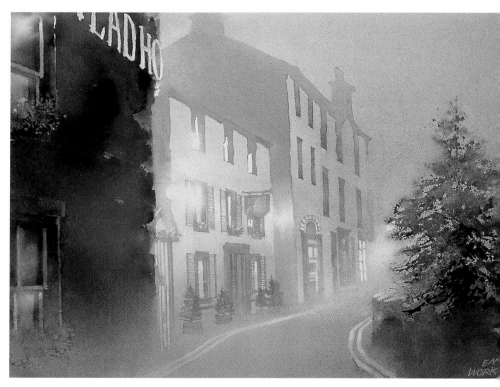

VILLAGE STREET
Watercolor on Arches 140-lb. cold-pressed paper, 19¼ x 26½" (49 x 68 cm). Collection of the artist.

Related Examples

The painting below and *Forest Pool* (next page) are further evidence of the blessings watercolor can bestow if you give it half a chance. For *Fisherman at Dawn,* I applied only two major washes at the same time. It was painted on illustration board, so I knew I wouldn't have any second chances with the big washes. I wanted to use only one glaze so the white paper would furnish the glow.

I saturated the paper and applied a large overall wash, a pale peach color. Keeping in mind that the sun was about to come up from behind the distant hill, I tried to keep color lighter there, spraying the sky and water with my water bottle. I had already prepared the colors for the big blue wash I would use for the hills, to go on while the first wash was still wet. Here I had the most incredible luck. The peach-colored first wash was just damp enough in the upper part of the painting to merge with the blue wash to make a third color, a bright rim along the top edge of the hill that gave me the effect of backlighting by the sun. And in the lower part of the painting, the peach wash was just wet enough to make the soft reflections—all in one sweep of the brush. This could never have happened if I had used dried glazes here, a more conventional way to paint. Incidentally, I had no idea these effects would come about this way, just a great curiosity to see what would happen and a knowledge of the limitations of illustration board.

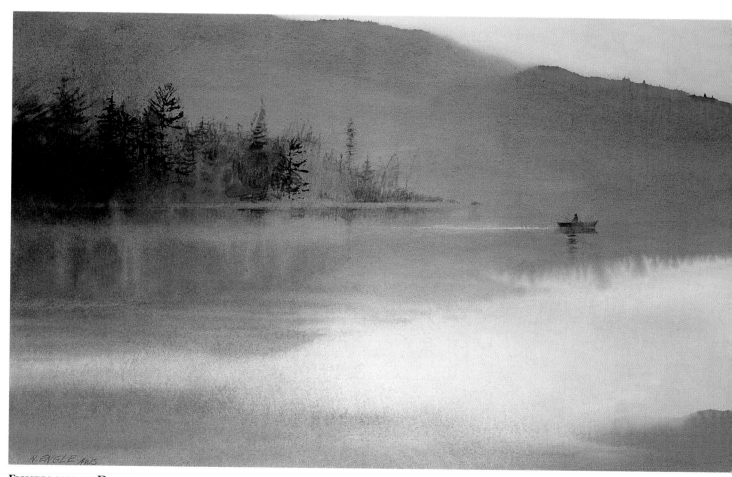

FISHERMAN AT DAWN
Watercolor on Crescent cold-pressed illustration board, 16 7/8 x 26 3/8"
(43 x 67 cm). Collection of Art and Jo Bennett.

Forest Pool illustrates how the methods used in the *Village Street* demonstration can be adapted to endless other situations—here, a wilderness scene.

By varying the amount of each primary color used in a painting, we can get virtually infinite results, because, of course, every other color derives from red, yellow, and blue. In this case, the yellow was extended as a much larger circle, the red band was kept small, and the blue was permitted to blend with the yellow. This meant that the blue and yellow were modified by the red near the light source, but the red had less and less influence as the paint flowed deeper into the woods on the right. As you can see, even the yellow had less influence on the extreme right. This is the advantage of the "bull's-eye" method of applying paint—it makes everything almost automatically right! Of course, I don't always apply the paint in circles, only when there is a definite and obvious light source in my composition.

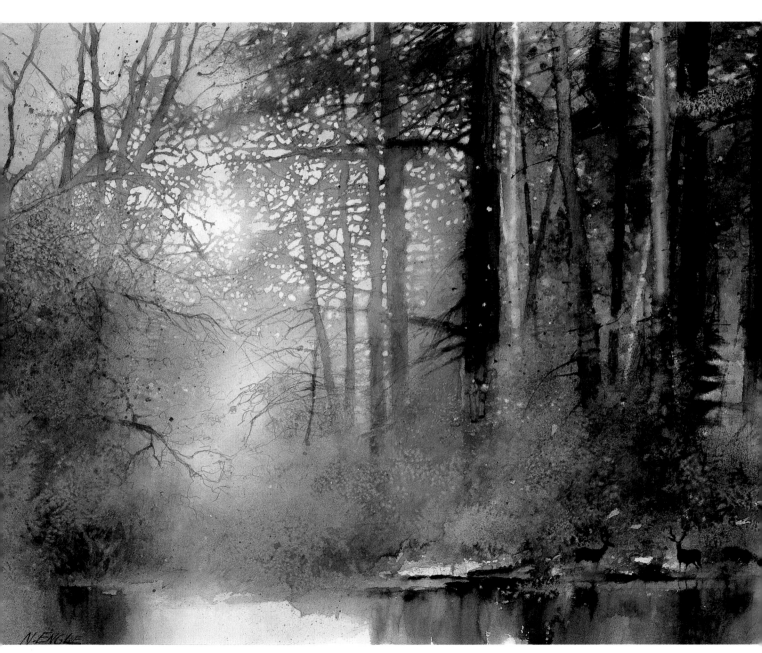

FOREST POOL
Watercolor on Arches 140-lb. cold-pressed paper, 20¾ x 25"
(52.7 x 63.5 cm). Private collection.

THE TWELVE-WAY WASH

Although I call this technique the twelve-way wash, I have't really counted the colors. It is a continuation of the previous demonstration, planned to fully utilize the qualities of the white paper. All the colors are applied in a single wash, so that only one thin layer of paint is covering the paper in the crucial areas, again allowing its brightness to glow through. My effort is to show you how to organize a large, many-colored wash to cover (and carry) the whole painting at once in a way that prevents the effect of mud. It's exciting to watch all of the floating colors interact and to guide them into realism.

Achieving Luminescence with the Twelve-Way Wash

This demonstration is meant to help you develop the skills for manipulating even more colors and running water simultaneously. I painted this subject after all the brilliant colors of autumn were gone. Here the hues are more muted, emanating from the fall bushes and underbrush, which retain their colored leaves later into the season than the trees do. Even the bark on some of the bushes is many-colored—red, purple, and maroon. The colors in the water are reflections of the bushes, grasses, and undergrowth, finally running into the reflections of the dark pines in the foreground.

All this was possible because I first masked the rock, the grasses, the birch trunks, and the area at the bottom around the reflections of the dark pine-tree tops, ending the mask arbitrarily an inch or so beyond the last reflection. I knew I could rely on the drawing and masking as a sort of safety net.

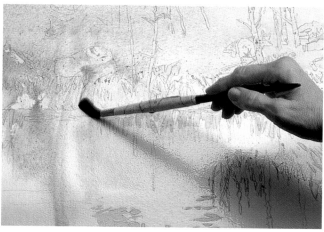

I began by saturating the paper with water, running off the excess before applying paint. Then I brushed in the sky with long horizontal strokes of cobalt blue, aiming for a cloudy look. Next, nearing the horizon, I added some long strokes of Winsor red, letting it overlap with the blue. This was followed at left by cerulean blue, which would become a middle-ground hill of trees. I then began applying paint in vertical strokes. Everything had to be very wet. First I brushed on a lavender, to carry into the water the reflection of the distant lavender hills.

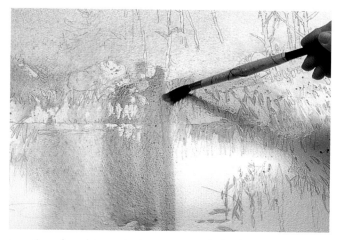

I continued applying color in narrow vertical stripes: Winsor red, followed by cadmium scarlet, as you can see. After this (but not shown) I applied a gold mixed from aureolin yellow and cad scarlet, a greeny gold mixed from aureolin and cobalt, and then a cool green mixed from cerulean blue and Winsor yellow. Next came pure cobalt, then cobalt mixed with cad scarlet, aureolin, and Antwerp blue, then Payne's gray. I continued making these stripes of colors working left to right, ending at the right with a very dark blue-gray. The colors not only covered the water, but also extended up into the bushes.

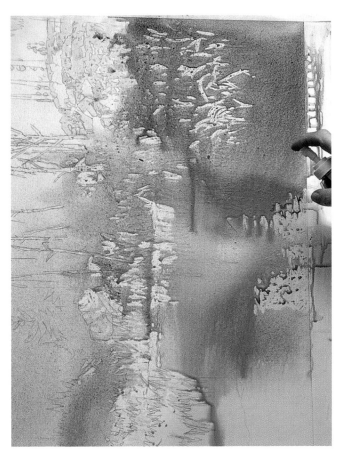

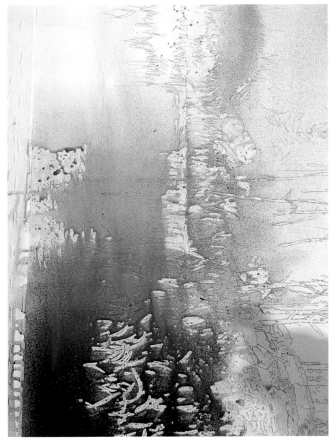

With everything still wet at this point, I turned the painting on end vertically, stood back, and sprayed it with water to get the paint moving. I didn't want to end up with stripes here! I let the dark paint run through the bright areas.

Next I turned the painting on end in the other direction so the bright colors would run into the dark areas. (The purpose of this tilting and turning was to subdue the bright colors; they were surrounded by their complements, so it worked.) Then I tipped the painting from bottom to top and top to bottom to fuse the colors, aiming to have the dark values gradually turn into bright areas and to avoid having just a narrow strip of dark on the right (a common occurrence when new painters try this technique).

With the painting back in its regular position, I added green mixtures (made from cobalt blue and Winsor yellow) on the left, from the bushes down into the water. I tipped the painting again to fuse the colors, spraying water near the masked areas to lighten them. Then I let this first stage of the painting dry.

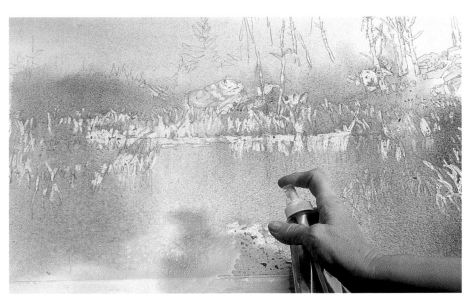

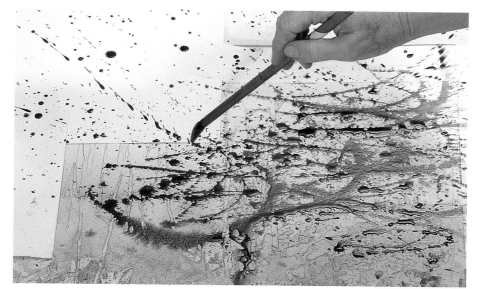

When all was dry, I placed a shield made of old pieces of paper over most of the left third of the painting, covering the treetop and sky areas there so I could paint the rocky bank and trees in the right foreground and create their textures using the paint-throwing technique. I then sprinkled the woods area very lightly with water and, using mixtures of various colors, flung the paint from a loaded brush in horizontal strokes to imitate the growth pattern of pine branches. I gradated values and colors from dark to light, again working right to left.

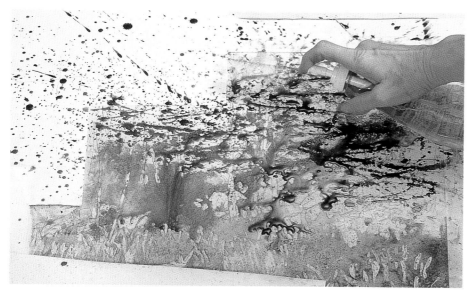

Next, using half-strokes with my spray bottle and working close to the painting, I delicately sprinkled water onto the areas where I had thrown paint. This turned all the flung dots of paint into pine boughs.

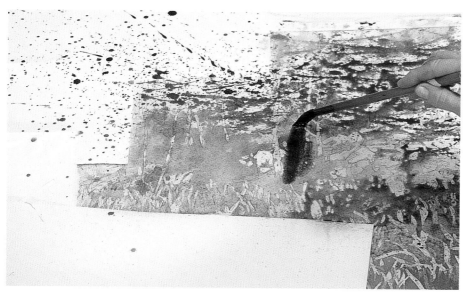

While everything was still wet, I painted in the darkest areas.

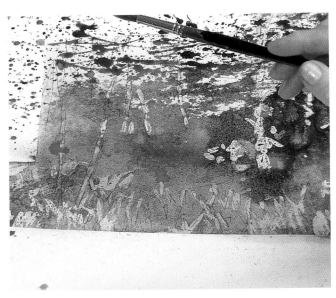

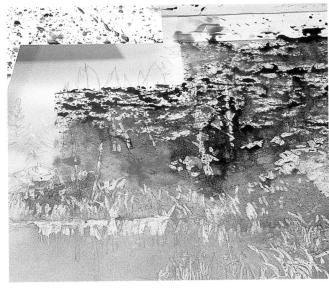

The last colors I threw onto the painting were the two opaque hues in my palette, cadmium scarlet and cerulean blue. I added these dots of color for accent, to brighten everything. I knew, for example, that the cerulean blue would read as light against the dark olive underneath it.

At this point I lifted the paper shield; if you're careful, the painting doesn't need to be totally dry when you do this. In this photo, notice how I'd already drawn the treetops above the textured area. I continued by painting them with conventional brushwork and joining them with the textural elements.

When all was dry, I rewet the painting with my spray bottle, from the shoreline down. Then, at the bottom of the composition, I painted in the darker values—the pine-tree reflections—but took care to paint only the lower third of this area, because my intention was to float the dark paint up into the bright colors by tipping the board up toward the shoreline. This flowing technique makes for a much smoother color transition than you'd get using a brush. The dark colors dissipate into the bright area, and all can be easily controlled by tipping up and down. At this point the painting was still very wet, and I was still adding darks. I corrected a few areas by adding blues and greens, which ran into the gold and orange. Why did I paint the brights and darks separately for the same stretch of lake? Because the bright colors reflecting the undergrowth needed a left-to-right horizontal transition, and the dark pine reflections needed a top-to-bottom transition. You can't have both at once without making mud!

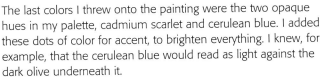

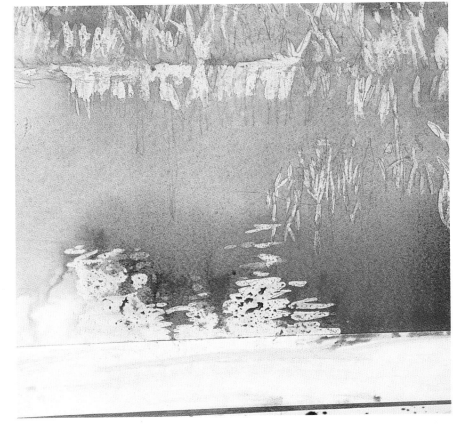

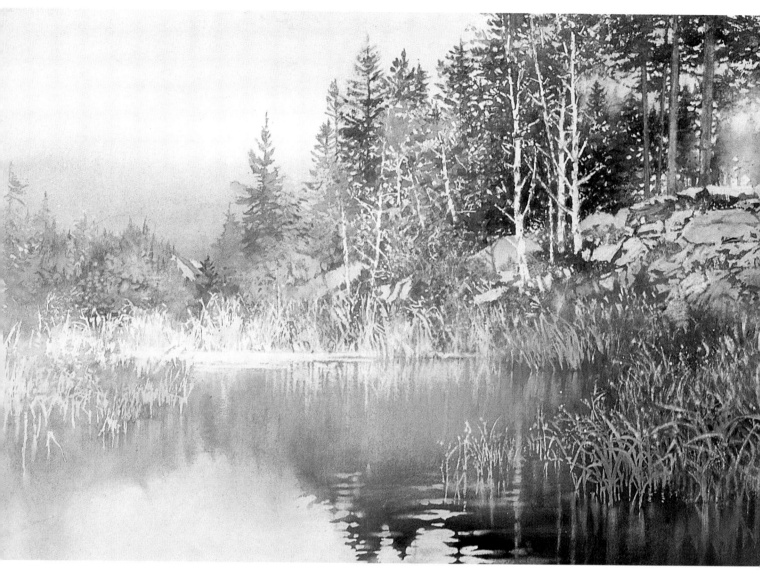

ISLAND LAKE SERIES

Watercolor on Arches 140-lb. cold-pressed
paper, 19⅝ x 27¾" (50 x 70.5 cm).
Collection of Northern Michigan University.

To complete the painting, I removed all of the mask and lifted color with a stiff brush and my Incredible Nib to define the reflections of the birch trunks and grasses, as well as the reflections of the grass in the water. Values in the areas of pure white paper (rock, grasses, and so on) that were left where the mask was removed had to be adjusted; I accomplished this by laying in washes of appropriate colors using a large brush.

When my paper is dry and I am faced with a rather abstract texture pattern, I look at my reference material and try to turn what I have into a realistic landscape by rendering some of the details almost photographically, usually with a #6 or smaller round brush.

Related Examples

Sometimes nature's colors and light are so beautiful and the scene so stunning that it's beyond description, in words or in paint. Immediately I feel an intense desire to see if I *can* paint what I'm seeing and share it with others, and an overwhelming sense of wonder and awe at God's work that makes me think, How can my own work even begin?

At such moments, I am always grateful for transparent watercolor, because I know this medium will work for me. I could make a competent oil painting, but the mystery would be missing, because in watercolor, you feel your way along, sometimes letting the watercolor lead the way. Open yourself to this experience.

The multicolor wash really allows the paper to blaze through with brightness. In *Lake Geese in the Sun* (below), this is especially evident in the misty area at the water's edge. Once again I used my "air" triad of Winsor red, Winsor yellow, and cobalt blue, and variations on the theme for the foliage.

You can see the areas that were masked in the water, on the birch trunks, and along some leaf edges. I threw and washed on all the paint at once from top to bottom. I created the sun-colored mist rising from the lake by spraying that area with water, then applying, in sequence, yellow, red, and blue, spraying again with water and tilting the painting to manipulate the colors.

My experience of the scene that eventually became *Golden Beach* (opposite) was too overwhelming to capture on-site unless I were to have changed my whole concept of painting and tried for a gestural style like that of the American artist John Marin (1870–1953). I studied the long reach of the tide coming in, water flowing and receding, reflections coming and going. I found it almost impossible to isolate the constantly shifting patterns and colors. The sun was shining directly on the cliffs, making them glow with red, gold, orange, yellow, rust, purple, all of these colors continuing in the water, along with blues from the sky

LAKE GEESE IN THE SUN
Watercolor on Arches 140-lb. cold-pressed paper, 26 ½ x 19 ¾" (67 x 50 cm). Private collection.

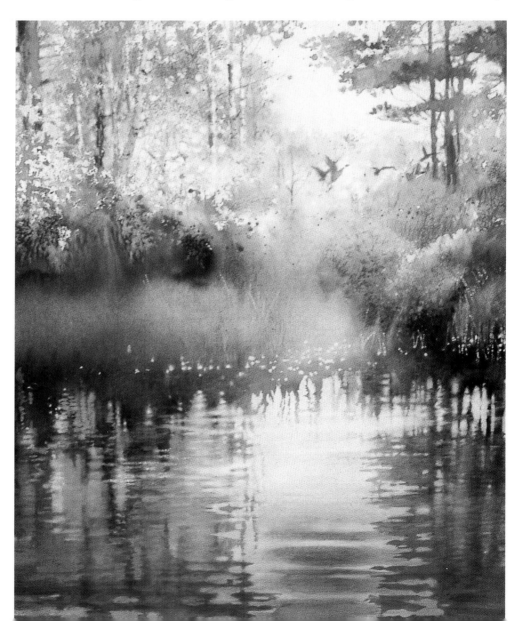

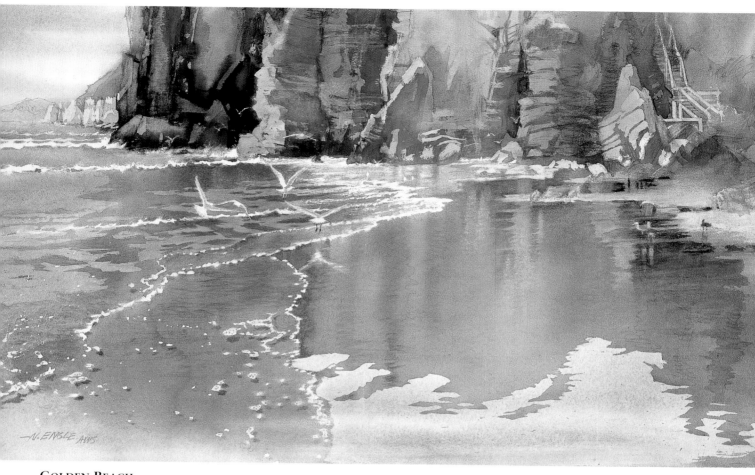

GOLDEN BEACH
Watercolor on Arches 140-lb. cold-pressed paper, 16 ½ x 28" (42 x 71 cm). Private collection.

overhead and the deep blue sea beyond. It was a case of now you see it, now you don't, because it was always moving, never still!

In my studio, I prepared the resist carefully. I had to allow many breaks in the coverage, as the mask can form a barrier that interferes with a flowing wash. I masked the cliffs where you see texture, and also along edges between the darkest and lightest values where I wanted to maintain control.

The action painting was easy and exciting. I applied all the colors on my palette at once, in all combinations, working my way across the paper from the blues at left through the warm hues of the cliffs to the lavender shadows. I washed the colors on in vertical bands, then tipped the painting to allow them to merge. It was important that the cliffs and their reflections be made from the same wash.

The watercolor medium seems to be made especially for painting skies, the air, the atmosphere. How often the real sky looks like a watercolor! My painting *April Light* (next page) is so titled because

of the color of the day. I had spent the morning with my camera following the river behind my house wherever it led, searching for patterns, photographing the river ice as it melted. This is possible for only one or two days in the spring, and on this day, the sun was brilliant in the woods, glowing through the snow, glittering on the ice, and blazing on the water—all material for future paintings.

But it was not until I came around a bend, out of the woods and into the open fields, that I was struck with the full force of this incredible April light over the whole scene. It made the river platinum and old silver, the shadows violet and rose, the grasses golden. The whole atmosphere was melting, there was an immense silence, and the very air over the fields and meadows seemed to be filled with peace. And how fortunate we are to have watercolor paints that let us at least try to approximate these colors!

In the photo of the painting in progress, with some of the mask removed, you can see that I have

used the same multicolor-wash methods as before. All of the colors, even the darkest values, were applied at once—Winsor yellow, Winsor red, cobalt blue, brown madder alizarin, cadmium scarlet, aureolin yellow, and Antwerp blue—and washed down to the bottom of the painting. I graded the wash from the golden colors at the top, through the middle grasses, and down to the violet in the water. The gold areas in the water previously had been masked; I tinted them this color after removing the resist.

I want to stress that I could not have attempted this kind of detail without good photography to rely on for the facts.

To finish, I added the middle-ground band of trees and detailed the foreground grasses. I also redesigned the snow in some areas for simplification. Note the harmonious quality of the painting; this is because the initial wash, applied top to bottom, unifies it, and because applying all the colors at once in a single wash allows the white paper to glow through.

Winter Brook Series (opposite) is a good example of how versatile the multicolor-wash technique can be. In this case, I discovered that it is a very exciting way to paint snow.

So many winter landscape paintings seem to rely on an all-too-familiar formula: French ultramarine

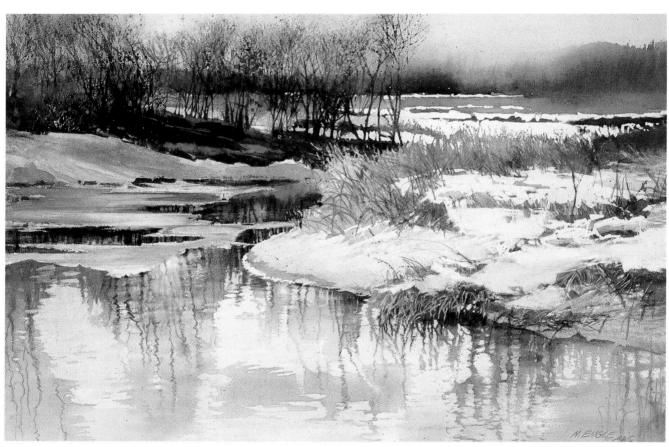

APRIL LIGHT
Watercolor on Arches 140-lb. cold-pressed paper,
16⁷/₈ x 28¹/₈" (43 x 71 cm). Collection of Alice Hunter.

Preliminary stage,
April Light.

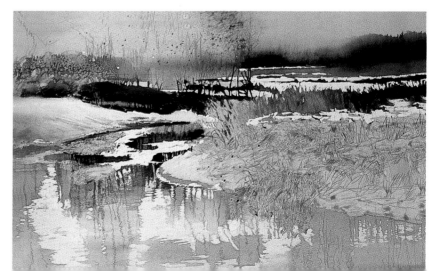

blue for the shadows, period. No subtlety. The result is really very flat and cold. Does it always have to be cold? Where is the sun?

I began this painting by drawing my composition on a sheet of stretched paper and applying mask to all of the areas I wanted to keep light—snow banks, etc.—in preparation for the darkest wash, which I put on first after sprinkling and spraying water on the whole area for texture. (Note that I didn't *saturate* the paper with water; this is because the edges and sunstruck areas required texture.) With a large brush, I floated in the rich, dark colors of my palette, and also flung some paint onto the paper and sprayed it with water. In this step I worked somewhat forcefully to make sure the darks would stay dark, since watercolor always dries lighter than it looks when it's wet. After this was dry, I removed

the mask from the snow banks and reapplied it only to the areas that I planned as my whitest whites. I also masked some of the darkest places in the river to keep the snow banks clean. Next I sprayed water on the painting and washed all the snow banks from the fallen logs downward with Winsor yellow, then Winsor red on top of that, then cobalt blue on top of that, and cerulean blue in the foreground. All this paint was applied in rapid succession, with everything very wet. I tipped the painting to spread the colors around, then focused a spray of water on the tops of the snow banks. The water made the paint drift down to the edges, making delicious round shapes. And it is the white paper that is allowing the colors to glow. Dark tree trunks and shadows were added later, and details were refined after the mask was removed.

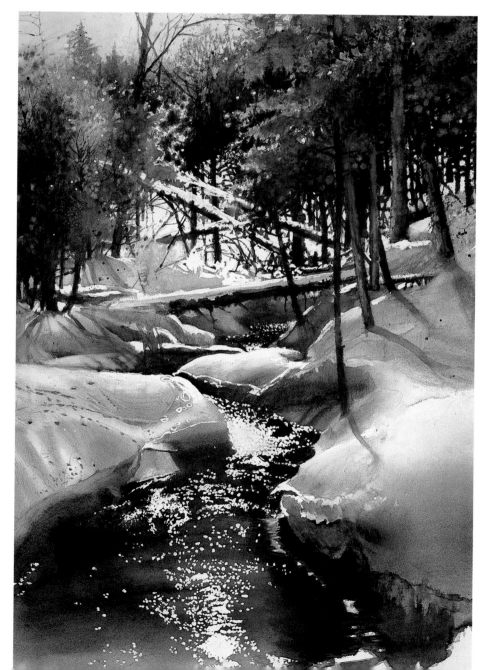

WINTER BROOK SERIES
Watercolor on Arches 140-lb. cold-pressed paper, 24 x 17½" (61 x 44 cm). Collection of Peter and Barbara Kelly.

TEXTURING TECHNIQUES
Exploiting the Properties of Water

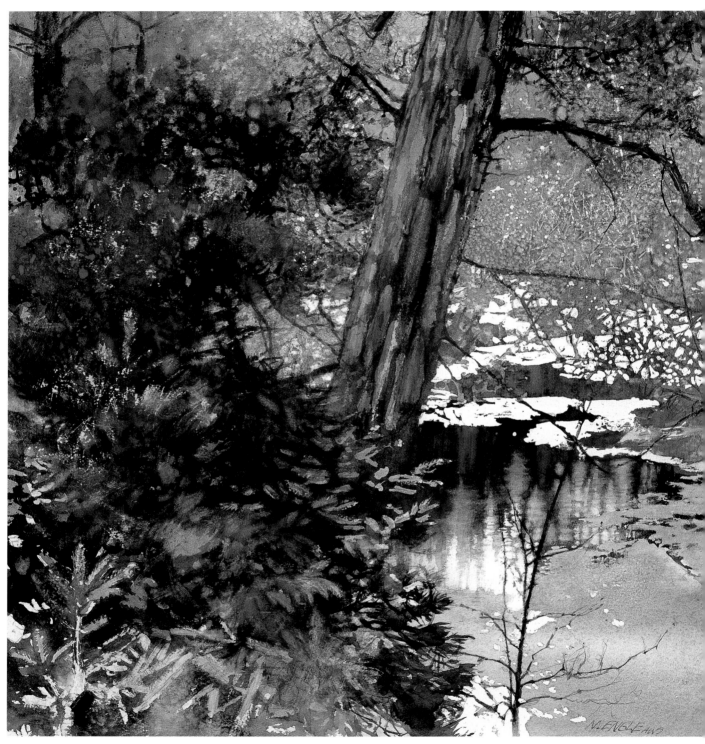

NOVEMBER THAW
Watercolor on Arches 140-lb. cold-pressed paper, 19¾ x 27¾" (50 x 70.5 cm). Private collection.

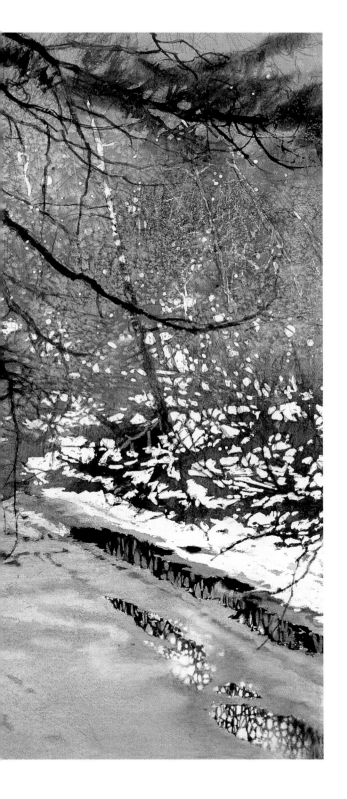

AS A LANDSCAPE PAINTER, or more specifically, a wilderness painter, I am constantly confronted with a hopeless tangle of shapes and colors, a wild array of vegetation further complicated by the light shining on everything. No one could paint it all literally. Even a single tree, let alone a whole forest—who could depict each and every leaf? Elementary as it seems, here is the basic question: How are you going to handle it all?

My attempts to solve these problems evolved into a two-step approach, as I described at the beginning of the chapter called "Warm-up Exercises," a kind of preview to this one. I first create a free and wild background of texture that gives an illusion of whatever my subject is in reality—leaves, grass, flowers, pine needles, or rock, for example—then I finish by painting very careful detail in well-selected places, usually in the foreground, so that the eye reads the more abstract, broadly rendered areas as realistic, based on just a few very specifically defined elements.

The challenge is how to make the textures. In this chapter I'll show you most of the basic methods I use in my work: throwing paint (flinging it onto the paper with a loaded brush), pouring and squirting it on, manipulating it with a painting knife, and sprinkling salt on it when it's still wet.

THROWING PAINT

It is my strong belief that random marks on paper have more grace than contrived marks. Imagine loading a paintbrush with water and paint and flinging the color at the paper, versus planning and painting each droplet. The first method results in something that looks lovely and free, while the second looks cramped and contrived. For me the same thing applies to leaves, trees, grasses—and as you saw in a few examples earlier in the book, I even fling masking fluid onto the surface to get random effects.

Long ago, I decided I wanted a more individualistic approach to creating texture. For example, a common technique for depicting foliage is to apply the paint with a sponge—but this can result in generic-looking foliage and paintings that begin to look alike. I felt a need to break away from methods like this one. It was years before I made the astounding discovery that water follows its own path. Using that fact, I was able to develop my own approach to textures. I think one of the best features of the technique I'm about to show you is that it gives as many different results as there are painters who use it, because it is not regimented or static, like a sponge. It can become your own, in other words.

Basically, you steer the paint with water. Because water follows its own path, it will more or less stay out of the dry areas on your paper, leaving hard-edged whites there while flowing freely as a wash. As I showed you briefly already, these are the steps: First sprinkle water onto the painting surface, then load a brush with paint and water and fling it at the paper, and then, most important of all, selectively spray the paint with water to steer it in the desired direction.

Throwing Paint: Capturing Autumn's Textures

The fall can be a nostalgic time—so many emotions, all that color, wood smoke in the air, burning leaves, the waning year. I was very excited about painting the back country depicted in *September Passage* (page 65), a favorite place for me. It is a true wilderness: no farms, no villages, a few logging roads, just woods, lakes, streams, and bogs, bears and moose, eagles and loons, partridges and wild turkeys, and all of it goes on for miles and miles. When I am in that place, I feel as free as every other creature living there. I wanted the painting to convey that freedom, with a subconscious feeling of aloneness, along with a spirit of adventure. I wanted to lead people down that road, to bring viewers into the painting, to make them want to go around the next bend or over the hill.

I made a careful drawing of the essentials to get the perspective right, the road going back, the proper proportion of the trees to the flowers, and so on. I then applied mask to protect the road, the boards on the bridge, and the river. (The dark spatter you see here is Pebeo mask flung on with a brush.)

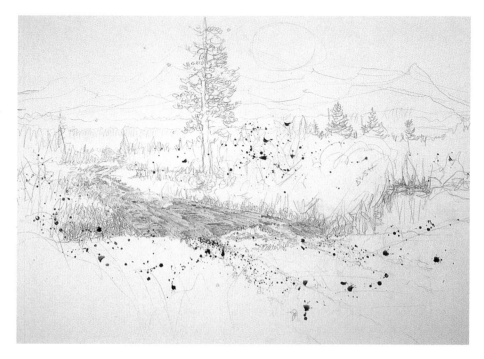

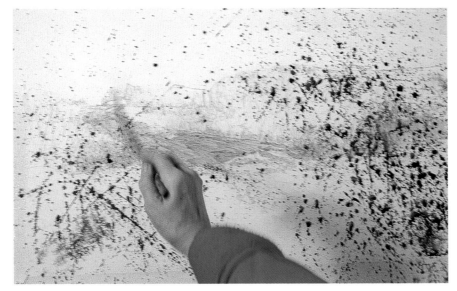

I placed a shield of old watercolor paper and white tape over the sky area for protection. It's a little hard to see in this photo, but the shield is covering the large tree and most of the background drawing. I then sprinkled the whole area with water from my Windex bottle to make a wet-and-dry pattern on the paper. Next, using a large Chinese brush (my wildest one for this technique), I threw various colors onto the paper—colors of fall grass, pine trees, the reds of maple and sumac, sand colors for the road, a lot of blues and darks for shadows and background, some lavender in the foreground. Of course, I had prepared an ample supply of paint and had plenty of clean water at hand.

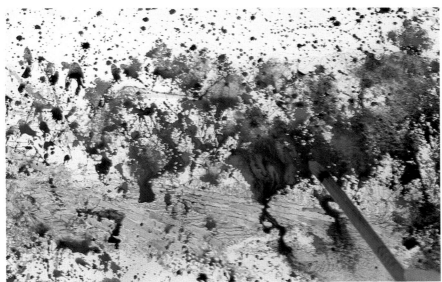

Here's a detail to illustrate how spontaneous you can be, and how bold with color. Because watercolor always dries lighter than it looks when it's wet, and because in the next step it would become diluted with water, I didn't worry about how intense it looked at this early stage. And although this looks (and was!) haphazard, I was very careful to preserve white areas by creating the wet-and-dry pattern on the paper beforehand. This is what's making the texture.

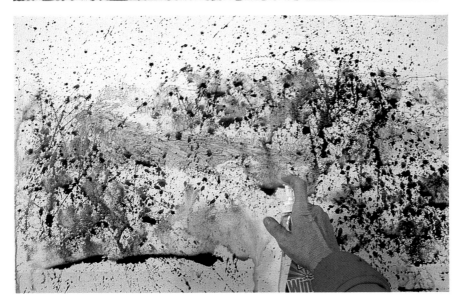

This was the most important step. Holding my water-filled Windex bottle about six inches away from the paper, I depressed the plunger about halfway to sprinkle water onto the surface, turning all of the thrown dots of paint into foliage, trees, bushes, and so on, aiming to preserve the dry areas and not wash everything away.

When all was dry, I removed the paper shield. Notice the pattern the throwing and spraying made on the areas where I'd drawn trees and bushes, especially at right; also note the pattern of blues and reds. Those shapes remain untouched in the finished painting. The effect I was trying for was not only the texture of the foliage, but also the light illuminating it.

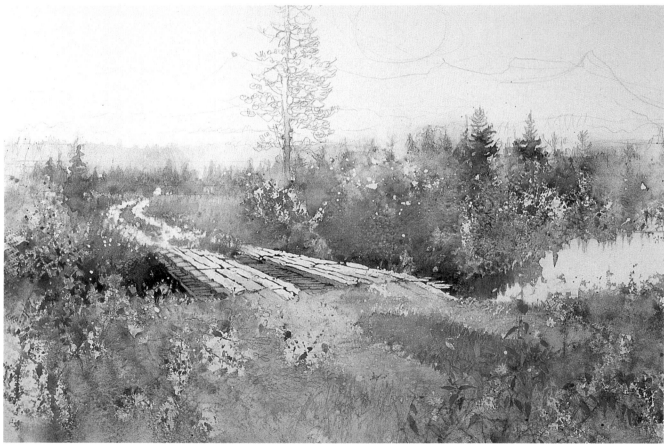

I sprayed the background with water and washed in the layers of trees and grass using traditional painting techniques. When this was dry, I removed all of the mask. Now you can see all the details that were there from the beginning, so that the painting looks almost finished already—like magic! Nex I began to develop the foreground flowers, adjust values on the bridge, create reflections on the river, add my deepest values, and paint in the tops of the smaller trees.

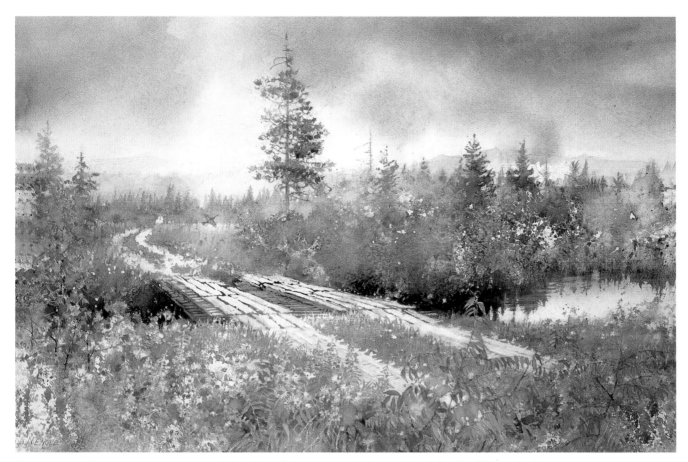

SEPTEMBER PASSAGE
Watercolor on Arches 140-lb. cold-pressed paper,
19 x 27½" (48 x 70 cm). Private collection.

To bring the painting to completion, I painted the sky, lifting color in some areas to create more light and atmosphere. I added details of grass and wildflowers in the foreground, painted the large tree in the middle ground, added more detail to the other trees, and designed the sumac and small maples. In the final step I corrected all the values, making them lighter or darker as needed to evoke the mood of this September day in the wild.

LOGGING ROAD
Watercolor on Arches 140-lb. cold-pressed paper,
9 x 12" (23 x 30.5 cm). Private collection.

A Related Example

I made *Logging Road* on a miniature sheet of stretched watercolor paper, and include it here to show that the methods I used to paint *September Passage* succeed even in small-scale works. Once again, I made a detailed drawing on the paper to begin, especially of the road. I masked out the crucial areas to protect them so that I could freely throw paint and spray and sprinkle it with water; you can see these effects on the edges of the trees and foliage. I added the tree trunks later, removed the mask, and painted in the details of the road and puddle.

Using the Water-Resist Technique

The first step in making this painting demanded absolute freedom, as it involved a wild throwing of paint for the foreground, yet at the same time the background had to be protected. How to manage this? The problem in this case was solved by using what I call a water-resist. The top part of the painting was so saturated with water that any paint landing there would dissipate harmlessly. The reason for using a water-resist instead of a shield was very important for this painting. I wanted to allow for an interaction between the background and the foreground. All of the color floating around in the water-resist area created a tone that would contrast with the white flowers I planned for the foreground, such as Queen Anne's lace and daisies. Also, because the tone that eventually became the sky and water was created with the same colors as the bushes and flowers, it automatically harmonized with these elements.

I taped illustration board to Gator board with white masking tape. Without making a drawing first, I saturated the top two-thirds of the board with water, which ended in a sort of vignette about one-third from the bottom. I then sprinkled more and more lightly with my Windex bottle throughout the bottom third, keeping the board flat. Next, with my Chinese brush loaded, I forcefully threw a lot of paint onto the surface in a vertical pattern to imitate the direction in which weeds and flowers grow, leaning this way and that. (You can throw with abandon, as the water-resist will protect the top areas.) The hues went from dark olive at right, through blue-green, cobalt, and, finally, lavender at left. I was careful to keep the top line of the weeds uneven so they wouldn't look like a clipped hedge. Then, using a more sedate paintbrush—a #6 round—I threw some very bright colors, such as cadmium scarlet and Winsor red, to create dots rather than stems. All of this paint was thrown on roughly the bottom third of my painting surface.

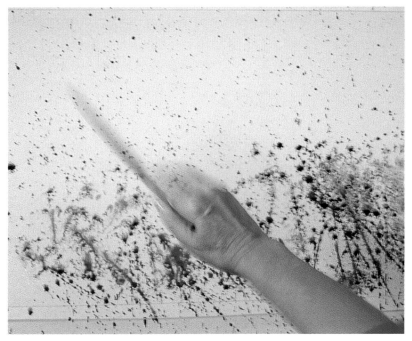

As soon as I felt that the paint application was heavy enough, I sprayed the top again and tilted the board to run excess paint and water off the top, then moved it from side to side to mix the floating colors (and avoid polka dots). Finally I tilted the board toward the bottom, and the wash more or less stopped at the top of the weeds and flowers. Next came the vitally important step in this technique. All of this flung paint would look like just that unless I *immediately* followed through by sprinkling water very close to the surface with a half-stroke of the spray bottle to guide the paint into wet and dry patterns. A few drops of water falling on a paint spatter turn the dots of color into leaves, flowers, and the like.

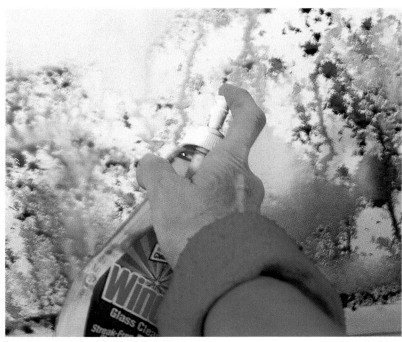

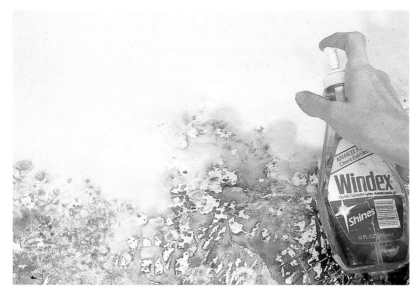

I sprinkled water to direct the paint so it ran where I wanted it to go. Once again, water will follow its own path and keep out of dry areas. To see for yourself, pick a colored dot on your painting and spray water around it in a circle. Dark paint will follow the water around and leave a white flower with a colored center. Needless to say, it is important to do this step while the paint is very wet. You may be skeptical of all this activity; why not just paint the flowers? The answer, of course—freedom! If you try this, you will see textures happening that could never happen with traditional brushstrokes, because nature is all confusion and so is the painting!

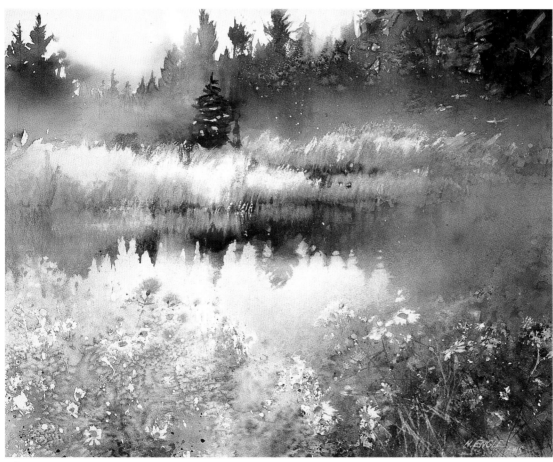

SUMMER MARSH
Watercolor on Crescent cold-pressed illustration board, 17 1/4 x 20 1/8" (44 x 51 cm). Private collection.

When the foreground was dry, I drew in the rest of my composition, a marsh. I masked the grasses; I also masked the water below the reflections of the dark trees, applying the resist in a band of just an inch or two, not all the way down to the flower tops. Then the tops of the trees were painted freely with a brush, washed all the way down through the grasses and reflections, and floated from side to side. After this was dry, I removed the mask, added detail to the flowers (for example, I lifted some color to define petals), and refined the grasses. As you can see in the right foreground, I added some knife strokes to make sharp, light stems and leaves.

Related Examples

If you try the methods used in the preceding demonstration, after the first three steps you will be left with a foreground that looks something like the one shown below at left. You might arrive at a similar place in your painting, and I wanted you to see all the possibilities of such a starting place. The main point is the richness of textures you can develop with this technique. Where you take your painting from there is up to you. In this case, after the paint was completely dry, I went through my files of places I have visited and photographed over the years and decided to use this farm scene. (In spite of all the techniques I use, all of my paintings are of real places, not made up.) The next step after I finish the drawing will be to float in the background colors, the trees and field; I'll probably mask the light areas such as the horse and barn roof. As I've started with a foggy foreground, I will aim to carry that feeling into the rest of the painting.

I painted *Mountain Meadow* (below, right) following the same methods I used for *Summer Marsh,* with only two differences. I masked the snow on the mountain peaks because I knew I could not control this area, plus a few flowers (yellow) next to dark trees. This was painted on stretched paper, so I knew lifting color to define the flowers later would be harder than if I'd worked on illustration board. Next I protected the top area with a paper shield (rather than a water resist, which works only with a slick surface), sprinkled the bottom with water, and threw the paint. In the second phase, sprinkling to turn the thrown paint into flowers, etc., I knew I wanted lupines, so I steered the paint to form the cone shapes characteristic of these flowers. After all was dry, I laid a blue wash over the sky and mountains and floated it down to the flowers. When that was dry, I added the dark evergreens and floated that wash down to the flowers. Finally I removed the mask and painted details on the flowers.

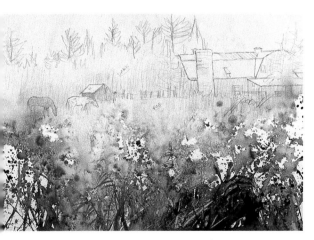

A typical example of a foreground you might create with the water-resist technique. I've begun to turn this one into a farm scene.

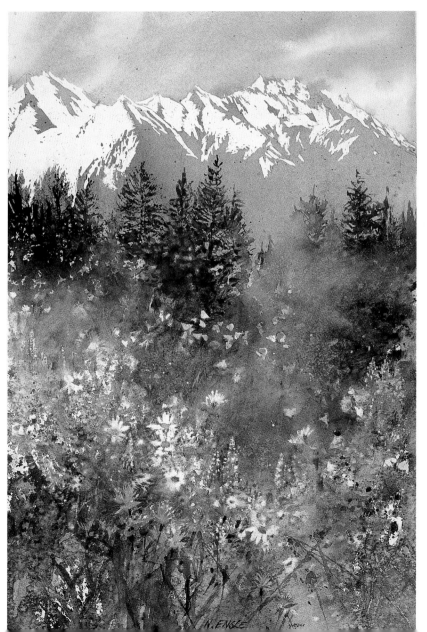

MOUNTAIN MEADOW
Watercolor on Arches 140-lb. cold-pressed paper,
28 x 19¾" (71 x 50 cm). Private collection.

Preserving Whites Without Masking

When I was working on this painting, I discovered the ultimate in exploring the limits of this technique. My problem was to paint one large, sloppy, very wet wash of many colors and still maintain the sharp white edges of the hundreds of tiny little leaves found in swamps and wetlands, a mixture of Labrador tea and many other bushes and grasses, all with light shining and fog drifting.

Masking all of those little leaves and so on was a poor answer; I knew in the end that would look stilted and phony.

I think most watercolor artists have an adventurous spirit and a great curiosity to see what will happen if they do this and then that—and a tendency to plunge right in and wing it. It's only a piece of paper, after all; fun comes first!

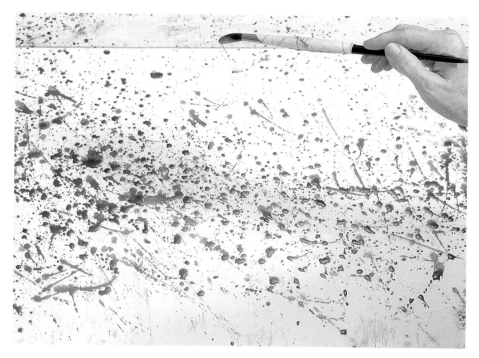

This was painted on stretched 140-lb. cold-pressed paper. The only mask I used was on the lily pads and a few sawtooth grasses in the extreme foreground. The paper was texture-sprinkled with water everywhere, not sprayed. Using almost every color—brights, darks, both triads—on my palette (I had dissolved plenty of paint in preparation), I began to throw paint at the paper, keeping in mind that I wanted darks more near the edges and bottom, and bluish combinations where the main foggy mist was planned. It is slightly unbelievable how much paint I had to throw to get a volume big enough to work with and avoid having it become too pale, washing everything away.

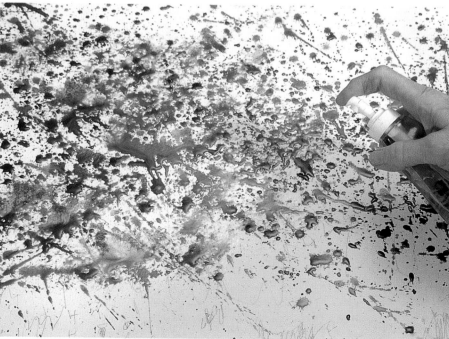

Here I have begun the key process of sprinkling all this wet paint to turn it into the texture of hard-edged whites (thanks to the wet-and-dry pattern created on the paper in the initial sprinkling). It is necessary to work fast at this point. Notice in the photo how wet these dots of paint are.

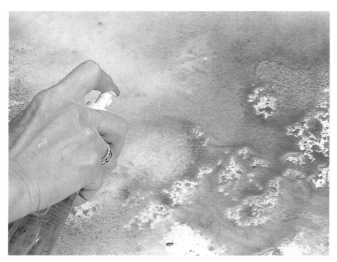

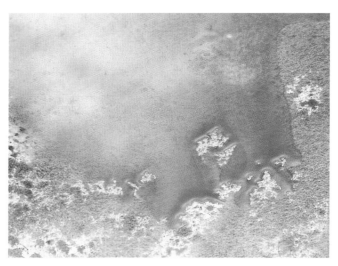

As you can see here, I brought the sloppy wash down the page. Most of the colors have merged to form the bright olive hue I wanted, gradating into blue and then to dark, leaving a faint impression of leaves through the fog. At this point, I am steering the paint around the dry areas that form the tiny leaves.

I am so proud of my photographer for capturing in this picture the flood of wet paint moving down the page and refusing to venture into the dry areas. This is not masked; this is only dry paper meeting with wet. Here is my texture technique in a nutshell.

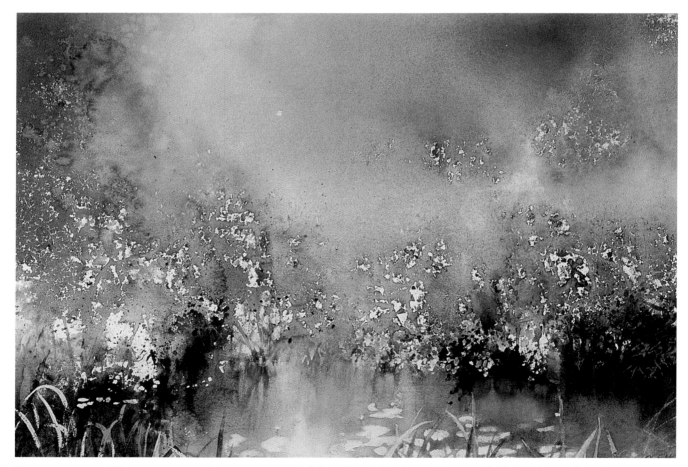

ILLUSIONS OF A MARSH
Watercolor on Arches 140-lb. cold-pressed paper, 19 x 27¼" (48 x 69 cm). Collection of the artist.

There was not much left to do to bring the painting to a finish. I darkened the values under the bushes, where the water starts, by rewetting that area and floating in dark colors, letting them drift down to the light areas at the bottom of the painting. After removing the mask from the water lilies, I added reflections and details there.

POURING PAINT

Almost every strategy I have developed for manipulating paint has come about because I like to work on illustration board, whose relatively slick surface is in some ways so difficult to handle that new ways of painting have to be devised to cope. One of the problems is that it is almost impossible to apply washes in multiple layers, especially in the darker values, as everyone who has tried it knows. Instead of staying put, each new wash tends to lift the one that preceded it, whether or not it has already dried. Imagine painting on glass. Of course, many wonderful effects are possible just because of this fact, but sometimes you want a wash to behave like a wash, to cover an area smoothly, with no distracting marks.

One solution is to pour on the wash, therefore avoiding the brush marks and other problems as well. And as usual, when something different is attempted, new horizons open and new possibilities become apparent—for instance, pouring one wash against another, a wet wash against a half-dry area, removing areas of half-dry wash intentionally with more aggressive spraying—there's no end of experimentation.

Imitating Nature

Although this was painted on paper rather than illustration board, I still wanted to use the pouring technique, because I wanted to imitate nature. I live in a beach house on Lake Superior, so naturally I am always walking along the shore and observing wave action, patterns of wet and dry sand, endless variations of landscape and seascape. It occurred to me to try to match the actions of nature on a painting surface.

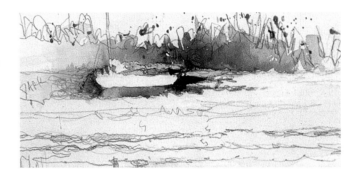

I set the stage for this watercolor by first painting the top area of the middle-ground sand (shown above at right), as I knew I would be masking this to maintain crisp whites around the edges. This area, as you see in the finished painting (next page), is too high and dry to receive any water action over it. After applying the mask (which is hard to see in this photo), I painted a small area around the boat to establish values there, and then painted the rest of the foreground sand, letting it half-dry. Next, in a measuring cup with a pouring spout, I mixed some blues with a lot of water and, tilting my painting surface, lapped the diluted color onto the beach area, just as water would lap upon a shore in real life. Notice in the photo how where the blue water meets the half-dry sand, it makes a new, darker color all by itself—a rim of damp sand, imitating real life. The wonders of a water-based medium!

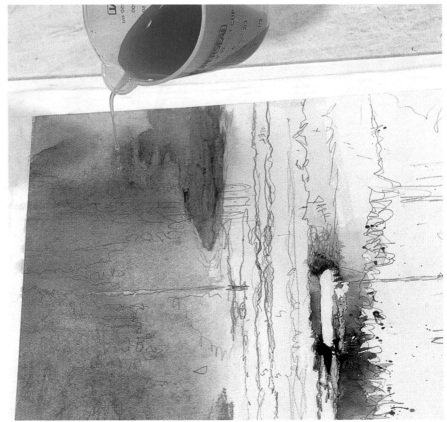

This detail of the finished painting shows you more clearly the effects of the pouring technique. Bringing the blue water to the sand with a brush doesn't supply enough volume of paint and water; even a large flat brush absorbs some of the liquid and can leave brush marks. Squirting focuses the paint too narrowly. My intention was to find something that would imitate a real wave lapping the shore. You can see here more clearly where the blue water has found its own way into the damp sand, making an entirely natural look. I don't think this particular effect can be achieved in any other way in watercolor; I have tried but been unable to duplicate it in other paintings. I suppose it is possible, but only after a huge amount of labor, and in the end, I think it would look stiff and contrived rather than loose and free! In fact, how *could* you approach this problem with a brush? You would have to design the water pattern, and any design effort that's meant to copy a natural effect is bound to be less graceful than what nature itself can do. That is why I try in all of my work to devise "happenings" that are based on nature's own action.

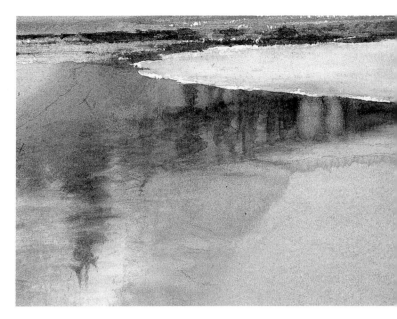

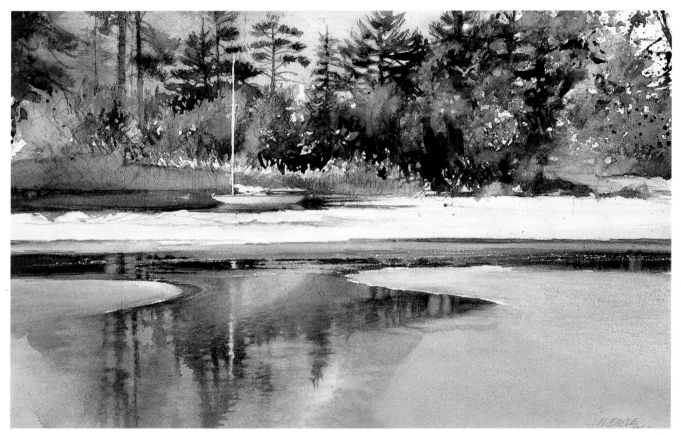

ISLAND HOME
Watercolor on Arches 140-lb. cold-pressed paper, 13 ½ x 21" (34 x 53 cm). Private collection.

To finish the painting, I masked the edges of the background sand, the line along the top of the grasses, and the house in the distance. I also carefully applied mask in the foreground to protect my blue water before putting on the darkest wash, the reflection of the pines. The top of the scene was painted freely with techniques described elsewhere. After everything was dry, I removed all of the mask and connected up the foreground sand, adding details last.

A word of warning: The effects I achieved in this painting were spontaneous, and to try to copy them in a composition similar to mine would be disastrous. Try the technique on scrap paper until you have some control, then use it in a real situation.

A Related Example

I came upon this isolated stretch of river while fishing and thought at the time it was a painting. Because the major logjam was making the running water very smooth downstream (just the place for a trout, too, by the way), I could feel how pouring water and colors on a paper surface to capture this look would work as I observed all the rapidly changing lights and colors before me. I returned later with a camera to get the facts of the scene, and eventually did use the pouring technique.

I masked out the log in my composition so it would serve the same purpose as the real log: to slow the fast-flowing water—and in my case, flowing water and paint. I also masked the sparkles on the water, the edges of the sunlit leaves, and the rough water at the very bottom of the painting. I then sprayed the entire surface with water; it was important to keep everything wet so I could move the paint around without creating any hard edges. I

mixed dark colors in several containers (a lot of them from the kitchen!) and poured these hues on from the top of the painting, keeping them away from the extreme left. I allowed the colors to float down to the bottom. The log did slow down the wash enough for me to pour on the bright colors below it in vertical stripes; then I tilted the painting a bit from side to side. Next I tipped the painting on end and sprayed water above the river to create the blue mist. When spraying water on a painting, you must always have a "safe place" for the excess to run off without washing away something important.

After everything was dry, I removed all of the mask, including the log, and painted the necessary details conventionally. Even some areas in the free wash of the reflections needed to be touched up and enhanced. Remember, the first washes are fun, but the detail half of my work is necessary for the realism, whether it is achieved first with mask or later with paint.

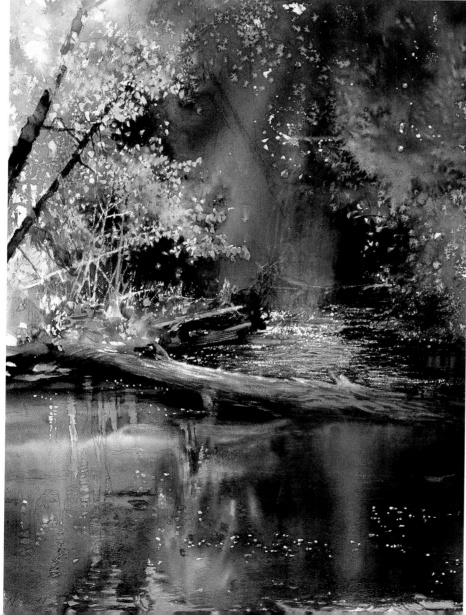

MORNING ON THE YELLOW DOG RIVER
Watercolor on Arches 140-lb. cold-pressed paper, 27 ½ x 20" (70 x 51 cm). Collection of Dr. and Mrs. D. Elzinga.

SQUIRTING PAINT

Squirting paint or water out of plastic bottles is basically the same as pouring it, except this method gives you a bit more precision. One great advantage in squirting instead of using a brush to apply paint is that it enables you to deliver a great volume of color all at once to your paper surface. Even a large brush obviously will hold only a limited amount of paint, requiring frequent starts and stops for refills.

But that is only the beginning! As you saw in the sea-painting exercises, we were able to form waves by squirting the paint in a way that imitated wave action. It is possible to maintain fairly good linear control this way, while at the same time, the paint insists on being loose, so you have the best of both worlds. I have painted such detailed subjects as horses and action figures with this application method.

And that brings us to another advantage. This is the ultimate tool for following my underlying principle of combining authority and aggression with grace. You can be very aggressive and direct with a squirt bottle, and be graceful at the same time because of the random and haphazard marks the tool makes. The control is never total.

Using Squirt-Bottle Techniques

Most of *Spring on the Upper Garlic* was done with the squirting technique, and it was such an exhilarating experience to see it all happening. No matter how serious your concept may be, the actual painting of a watercolor should be fun!

In this case I mixed many colors and poured them into squirt bottles—one with a mixture of Winsor red, aureolin yellow, and some cerulean blue to make a gold color for the emerging field of grasses. I also had bottles of blues, purples, and a rich mixture of darks.

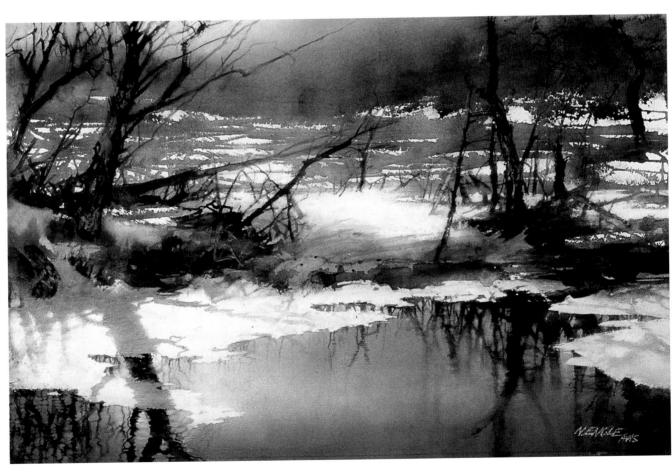

SPRING ON THE UPPER GARLIC
Watercolor on Arches 140-lb. cold-pressed paper, 18 1/2 x 27 1/4" (47 x 69 cm). Collection of the artist.

After drawing and masking only the ice and snow on the river, with rapid strokes I began squirting paint horizontally across the entire sheet of paper. This process left random snow patches that look as they appear in nature (detail 1). What if I had designed and masked these instead? That's right—I would have gotten what I'd consider a stiff and contrived look.

I learned something surprising by doing this, a bonus that watercolor almost always gives. When you work on paper as opposed to illustration board, as you squirt the color across the sheet, moving rapidly, not only will the paint fall gracefully on the paper, but linear, vertical grass shapes will form. Why? I have no idea, but it works.

Immediately after this step, I turned the painting upside down and sprayed water from the horizon upward, being careful to preserve the profile of white snow patches. More dark paint was squirted on the woods area, which by now was very wet. You can see in the closeup (detail 2) how the dry paper repelled the paint and remained white for the snow areas, while the wet parts of the paper took the color.

Next I laid the blue wash for the water; after this, I squirted paint to delineate the smaller branches as well as all of the dark reflections (details 3 and 4). After I lifted the mask, I painted the details conventionally. I have no magic for details—just *work!*

Detail 1

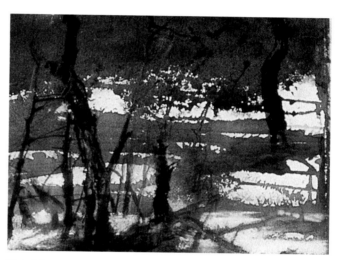

Detail 2

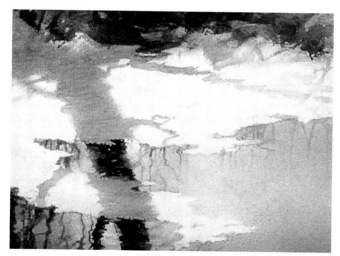

Detail 3

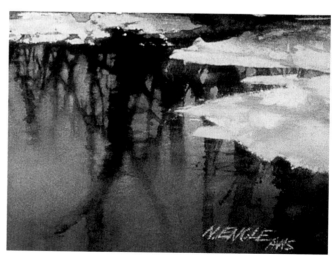

Detail 4

FINGER PAINTING AND WIPING

Here are a couple of techniques you might want to try experimenting with when you're in a state of mind where you just don't care what the outcome may be—a mood in which you feel you have nothing to lose, nothing to prove, intend no product—in short, have a desire simply to play, to explore, and, essentially, think you are going to throw all this away in the end. Invest no time in drawing, stockpile lots of boards, and have lots of paint and water at hand. Of course, as you go along, good things begin to happen, and you do begin to care. Steel yourself! Recklessness is important. Trust the water. Trust the paint.

The two exercises illustrated here took about thirty seconds each. All you need to prepare is your mind! For both, I worked on hot-pressed (smooth) illustration board, chosen because of its glasslike surface, which resembles the slick surface of my white porcelain butcher's tray palette, as well as the clay-surfaced material kids use for finger painting. I have always noticed when wiping up my palette after a painting session that the marks make the remnants of color look like a calm sea, so I decided to try achieving this effect in a painting with a bit of selective wiping with tissue and, in another revelation, my fingers. If your palette is porcelain and you want a preview of what can happen, try spreading out some blues and greens and wiping them with a tissue. Watch your palette perform! The overall goal here is to do it fast and get it the first time, or move on and do it again!

To begin, working with my usual palette of colors, I mixed my paints with water and poured them into squirt bottles. I did not wet the board before applying color. All of the textures I created were done entirely with finger painting, wiping with tissue, and squirting and spraying with water.

My only thought in this example was to experiment with the paint, the surface, and wiping and finger-painting techniques. Wiping the paint makes for a larger, less textured or less layered look, as you can see by the strokes through the darkest areas near the top. Finger painting has a more interesting look; in the blue area merging into the lavender, the light strokes with a dark stripe in the middle are the result of this technique. The top and bottom edges of this example were created by squirting those areas with water and tilting the paper; no brush was used at any time.

In this exercise, my thinking was about depicting a realistic landscape—sky, clouds, and sea—which I attempted to do by moving the wet paint not only with my fingers, but with my knuckles and palms as well. Forget control! Impossible! Fortunately, this board makes it very easy to lift colors and get rid of mistakes. The downside is that it is almost impossible to *add* color, particularly glazes on top of an earlier layer that has dried (unless you're working with very light colors).

Two Examples, Same Subject

To apply these techniques, I painted two versions of *Storm over Antigua,* shown below. In the first (left), I worked on hot-pressed illustration board. I mixed some sea colors and poured them into squirt bottles, with which I applied the paint. I also used some Winsor & Newton liquid watercolors; these come in bottles with eye-dropper tops that can be used for squirting. (More on liquid watercolors later.) At this stage, the paint was thick enough to manipulate without any brushes, just fingers, knuckles, elbows, tissues, and squirting with water.

The painting was done in two stages. I knew I couldn't control the sky and water at the same time, so I masked the strip of Caribbean blue at the horizon to separate the two areas. I also masked the breaking wave and other whites in the foreground.

When the sea area was dry, I masked the sailboat, then applied a wash of the underlying bright sky color, extending it down to the (still masked) blue on the horizon. When this was dry, I squirted paint onto the surface to create the dark storm clouds.

Because I was working with running water and paint and wanted to control the overall shape of the cloud mass, I applied mask to the clouds' bottom profile to stop the flow of the paint as it moved downward.

When all was dry, I removed the mask and painted the details. To blend the dark blue on the horizon into the rest of the sky, I wet the area carefully with a fine mist sprayed from a soft toothbrush, then immediately filled the toothbrush with dark blue paint and sprayed this into the wet mist.

The first version of this painting was all play and experiment, whereas the second was painted conventionally, with a brush on stretched paper. There was some squirting and spraying of paint and water, but most of the effects were achieved with masking and typical wash applications.

My aim in rendering the same subject twice, using two different approaches, was to help you see the rather significant variations that can result from the materials and techniques you choose. Which of these two paintings is better is up to you, but I know which one was more fun to create!

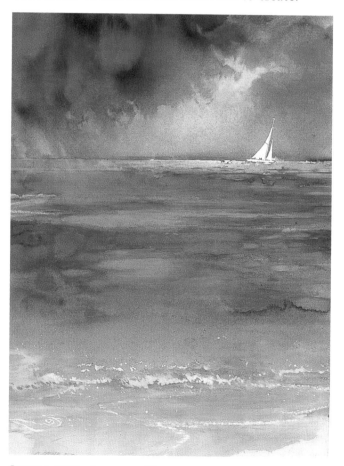

STORM OVER ANTIGUA I
Watercolor on Strathmore hot-pressed illustration board, 27 ½ x 19" (70 x 48 cm). Collection of the artist.

STORM OVER ANTIGUA II
Watercolor on Arches 140-lb. cold-pressed paper, 27 x 19" (69 x 48 cm). Collection of the artist.

PAINTING WITH A KNIFE

There is something so satisfying to me about scraping a palette knife across a lot of wet watercolor in long, sweeping strokes to make rock textures, as you saw in the first demonstration in the chapter "Warm-up Exercises" (see especially page 26). It's rather like frosting a cake or plastering a wall, applying lovely clean plaster in long, long swaths! This knifing business is very soothing, a great stress reliever—and, in a watercolor painting, exciting as well. I started out as an oil painter in art school, so I have always used knife work on paintings, but decided to use it with watercolor when I was assigned to illustrate a children's book that was to include scenes of Mexico and Arizona. There were a lot of adobe buildings and white-washed plaster in the landscape, and the best way to paint them was to imitate in paint the way the plaster is applied to

a surface: with a blade, or palette knife. Ever since, I have found it to be a tool basic to my work.

Two Examples

I was inspired to paint *Small Brook* (below) because it was a delightful discovery I made while searching for a large waterfall in the area. The water in these little brooks off the beaten path is usually pure enough to drink, ice cold, and full of native brook trout.

Because of the lively running water and the sun on the leaves, I could see I would need to protect these areas by masking them, but by doing so, I could be more abstract and free, not less. After I completed the drawing and applied the mask, I washed in all of the colors, the lights and the darks, all at once. I concentrated on the foliage

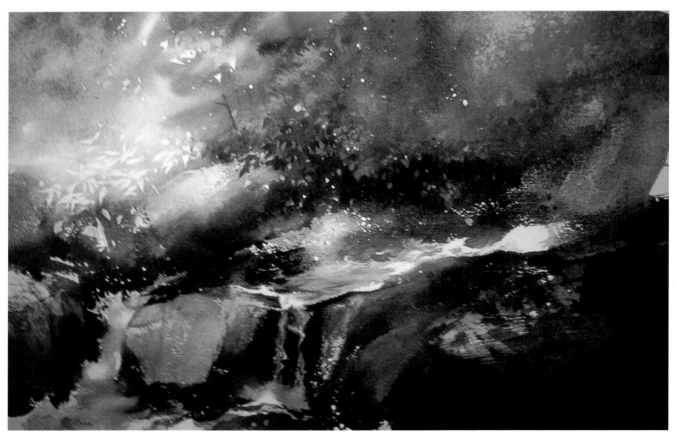

SMALL BROOK
Watercolor on Arches 140-lb. cold-pressed paper,
11 x 16¾" (28 x 42.5 cm). Private collection.

until the paint on the rocks was one-third dry, then went to work on them with a palette knife. (In fact, even some of the foliage was knifed.) This is a matter of scraping broadly with the knife until you have what look like rocks. If you need more paint as you go along, you can add it with the knife or with a brush; I sometimes slash in some new colors with the knife. This was painted on watercolor paper, allowing for more manipulation of values. After removing the mask, I added detail to the water. One great advantage of using a knife for making texture is that you get a second chance. If the paint dries before you can get around to knifing it, you can rewet the area, wait a bit, and knife it again!

I painted *Maine Lobster Boat* (below) on illustration board, my favorite surface for knife work. I laid in the sky wash with no mask anywhere, let the painting dry, then sprayed the bottom with water and floated in my wash. When all was dry, I did a detailed drawing of the rocks' edges, and drew the lobster boat as well, then masked it. I painted the distant shores traditionally.

In the foreground, I painted the edges of all the rocks with water (white areas were kept dry) and floated in a whole volume of dark colors to define them. When the area was not quite half dry, I used my knife to create the rock textures. I added the darkest darks later and knifed them as well. Last, I painted in the darker trees and added details to the lobster boat.

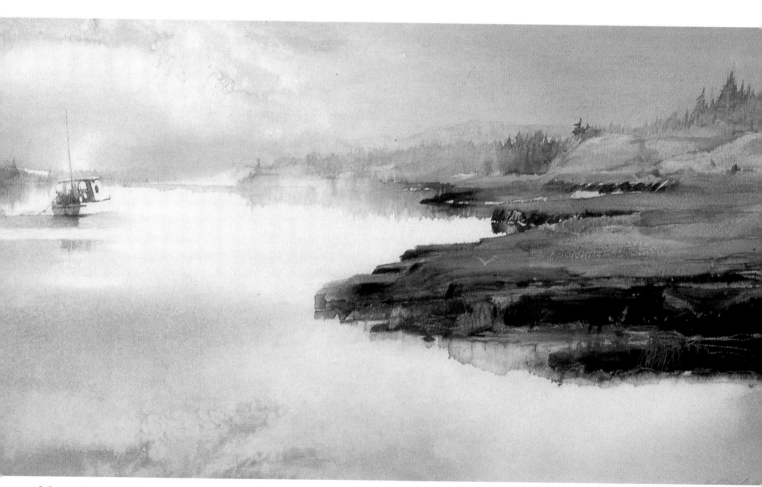

MAINE LOBSTER BOAT
Watercolor on Crescent cold-pressed illustration board, 16 x 26½" (41 x 67 cm). Collection of the artist.

TEXTURING WITH SALT

You can create interesting textures by sprinkling ordinary table salt on a painted area that is still moist. The salt grains absorb pigment, leaving a texture pattern behind as the paint dries, a pattern that in my opinion looks like foliage—little leaves, twigs, and the like. When the painting is dry, you simply brush the salt off with your hand or a Kleenex. The coarser the salt you use, the bigger the pattern. A question always asked by beginners is, "When do you put on the salt?" This *must* be done when the paper is about half dry. If you do it too soon, while the paper is too wet, the salt will float around and do nothing. If applied too late, when the paper is too dry, it will do nothing. You have to apply the salt at just the right time, or it will fail (and if I knew what the precise "right"

time was, I'd be rich!). In any case, it's better to try applying salt sooner rather than later.

I have heard that in time, salt can harm a watercolor painting, but I think there can be exceptions, depending on how it is used. I believe in using it sparingly and very discreetly anyway; I want my work to look like nature, not salt. My painting *Rainbow Falls* (below) was started twenty years ago and looks the same now as it did then. Everyone must make his own decision; for me, the advantages gained with this tool outweigh everything else.

Two Examples

The paintings shown on these two pages illustrate some of the ways salt can be used creatively. I began the first example, *Rainbow Falls*, by laying in a lot of

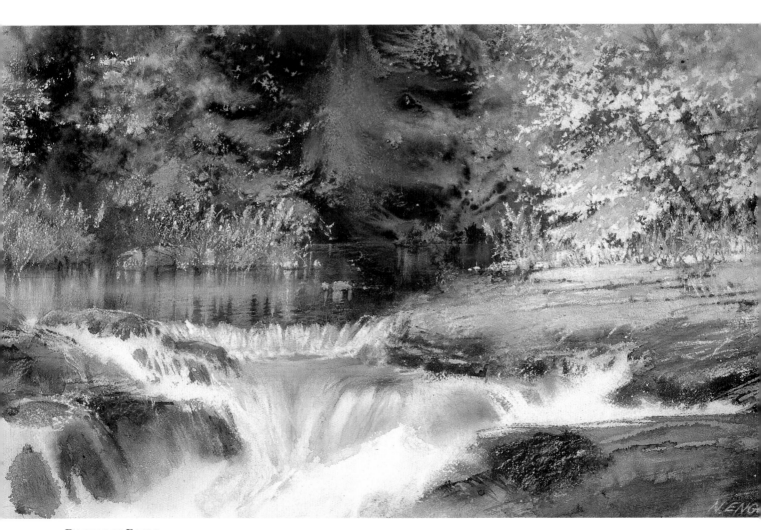

RAINBOW FALLS
Watercolor on Arches 300-lb. cold-pressed paper, 20 x 27¾" (51 x 70.5 cm). Collection of the artist.

very deep colors—the triad of Antwerp blue, cadmium scarlet, and aureolin yellow, plus Payne's gray—and adding water. When the wash was half dry, I applied salt, then sprayed the painting a bit with water and tipped it. To my amazement, the salt painted all the pine boughs for me; I didn't lay a brush on any of that lacy pine texture. The reason this worked the way it did was that water was added *after* the salt, and that tipping the board to move the running water and paint gave it direction.

I feel I should point out that it is not wise to base all of your texture effects on salt, because it's more likely to fail than succeed. You can, however, get lucky with salt, because sometimes it's all a matter of timing—applying it when the paint is at just the right dampness, when the humidity in the air is right. I think of all salt effects as lucky.

Salt was a great help in solving the always enormous problem of painting the ten million dead-looking twigs of bushes in winter. In *River Geese,* this was complicated by the fact that the bushes were in the middle distance. Up close you can paint details; far off you can wash in general shapes. But there's no easy answer to the question of how to handle mid-distance textures. Because of my underlying principle, I could never be happy with just suggesting these bushes; I needed to go for the reality.

I was again lucky with salt in *River Geese,* because I could combine the effects it made for me with some finer detail of twigs and branches and lose part of it in the fog. The big washes were laid in, and the salt applied to the tops of all the bushes on the right. When the painting was dry, I designed the fog using white chalk, working around the salt effects that were already there. I then lifted out color from those areas with a toothbrush to create the fog. Finally, I toned the fog areas and added details.

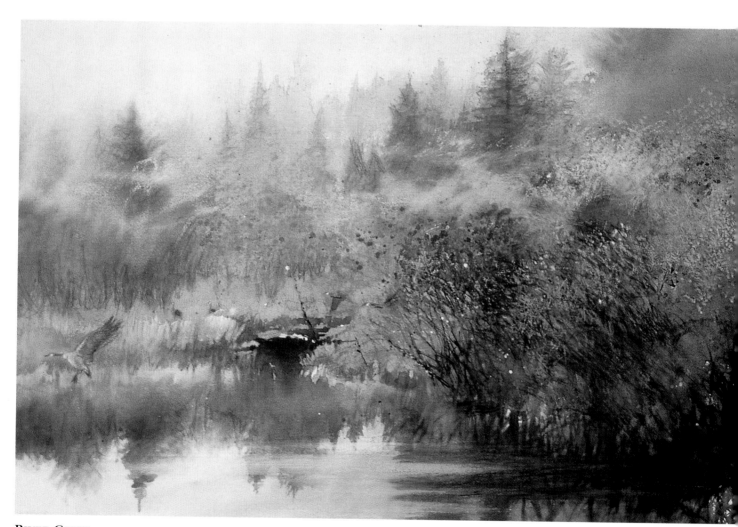

RIVER GEESE
Watercolor on Arches 140-lb. cold-pressed paper, 19 1/2 x 27 1/4" (49.5 x 69 cm). Collection of the artist.

STAMPING TECHNIQUES
Solving Texture Problems Your Own Way

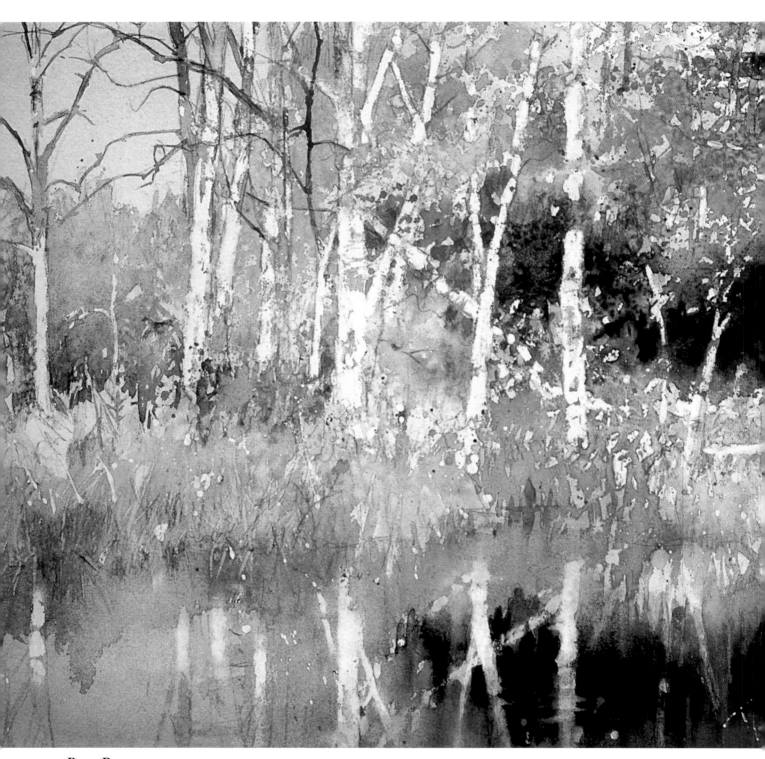

BLUE POOL
Watercolor on Arches 140-lb. cold-pressed paper,
25 x 24" (63.5 x 61 cm). Collection of Sandy and Ed Quinnell.

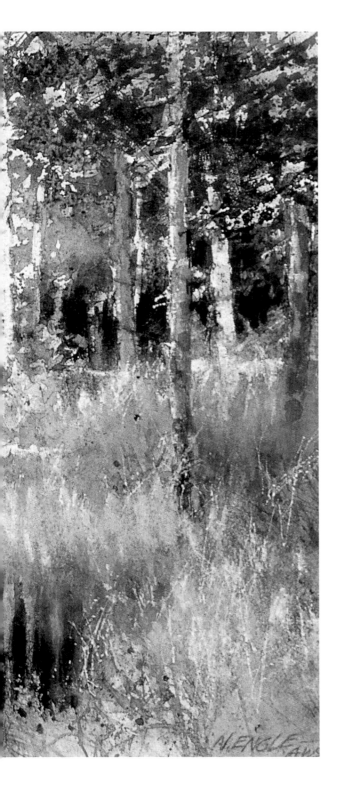

ARTISTS INVENT TECHNIQUES to solve problems that become evident while painting, and as you've seen, many of my own methods have come about this way. Back in the early 1960s, when I was working as a children's book illustrator, I observed a fellow designer using found objects such as feathers to stamp an image onto paper. I was also familiar with Japanese fish prints, made by inking the side of an actual fish and stamping it on paper to leave behind an impression of not only its shape but also its scales and other surface textures. This opened up new horizons for me, as I began to see how using stamps to apply paint would let me create such things as rocks, trees, and texture patterns in my work. I discovered that the results were more realistic looking than anything I could have accomplished with a brush. So, in my never-ending search to make my paintings look more real, what started as an experiment turned out to be a very effective means for achieving realism.

Rather than use commercially made stamps, I made my own from pieces of illustration board to represent trees, grass, cattails, and other subject matter. I once even painted a whole town with stamps I made of a few different house shapes. A bonus of this technique is that it lets you create multiple images of the same object or pattern easily and quickly, thus relieving you of the time-consuming and often tedious task of painting a lot of repeating elements, such as trees covering a hill or bricks forming a wall.

Besides stamps (or printing plates) made of illustration board, alternative tools such as crumpled paper and even your fingers can be used to paint repeating elements, as you'll see.

MAKING STAMPS

Two basic kinds of printing processes are relief printing and intaglio printing. Relief printing is achieved by inking or painting a raised surface on a printing plate; the ink stays on only the raised surface, and the pattern is transferred to the paper. This is how woodcut prints are made. Intaglio printing works the opposite way: The image to be printed is incised into the plate, so that ink or paint applied to it goes into the cuts and stays off the plate's surface. The incised image is then transferred to the paper. This is how etchings and engravings are made.

I create printing plates—stamps—by cutting an image into a small piece of illustration board using a sharp blade such as an X-Acto knife, razor blade, or utility knife. A dull razor blade gouges a thicker cut, making a bigger place for the paint to collect; you can experiment with this. I then make a handle by attaching a piece of masking tape to the back of the stamp.

One advantage of illustration board here is that it's laminated, so you can vary your plates. If you would like a more intricate shape you can cut your design through only the first layer of the board, then peel away the excess; you will then have a raised surface.

Stamping Rock Textures

This is one of the easiest ways to depict the textured surfaces of rocks. You can achieve a lot of variety in the patterns you create by using more or less paint on the stamp. This particular exercise works best using illustration board rather than watercolor paper as a painting surface.

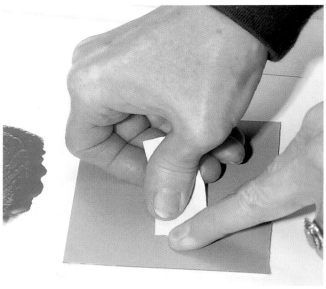

I cut a rectangle of white cold-pressed illustration board—you can make it whatever size or shape you want the rock, although for practicing, I recommend a piece measuring about 2 x 3" or 3 x 3". Turning it face down, I attached a masking-tape handle to the gray side of my piece of board. That's it—no scratching or gouging, just a plain piece of board.

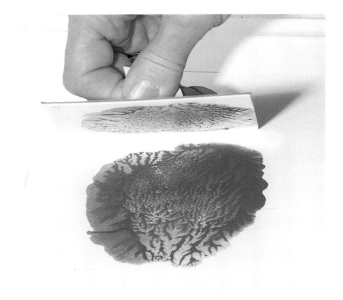

I applied a variety of colors on the white side of my stamp; the thicker the paint, the better. It's best to include some cerulean blue, because this color has such body. Next I pressed the stamp onto my painting surface (in this case, illustration board). When you press it down, it should feel very squishy. When I lifted the plate the first time, the texture I got was that of wet rock covered with lichen and mosses, the kind of rock found around harbors or beaches. You can also try applying wet colors to the painting surface as well as to the printing plate.

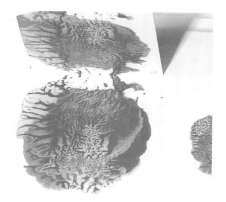

The more times you print with your plate without replenishing the paint, the drier the rock will turn out—the dry rock of fields or cliffs or mountains. If you make a scratch or two on the plate before printing with it, the dry rock texture will look even more convincing.

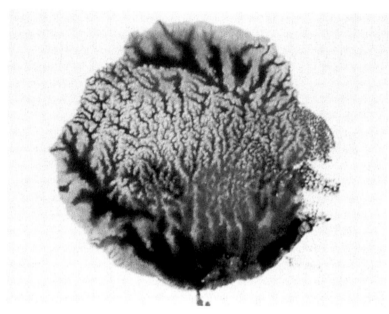

Note the different patterns that emerge. You can apply this method to many subjects other than just rocks. How about a head of cabbage? And believe me, the paint does this all by itself!

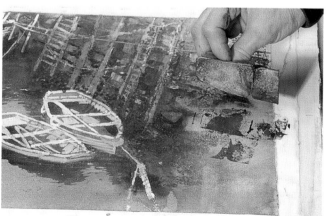

Here you can see how I used this tool on an actual painting. I cut my plate with rounded edges to resemble the large stone blocks used to build sea walls. All the old rock surfaces in this harbor scene were stamped. Immediately after printing these patterns, I sprayed them with water in places to integrate the stamped elements with the rest of the painting. Spraying also made some paint run down to add to the scene's realism.

A variation on this technique is to apply mask with a stamp. I had a great time with this experiment. I cut a printing plate and brushed Pebeo mask on it, then immediately pressed it down on my painting surface as if I were printing with paint. I let the mask dry, then painted a wash over it. When the paint was dry, I removed the mask to reveal the lovely pattern you see here.

Stamping Trees

We now move on to preparing the printing plate according to subject matter—in this case, pine trees. Cut a small rectangular piece of illustration board, attach a masking-tape handle to the reverse side, and on the white side, draw a pine tree. I usually start with a central trunk, then add all the branches. Next, scratch or dig this drawing with the corner of a razor blade. You can be quite careless; let the chips fall where they may. For variety, you can make several different tree plates or use different colors each time you replenish the paint on a stamp.

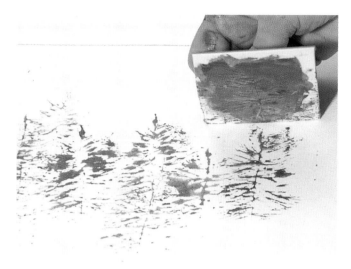

I painted a few colors on the cut side of my printing plate, filling all the grooves and scratches, and pressed the plate onto the paper. I always print on pieces of scrap paper first to break in the stamp.

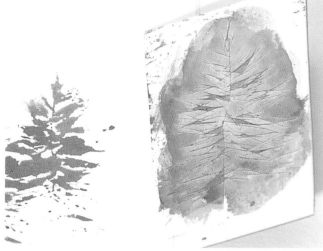

Here you can see clearly what a typical printing plate looks like. I was fairly careless in the way I cut the pattern into it, with pieces falling off the tree and so on. Just don't cut yourself when you do this!

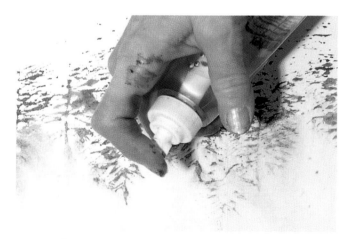

I stamped a pattern of several trees onto my paper and then, while the paint was still wet, turned the paper upside down and sprayed water along the tops of trees; the color that ran off became the sky. The bonus for creating trees this way is that in addition to the way the razor-cut pattern prints, you get a lot of little texture dots that stitch things together in a way you could never paint conventionally. A useful variation is to dampen your painting surface in some places so that when you apply paint with a stamp, you get a fog effect.

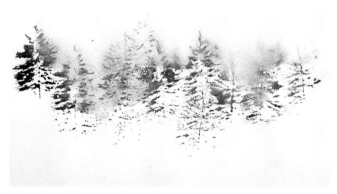

This is the effect gained from spraying the tops of the trees with water. You could spray the bottom instead to define the ground instead of snow—but don't spray both top and bottom! Of course, you could apply color to the ground or the sky first, let the area dry, and then proceed with your stamping as usual.

An Example

The tree-covered hillside in this painting was created entirely by stamping. I made two or three different tree stamps, sprinkled the paper with water, and stamped my way down the page. Immediately after this, I introduced a lot of dark colors in the sky and allowed the paint to float down the cliff and form the shapes of the trees. Then I sprayed water onto the top of the painting and allowed it to drift down to form the fog. I had previously masked all of the boats and rigging and a few dead tree trunks, but there was no mask on the cliff—I created all of these effects with the stamping technique!

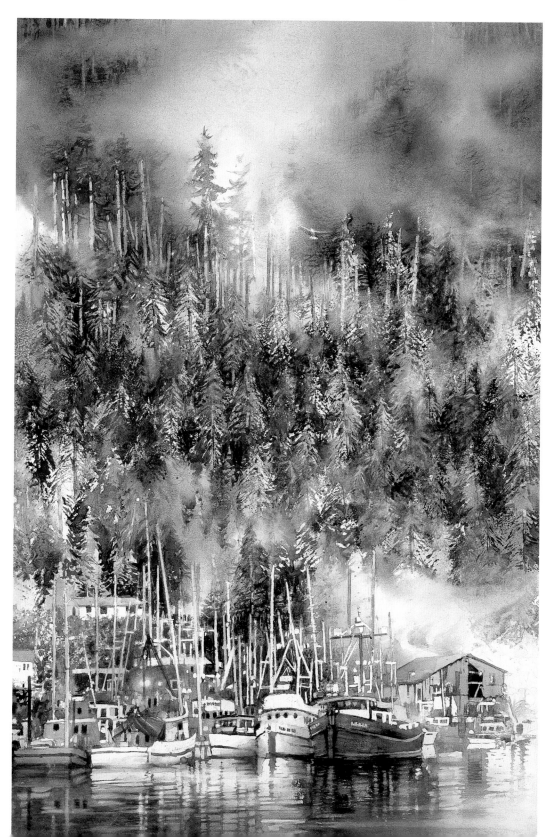

MOUNTAIN COVE
Watercolor on Arches 140-lb.
cold-pressed paper, 24 x 35"
(61 x 89 cm). Private collection.

Stamping Grass

Foregrounds can be difficult to paint because they are right up front—in your face, so to speak—where mistakes from clumsy brushwork are especially obvious. To solve such foreground problems, I developed a way to depict grass with the stamping technique. This method creates a graceful randomness that beginning painters find difficult to achieve using brushstrokes. (We all have difficulty with this; I once read an interview with a very old Chinese painter who said that if he lived another ninety years and practiced brush-work every day, he might then be able to "paint a line of rain going down a stone wall.")

The stamping method is very versatile—you can make any shapes you like. Just plan beforehand which way you want the grasses to lean in your painting, because the cuts you make in the stamp must lean in the opposite direction (since the image on the stamp prints in reverse). It is fortunate that our homemade printing plates never stamp the same way twice!

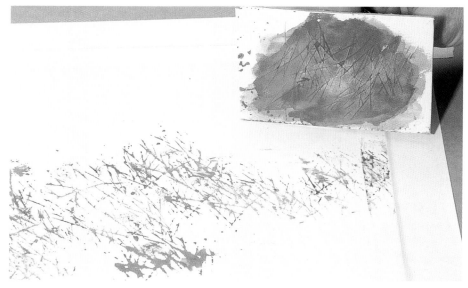

I made my printing plate as usual, scratching and gouging lines for the grass pattern and keeping in mind that this would print in reverse. When you make a new stamp, don't forget the first step—breaking it in on some scrap paper.

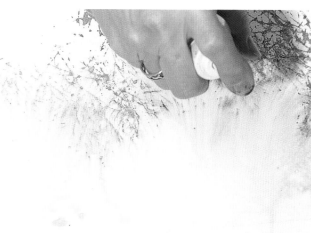

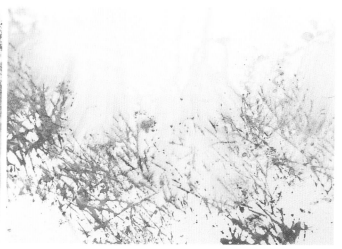

While the grass pattern is still wet, I turn the painting upside down and spray water across the top of the grasses. That way, the color that runs off the top of the painting becomes the sky and makes the grasses appear to drift in and out of a mist. And because the bottom of the grasses stays untouched, remaining as the original linear stamp marks on a white background, the effect is that of grasses poking out of the snow. To depict beach grasses growing in sand dunes, lightly wash in the color of sand first—sky, too, if you want. If you're working on illustration board, let this paint application dry for two or three weeks so it will settle in, then stamp the grass pattern over the initial washes. (Because of the board's slick surface, adding more paint or water sooner than two to three weeks will cause the initial layer of color to wash off.)

Related Examples

Both paintings shown here illustrate that the more tools you have at your disposal, the more interesting your landscapes can be. For *Grouse Country*, I combined throwing, stamping, and knifing techniques with large, continuous-tone washes. After masking the road, I threw paint onto the surface, then used a printing plate to create the grass, then applied all the wash colors. I painted the trees, some with stamps, when the background was dry.

The challenge of producing frozen grasses for *Edge of Winter* was interesting. I used a combination of stamping, salting, masking, lifting, and conventional painting. I applied mask to reserve whites in the area of the snow fence so I could wash in the shadow colors there; the ski tracks were also masked and a tone washed over the snow. And to create the light coming down from above, I sprayed water onto that area using, of course, the Windex bottle.

GROUSE COUNTRY
Watercolor on Arches 140-lb. cold-pressed paper, 13¾ x 20" (35 x 51 cm). Private collection.

EDGE OF WINTER
Watercolor on Arches 140-lb. cold-pressed paper, 18¼ x 27" (46 x 69 cm). Private collection.

STAMPING WITH CRUMPLED PAPER

I began experimenting with this years ago when I was spending a lot of time in swamps and seeking a way to capture the extremely complicated vegetation I found there. Applying Saran wrap to the wet painted surface was not giving me the textural effect I wanted. And although I love what happens with painting on crumpled paper, this approach violated my goal of taking the viewer into the scene, because after the paper has been flattened out, it's still obvious that it has been crumpled, thereby destroying the viewer's illusion that she or he has entered anything realistic.

Around this time, I knew artists who were slapping paint all over one surface and transferring it while wet to another. I had been stamping with my own printing plates for some time. My mind made a leap, and I began putting paint on crumpled paper and transferring it to my painting surface.

Creating Vegetation Patterns

This technique is a simple way to depict what can be complicated-looking tangles of plant life. It works best when the crumpled paper you use to transfer color to your painting surface is more brittle than soft. For this demonstration, I used tracing paper.

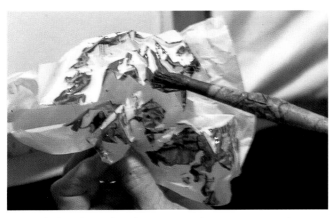

I crumpled a piece of tracing paper and, as you can see here, applied various colors of paint to the protruding edges and corners and nooks and crannies.

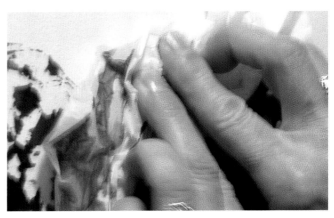

I pressed the crumpled-paper stamp onto my dry painting surface and flattened it out a bit to transfer the paint. I then reapplied color to the stamp and printed it across the page.

Here is the resulting pattern of random marks, which could be used in many situations, especially wherever you might need a hard-edged white.

Immediately, while the color was still wet, I turned my painting surface upside down and sprayed it with water to soften some of the pattern's edges. I see many applications here; to me, this example looks rather like snow with rock areas and vegetation.

Two Practical Examples

To show you how useful the crumpled-paper stamping technique can be in real painting situations, I have included two finished works here, one that employs the method in a fairly literal way and another that illustrates a variation.

In *Driftwood, Lake Superior* I produced the vegetation with a crumpled-paper stamp and then sprayed the area with water—to me a more convincing way to render nature's calligraphy than conventional brushwork. After all was dry, I drew in my subject's specifics (a shore of Lake Superior that's my front yard), masked some areas, and added the mass of background trees as a foil for the darker foreground trees. I also used salt (noticeably at upper left) and flung mask onto the surface, which subsequently, when removed, became white dots of spray or moisture or something shining in the woods. I often do this in paintings of or around water to make things look more lively. As I viewed the completed image, I was tempted to extend the area of sparkling water over to the right, to show more lake. But then, I think we all know that a painting is never really finished, because we want it to be perfect, yet know we are really not capable of perfection—so it's on to the next one!

I also include an illustration I once did for an article in *Playboy* magazine because it offers a slight variation on the stamping method. The article was about a place in the Arctic Circle that is so locked in with huge cliffs of glacier ice—some of them three hundred feet high—that all the fjords are open only about every ten or twelve years, when pieces of the glacier calve into the sea. For me, this was quite an assignment!

I made some printing plates for the ice and used all the primary colors, working in fairly thin paint applications because of the light hitting the ice. I also used another technique here, which works only on illustration board. I painted some transparent primary colors (like those in my "air" triad) onto my painting surface and immediately dropped Kleenex over the whole thing—just casually, not so it would lie flat. When I picked up the tissue from my painting, I saw that ice shapes had formed.

Incidentally, dropping facial tissue onto wet paint on your painting surface also works well for creating wispy, delicate cloud formations.

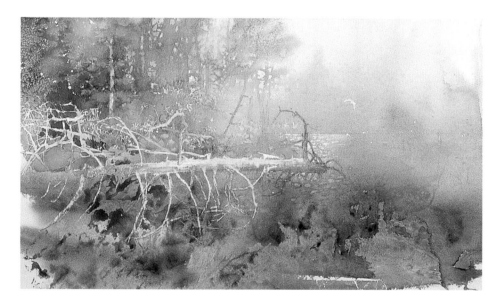

DRIFTWOOD, LAKE SUPERIOR
Watercolor on Arches 140-lb. cold-pressed paper, 13 ½ x 20¾" (34 x 53 cm).
Collection of the artist.

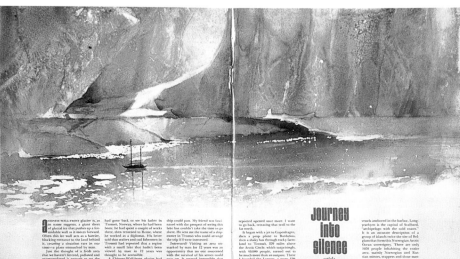

In this illustration for a story in *Playboy* magazine, I created the ice textures with printing plates and Kleenex dropped onto the surface while the paint was still wet.

OTHER PRINTING TOOLS

Illustrated here are a few additional variations on printing techniques you can use to deliver color to your painting surface. Besides cutting pieces of illustration board into specific shapes for stamps, you can also use them to drag paint onto the surface in textural ways. Natural objects such as feathers or ferns are effective stamping tools—and so are your fingers! I stress again the importance of having among your supplies as many "tools" as possible. Mathematically, think of the combinations! But I would also remind you that all such tools are only a means to help you express the concept of your painting, not ends in themselves. And again, all of the texture effects I have shown you are only the first half of most of my work; the second half is making it all into a painting, a work of art.

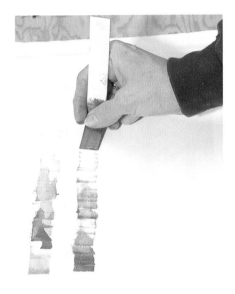

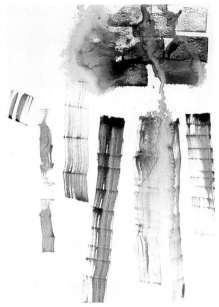

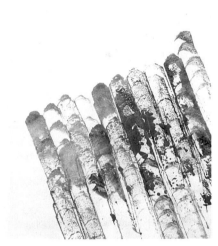

An effective way to handle difficult tree trunks like bamboo and palm: Cut out a piece of illustration board in strips, some thin, some wide—whatever size you need. Dip the bottom of a strip into the appropriate color on your palette, then drag the strip along the surface of your painting, hesitating for the joints of bamboo or rings of palm trunks, as in the photo. This works best on illustration board. With no paint refills, you can get lighter and lighter as you proceed. Of course, you can replenish the paint and retain the same values, or you can have heavier paint on one side for highlights.

Here are more tree trunks; note how you can vary the image while the paint is still wet by spraying or squirting water on selected places on the trunk. Above the tree trunks is a portion of a brick wall, which I achieved by cutting small rectangles of illustration board, picking up color, stamping it onto my painting surface, and spraying water on it while it was still wet.

This was an experiment I tried when I was in Southern California, where there are a lot of tile roofs. At the time, I was painting a mission and needed a way to depict the pattern of its terra-cotta roof tiles. I cut some narrow strips of illustration board, rounded the tops, scratched some contour lines into the printing surface for the tiles, and stamped with various colors in a rather irregular style, as this example shows.

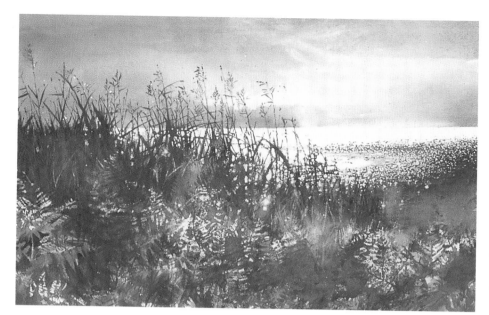

MIDDAY, LAKE SUPERIOR FERNS
Watercolor on Arches 140-lb. cold-pressed paper,
20 x 28" (51 x 71 cm). Collection of the artist.

This painting was made by using nature forms as printing plates, combined with mask used for the top area of grasses. I picked a lot of baby ferns (right from this spot!), painted them totally with Pebeo mask, and stuck them on the paper surface while the mask was still wet. Next I picked more ferns, applied paint to them, and printed them on my painting. I had previously drawn and masked the lake and grasses. All I had to do then was paint the big washes, remove the mask and debris, and refine details here and there.

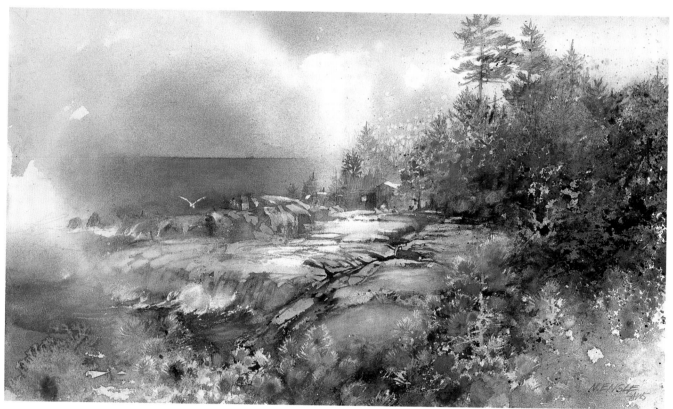

MIDDLE ISLAND POINT
Watercolor on Arches 140-lb. cold-pressed paper, 13 x 20" (33 x 51 cm). Collection of Holly Varner.

I rendered all of the Norway pine saplings and ground pine in the foreground of this painting mostly by printing with my fingers. This type of pine has large oval clumps of needles—lovely red trunks, too. It's one of my favorite pine trees. After applying a lot of paint in many shades of green mixed from my blues and yellows, I pressed my thumb and fingers into the wet color. When I lifted my hand, I had dark places in the middle of where my fingers had been in contact with the paper, surrounded by a lighter shade. When the area was dry, I reinforced the effect with razor blade accents. Other textures were achieved by throwing paint, spraying with water, and applying salt.

DESIGN AS AN EMOTION
Strategies, Problems, and Solutions

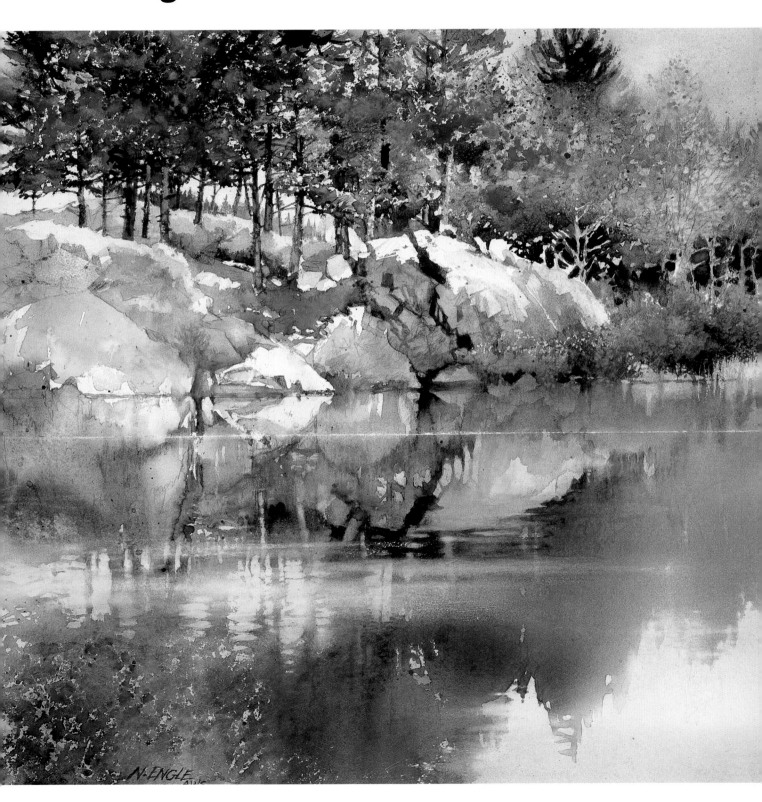

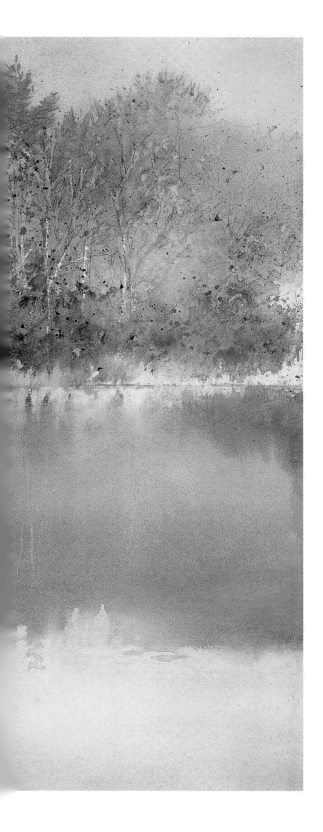

I HAVE DELAYED until the eleventh hour writing about design. However, I wanted you to be free and unfettered in getting familiar with handling running water and paint before concerning yourself with building a painting.

After the first excitement of starting a new painting is over—after all the exploring with brush, paint, water, and spray—comes the struggle to make the image work. More often than not, it's an exhausting struggle.

Design basically means making sure everything works properly, that large shapes and small ones work together, that light and dark values are connected, that the design leads the eye. I have asked many fellow artists who judge competitions what they look for first in a painting (aside from passion), and the answer most of the time is design. I feel it is the most important element, whether I'm judging someone else's work or my own. But when I am in the process of making a painting, I am constantly waging a war between painting freely and imposing structure on the work.

By encouraging you to approach watercolor with a sense of freedom, I don't mean to imply that you should ignore the formal rules of design, because they are very important and must be a part of your thinking. But because I can't improve on the information about design given in many other books, I make no attempt here at rehashing it. Just know that you should always keep the rules in mind, but not allow them to hamper your freedom. Think of when you learned to dance, counting out the steps with great effort. When you dance now, the rules are part of you and furnish the base for creativity and freedom.

The examples shown here are meant to illustrate design thinking and problem solving, not necessarily step-by-step painting.

QUIET WATERS
Watercolor on Arches 140-lb. cold-pressed paper,
19³/₄ x 27³/₄" (50 x 70.5 cm). Private collection.

FORMULATING A DESIGN STRATEGY

When I was a student at the Art Institute of Chicago, we were asked to select paintings in the museum's collection and analyze their composition. In those days I didn't have a clue; I had no design sense, just a desire to paint nature. But gradually, through years of working as a bull-pen layout artist and then as a graphic designer, I grew what I call a design reflex: an ability to feel when something is right without having to consciously apply fixed rules. That's how I know a design sense can be acquired—or if it's simply dormant, developed.

An artist's sense of design is almost physical, having something to do with weight, with tension. A lot of it is feeling. For example, while painting something that is getting cluttered and losing direction, you suddenly have a great urge to make some bold, sweeping gestures, to simplify, to make large shapes. This feeling is so beyond design, it is really an expression of emotion.

If you have ever balanced on a narrow rail, you know the feeling of making many, many little adjustments with your shoulders, head, arms. You instinctively know what to do to stay balanced. I believe this is how your design reflex should work in a painting. If a picture is too weighty on one side, or top-heavy, or something in it is threatening to fall out of the corner, you will almost physically feel it and make the necessary adjustments.

With experience you learn how to strategize—in other words, how to anticipate the design needs of a given painting situation and meet them successfully. The following two demonstrations illustrate some ways I used design to express my subject matter most effectively.

Preserving Impact with Design

This painting was built totally around a spectacular sky I saw over a trout stream behind my house. At that point, nothing else mattered to me—not composition or values or anything else about art. I just wanted to paint that sky!

It was one of the first days of spring in a year we had nine months of winter, bitter cold, ice, four hundred inches of snow, power failures, and sheer misery. I was ready to paint the spring, and to believe that even summer might come again!

Because there were many details in the sky contributing to the whole effect, such as the sunlit edges of the clouds, I decided to use some mask. If the shapes were not preserved, the impact would be gone, as this real sky was gone forever, lasting only about fifteen minutes. But I had a camera!

After drawing and masking, I activated my whole palette, including large amounts of blues and reds. I saturated the paper with water and laid the wash all at once, adding new colors and adjusting values as it floated down the page (a lively half hour!), tapering off and ending where the sky meets the ground. As all of the woodland was also glowing with color from this sky, I threw salt and dripped water into selected woods areas when the painting was half dry. When it was completely dry, I added a few preliminary dark tree accents to fix in my mind the value spread.

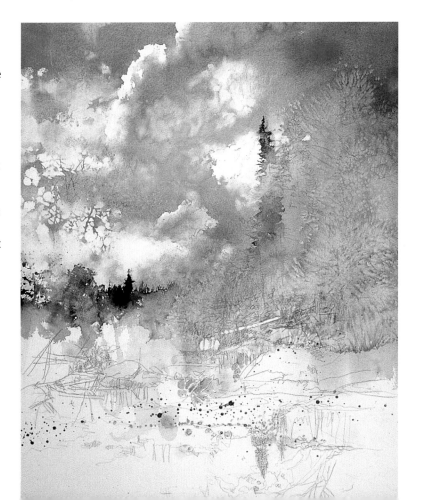

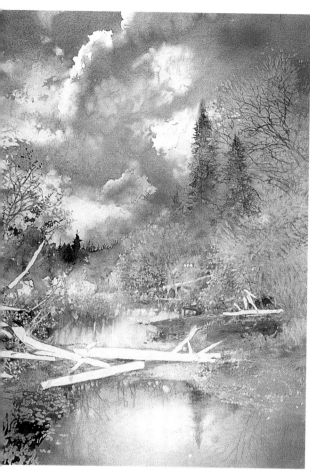

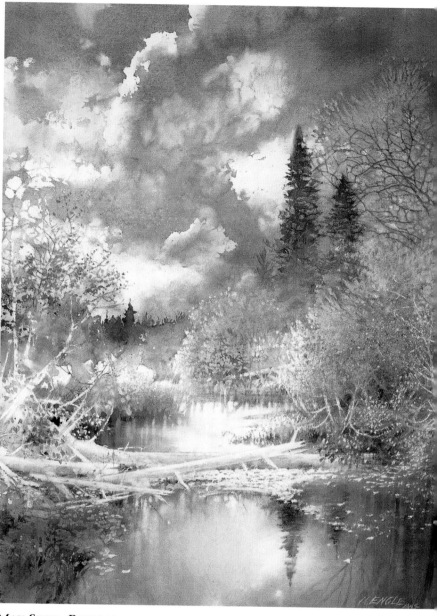

Now for the design part—in fact, the structure of the whole painting, ignored until now. I had previously painted a large, free wash in the foreground to establish the water and the perspective of the riverbanks. I cut some shapes out of white masking tape to create the logjam causing the still waters ahead of it, where the large pine tree is reflected. I arranged my tape-logs in various positions until I was satisfied with the structure. I also began here to add detail to large masses of trees.

MAY SKIES, RENEWAL
Watercolor on Arches 140-lb. cold-pressed paper, 29¾ x 19⅞" (75.5 x 50.5 cm). Collection of Arlene Wright and David C. Arntson.

With the tape still in position, I first traced the logjam area on a sheet of tracing paper. Then I removed the tape-logs, transferred my tracing onto the painting, and, using my tracing marks as a guide, made a sort of stencil for the driftwood by placing strips of tape all *around* the logs. Then I was free to lift paint from the exposed area with a toothbrush. I changed the driftwood yet again, corrected values, and designed more graceful bushes leaning over the water. The whole idea here was that I wanted all the attention to be on the sky.

Planning Design Values

I originally painted *House by the Sea* as an illustration for a story that took place in French Canada, and I had just been there on a two-month painting trip, so I had a lot of material to work from. After reading the manuscript and going through my files, I decided to use a Victorian house from my own home town in Michigan as a model for the one in the story.

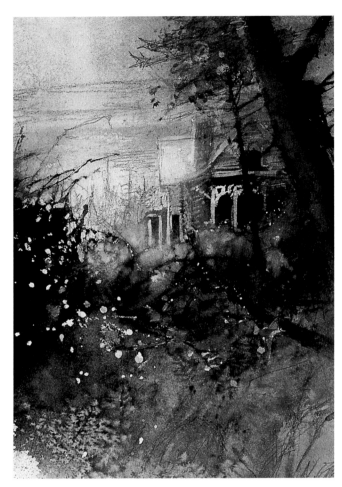

In this initial drawing, you can see that originally I made the house ordinary, rather like an old farmhouse. I knew it had to appear in a setting high above the water, as the story placed it there. One day I was driving along a street that's high up and overlooks Lake Superior and noticed a Victorian house I hadn't seen in twenty years. As I became reacquainted with it, I decided Victorian was the way to go in the illustration.

This is a very rough "thinking" sketch, which I've included because it shows the change in the house from the earlier drawing. It also shows my plan to hide it a bit with foliage, which was important to the story.

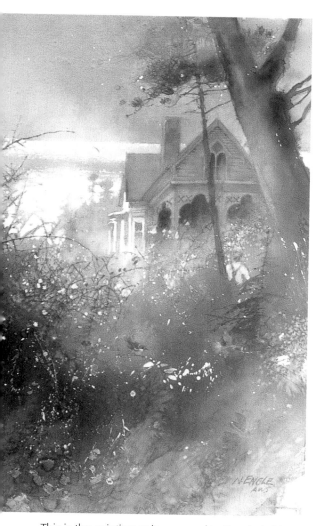

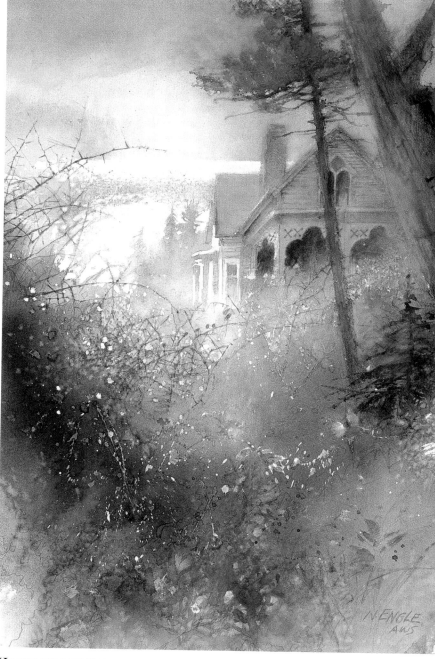

This is the painting as it appeared in *Reader's Digest* in France. When planning the design values, I turned to the story again. The plot called for a boy to approach the house unseen, so I added drama by keeping the values dark in the foreground and leading the viewer's eye to the house and then to the sea. The idea was for the reader to see what the boy was seeing. I masked the light on the water, the boy's shirt, and the house—every board and curlicue. I also flung mask onto the paper to create random white accents. The wash was added all at once. I varied the colors and the values, especially the darks in the porch, as I guided the paint down the page. When all was dry, I peeled the mask off the house and added a tone over the roof and shadowed parts. Trees were added last, and prickly dark shrubs.

HOUSE BY THE SEA

Watercolor on Arches 140-lb. cold-pressed paper, 28 ½ x 19 ½" (72 x 49.5 cm). Collection of Ed and Edith Nelson.

This is the same painting, subsequently reworked for publication as a limited-edition print. I removed the boy and the bird, added more wild roses, and a bit more detail in the foreground.

MAKING REPAIRS

I don't want to give the impression that all my paintings are finished effortlessly. In fact, I planned this section not only to help you correct, or "rewrite," your own paintings, but also to make a statement with these works in progress: that almost no one magically gets it right the first time.

Some artists make fewer mistakes because they can see in their minds exactly how something is going to look before they commit to it. I have to see it painted on paper before I know whether it's wrong, even if my thumbnail sketch seemed right. I have somewhat evolved away from working with such sketches, because I need to be free to go with unexpected turns the watercolor takes, even if it gives me trouble later. It doesn't mean not being in control, it means choosing to trust.

This section isn't only about fixing mistakes, it's also about improving the painting! Nature may always be beautiful, but it is not always graceful. It requires art to give it grace. So again, in the interest of encouraging you to paint boldly, here I offer some remedies in case *you* have been less than graceful.

I think there are two kinds of artists. Each paints a watercolor that has some excellent passages, but also some not so good ones, and maybe one bad mistake—say, in the top right corner. Artist #1 paints the same image again, and now it has more brilliant passages, but also others that aren't so good; this time the top right corner is okay, but now there's a mistake at bottom left. He paints it again; maybe there's nothing bad about it this time, but maybe by now, nothing brilliant either. Artist #2, on the other hand, stays with the first painting, mistakes and all, and chooses to fix the problem areas. I'm in this category, because sometimes the "happenings" are too good to give up, so I've developed ways to do away with the flawed parts.

I feel the first effort at a painting is the most honest—when you are edgy, still searching for answers. If you make the same painting three or four times, you may get better at doing it, but there is a danger of getting too polished, becoming not real, because your passion has already been spent.

But we don't always fail! Sometimes all the elements fall into place at once, combining to make a painting successful with minimal effort. Although most of us screw it up somehow even then, that feeling of success is so addictive, it keeps me painting!

Erasing a Mistake

Repairing watercolors when small mishaps occur in a textured area—in the trees or grasses, for example—is simple: You remove the mistake and repaint the area. For example, if you make a mistake in an area of foliage, you can lift it out with a stiff brush without worry, knowing that when all is dry you can repaint more leaves and branches seamlessly, since it's all texture anyway. More care should be taken when you are correcting a larger textured area (more on this later). But when the mishap is in a continuous-tone wash, it could ruin a painting. I found this out the hard way, and also found a cure for it from sheer necessity.

In this case, I had been making a painting for Reader's Digest Condensed Books for about three weeks, working day and night to meet a firm deadline. On the last night, when it was almost finished, I was so tired that I dropped a brush loaded with dark paint on it, right near the top. The paint cascaded down through everything, dry areas, wet areas. The painting was to be picked up in the morning to ship out! What was I to do?

First of all, fortunately I had used140-lb. Arches paper, which can stand up to scrubbing. Where the area under the spill was dry, I was able to simply (though carefully) wash off the unwanted wet paint. But a lot had spilled on a graded wash, which meant I had to scrub with a toothbrush all the way down to the white paper to get it off completely. This left a white hole with a continuous tone all around it. You could apply twenty washes over it and still have a value difference between that area and the surrounding color. If I tried to rewet just that area and fill in the color with a wash, I would have had a ring around it, where wet met dry. It took me all night, but I finally found a solution.

A short time before this happened, I had had occasion to look at one of my paintings through a strong magnifying glass. If you do this, you will see the pores of the paper, and what looks like a solid color surface is really a series of dots. So I decided to put back the color with dots as well, using a technique called stippling. As an illustrator, I had done this before, but never for this purpose. It's tedious and time consuming, but effective! The following demonstration illustrates a similar situation.

Do not use white paint for such repairs. Transparent watercolor is usually darker when wet than when dry. However, when you mix white paint with transparent watercolor, the opposite is true: The color is lighter when wet and darker when dry. Because of this, it's harder to match the repair work to the rest of the area.

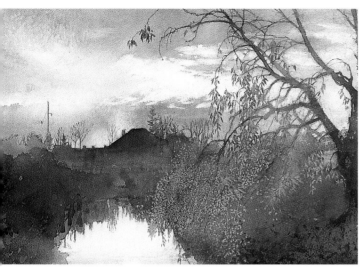

While making this painting, I got carried away with the willow leaves, and when I stepped back from my work, I realized that the branch hanging out of the sky at the top of the composition was all wrong. It stopped the eye like a target, leading nowhere.

I gently lifted paint from the problem area, first with a small, soft brush, water, and Kleenex. I always start with the least abrasive tools, swabbing the darkest colors first and working outward from the middle of the area to be removed. Be sure to confine the area and take care not to let the water or paint run.

Next, using a stiffer brush, I scrubbed down to the white paper, repeatedly drying the area with the tissues. As I don't use staining colors, this is rarely a problem. In radical cases, once the scrubbed area is dry, I rub it lightly with sandpaper. Finally I softened the edges of the repair with water and a small, stiff brush, working outward from the center to make a kind of vignette; this makes the repair easier to merge with the surrounding area. I then let the painting dry thoroughly, which is essential before moving on to the next step.

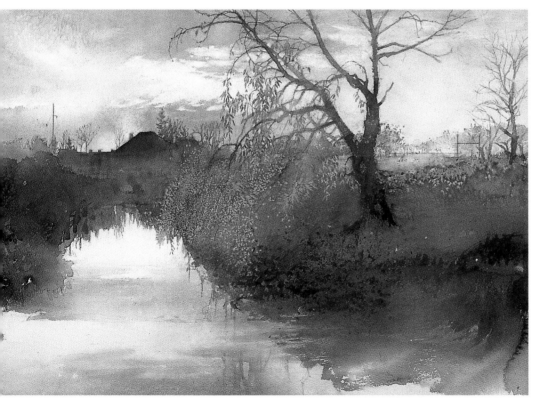

I mixed paint to match the sky's hue and diluted it with water to make it a bit lighter than the sky. Using my #3 round sable brush, I stippled next to the edge of the repair area to check the color and value. I picked up a very spare amount of paint on the tip of the brush, just enough to make a dot. I started to fill in the area timidly, first with very diluted color, and gradually with darker values that matched the sky, until the white was covered. As I went along, I constantly dried my work with a hairdryer— the most important part of this technique. (Otherwise you'll soon have a puddle that won't merge with the rest of the sky.) And now the offending branch is gone.

EDGE OF TOWN
Watercolor on Arches 140-lb. cold-pressed paper,
19 1/2 x 29" (49.5 x 74 cm). Collection of the artist.

HANDLING TEXTURES IN DESIGN

I and another judge once rejected a painting from a juried show because although it was mostly well done, there was a snow-covered area in the foreground where grass stuck out willy-nilly, guided by no apparent thought for design. As much as I aim in my own work to create a rich tapestry of textures, I make sure in the end that they are all designed to work within the context of the subject and are connected to the scene's shapes. But I need to see things on paper before I know if what I've done is right, so I've developed ways to get a preview of the finish, like the approach shown below.

Connecting All the Elements

I think it is irritating to look for very long at a painting that has a helter-skelter approach to flowers, grass, birds, whatever. These elements need to flow and be connected to something else, to be a part of the overall scene. In the painting for this demonstration, *Wild Rose Marsh,* the flowers I created in the foreground made a promising textural start, but they lacked direction.

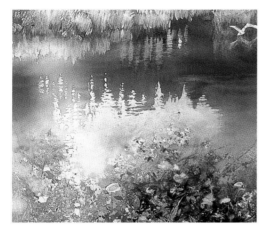

I cut some white masking tape into rough rose shapes, painted them pink, and moved them around until I felt the flow of the design was balanced and graceful. I also made a masking-tape seagull and placed it in various positions (here, at far right). When I was satisfied, I drew the bird's reflection on the painting in chalk.

I drew around each of the masking-tape roses with a pencil, removed the tape, and with a small, damp stiff brush lifted the paint within the pencil lines. When these areas were dry, I defined the rose shapes and painted around them to make them more realistic, matching the surrounding colors. Once that dried, I detailed the roses themselves.

To lift paint from areas that are too dark for a regular pencil line to be visible, I use a white chalk pencil instead, as with the seagull here. I placed pieces of masking tape around the gull drawing to make a stencil, lifted paint from the defined area, and then added the bird's details.

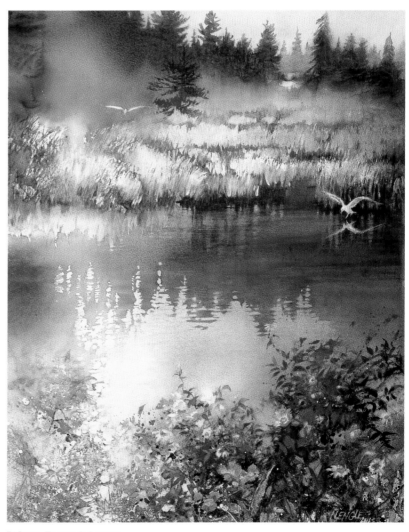

WILD ROSE MARSH
Watercolor on Arches 140-lb. cold-pressed paper,
27½ x 17½" (70 x 44.5 cm). Private collection.

USING CHALK AND MASKING TAPE AS DESIGN TOOLS

Whenever I contemplate making major changes to a watercolor, I feel a lot of doubt about what might happen if after removing paint and altering the image, I don't like what I've done. To alleviate such worries, years ago I began to use chalk—just ordinary kids' chalk and chalk pencils, in all colors—to work out design solutions directly on the dry surface of the painting in progress. I can't tell you how often I rely on this method while in the process of painting (instead of beforehand) or when correcting a bad design. The following demonstrations illustrate how I do this.

Designing the Pattern of a Reflection

Island Lake II (page 105) is a painting of a very special place for me: an inland lake near where I live. I often throw a canoe onto the roof of the car and go exploring there. I had wanted to paint this area for some time—in fact, I had started a series on the theme.

I was thinking of a second in the series when *American Artist* magazine offered me a commission for its American Artist Collection. I submitted several half-finished paintings of various subjects, and *Island Lake II* was chosen.

I wanted the lake to be calm and wanted to show a lot of color in the reflections, but found to my horror a large design problem—and I hadn't given it even a moment's thought. After I created the reflection of the large rock formation in the water, I stepped back to view the painting and saw that the rock and its reflection, complete with detail, looked like a damaged volleyball. The magazine had already approved the top half of the painting. What to do?

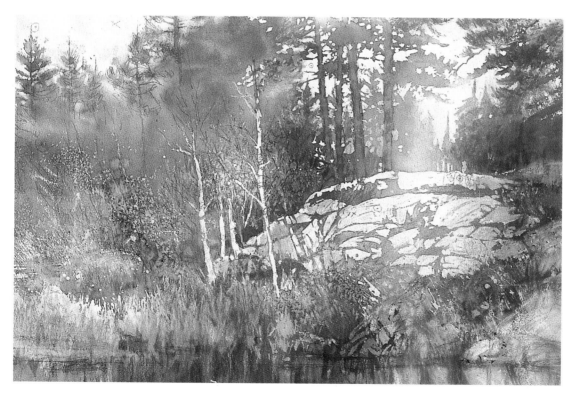

When this painting was selected for the cover of *American Artist,* only the top half of the image was finished, as you see it here; I hadn't yet started any of the reflection area.

It wasn't until after I'd painted the rock's reflection in the water that I saw I had a design problem. To solve it, I had to decide what device to use to break up that "volleyball." I could show a mass of more rock jutting out—hated that—or a bank of grass or reeds in the water—I've done that before, too, but in this vertical composition, hated it. I decided to try breaking the surface of the water (and the "volleyball") with a slight puff of a breeze, just a ruffle across the water. Here, you can see how I used strokes of dark chalk to simulate the ripple.

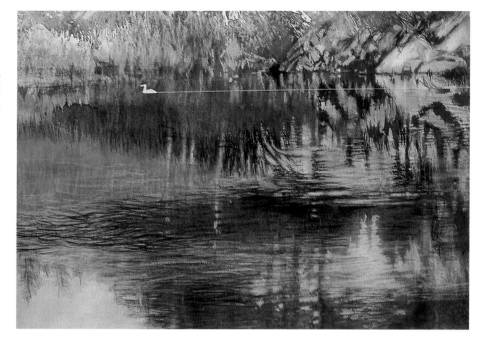

Whenever a breeze blows across sections of a calm lake, it breaks the reflection, and also reflects the sky. In this step, note how I designed the pattern with white, blue, and dark gray chalk. I also cut a Canada goose out of white masking tape, attaching a piece of white thread to it for the bird's wake, and tried placing it around on the painting to find just the right spot. It was interesting to me that the most effective place, aside from design requirements, was the still area of the rock's reflection.

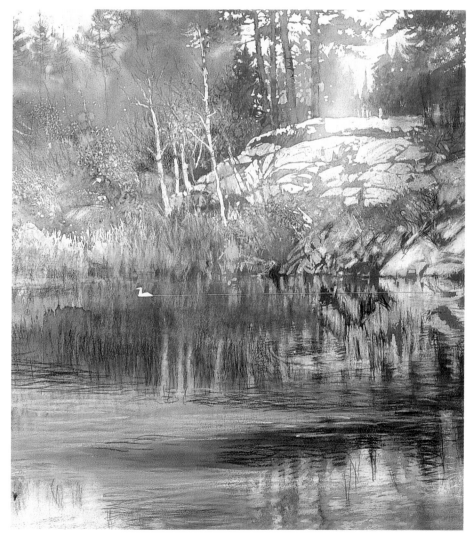

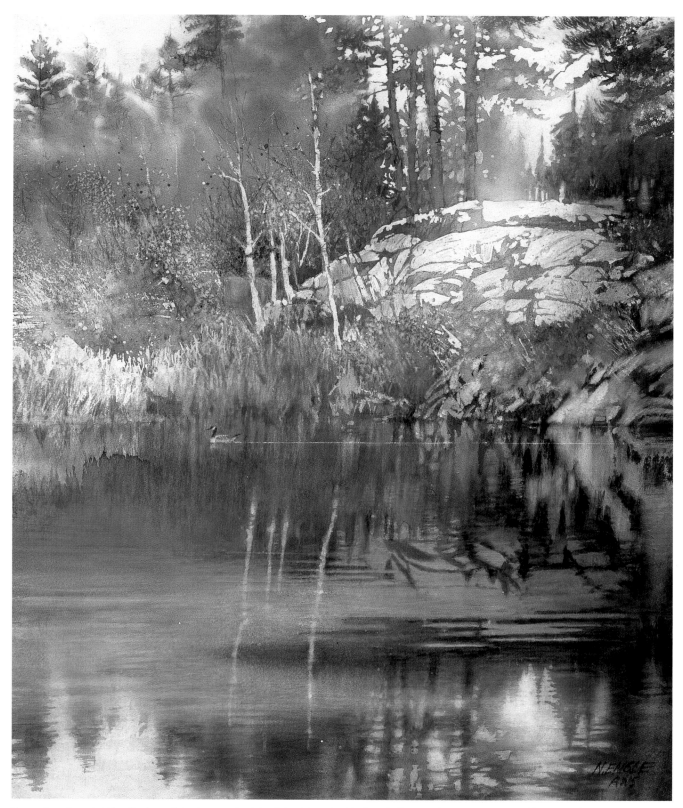

To capture in paint the illusion of ripples on the lake I'd achieved with the chalk, I made a very detailed tracing of my new design (the thinner the tracing paper, the better). After erasing the chalk, I removed some of the paint from the necessary areas with a toothbrush, razor blade, and sandpaper, then washed in the new colors and repainted some darks while the wash was still wet.

ISLAND LAKE II
Watercolor on Arches 140-lb. cold-pressed paper, 29 ½ x 19 ½" (75 x 50 cm). Private collection.

Solving a Basic Design Problem

I was teaching a workshop at Isle Royale National Park, located in Lake Superior, and this was a demonstration I did on the spot and then brought back to the studio to develop further.

Here the mask has just been pulled off the wave pattern. Back in my studio, I decided that I wanted the waves to be livelier.

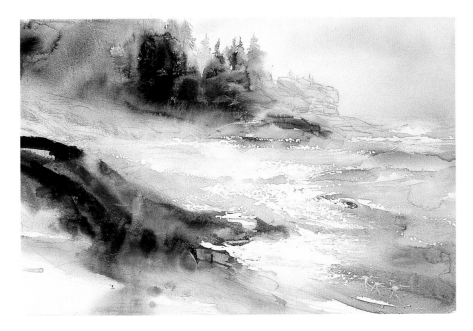

At this stage, I've removed most of the mask and painted a bit of the waves, drawing and designing the rest with chalk. I added an eagle at the upper left where there was a flaw in the painting. I usually frown on such antics, because it is within our power to get rid of flaws—but I really wanted an eagle there! However, all my redesigning still didn't solve the main problem. If you look at this photo from far off or with your eyes squinted, or could see it reduced to the size of a 35-millimeter slide, as I did, you'd notice two dark shapes: the tree line that begins at top left and slants toward the right, ending at about the center of the composition, and the line of rocks that begins at center left and also slants downward toward the right and ends near the middle. This very basic design flaw—two shapes of about equal size running parallel to each other—bothered me from the beginning, so I had to solve it.

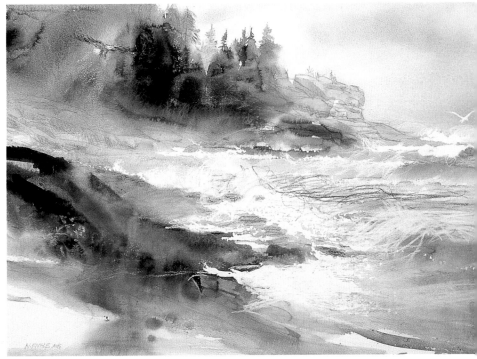

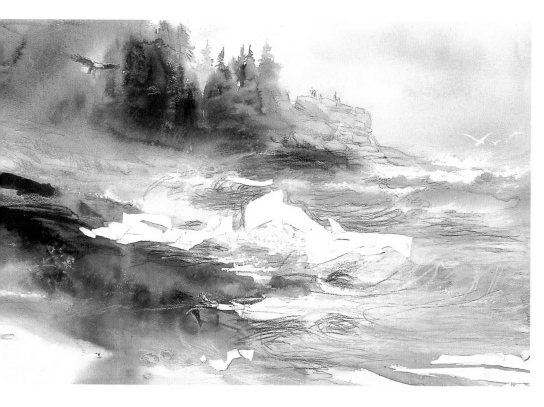

I began working with white tape, cutting into the rock line, forming much bigger waves smashing against the rock, leading your eye back across the painting and breaking up those parallel lines! A more dramatic landscape, and on the way to being a better design.

ISLE ROYALE
Watercolor on Arches 140-lb. cold-pressed paper, 20 x 28" (51 x 71 cm). Collection of the artist.

Avoiding Symmetry in Design

To anyone who has ever struggled over a painting, I hope you know that we all do. With me, the question is not about the technical aspects of how to fix a flawed painting; rather, it's about deciding which approach is the most appropriate to solving the specific problem. Knowing the mechanics means I can concentrate on the main issue. In this case, it was to find a way to repair a painting I had called finished. In fact, I had actually sent it off to my publisher, where it was rejected.

When the painting was returned to me I could see many mistakes. (This photo shows the beginnings of my corrections: I added that piece of tape for the sun and did some charcoal work to make the trees higher.) First, note how the line of clouds slants from the top left toward the right, and that the tree line below it also slopes from left to right, paralleling the clouds. The sea looks squeezed in between these two elements, and if there's anything I hate, it's a squeezed sea. Also, it's all too spotty—the daisies in the foreground are at war with the wave patterns.

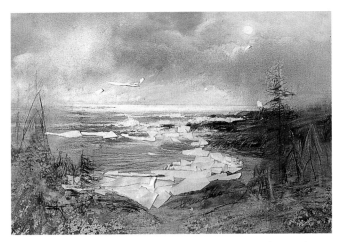

Time away from a painting really gives you perspective. I'm working with chalk here, making the clouds slant the other way and getting rid of the parallel elements. I've also created an easier path to the beach, and have begun adding wild roses so that the flower shapes can be higher off the ground. But there was another problem: Look at the previous step and you'll see that there's a tree on either side of the composition, with the sea in the middle. So I got rid of the trees on the left. But there is still a design flaw.

Here I've been at work with the white tape again. In the previous photo, note how the long line of rock on the right makes your eye slope out of the picture space, out the bottom left corner. In this step I've created a new line, a sharp V that in addition to the line of pine trees, brings the viewer's eye back to the horizon. I also raised the horizon to make the sea a larger expanse, to give it the wide-open look it has in real life. Doing this also puts the viewer on a higher cliff. I wanted the viewer ultimately to look out to sea.

DOWN TO THE SEA IN SUMMER
Watercolor on Arches 140-lb. cold-pressed paper, 19 x 28" (48 x 71 cm). Collection of the artist.

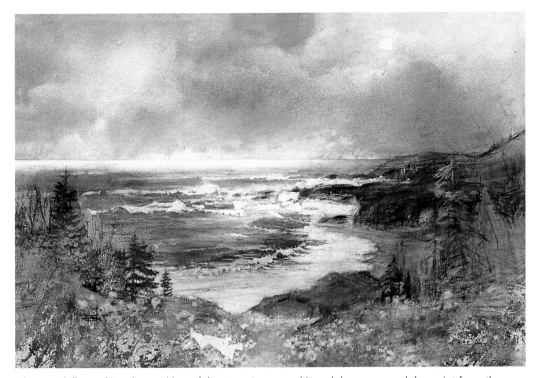

After carefully marking the position of the tape, I removed it and then removed the paint from those areas using my tape-stencil techniques. I have given the viewer more beach area, as I want to entice him to go down to the beach. I am beginning to paint the sea in a more sweeping fashion, designing simpler patterns. The foreground flowers will be more connected—in other words, a mass rather than spots. The white tape in this area will be a mass of daisies. I have begun to see a ray of hope for this painting after all, so I encourage you not to give up on your own efforts too soon if you feel there is something worth saving. In this case, I couldn't give up the concept of being high above the sea and surrounded by flowers on a summer day! I was painting this during one of our rough winters.

PRACTICING DESIGN SKILLS

With practice your design skills will improve greatly, but this does not have to take years and years of experience. We can telescope that time with some intensive work, like the exercise described here.

You will need a stack of cheap white paper, preferably the 11 x 17" size; a stack of old magazines; and scissors and tape.

First, cut out colored pictures of all shapes—rectangles, squares, etc.—and also pictures of people and objects in outline. Turn all of them upside down. Cut out copy (running text, captions, headlines, sidebars, and design elements). Turn everything upside down so you are seeing only shapes, and arrange them on your 11 x 17" paper until the design feels "right" to you. Because you are working abstractly when you do this rather than trying to depict a real landscape, you will begin to see how important the white space in between all of your cutout elements becomes.

Tape everything into place, and then do another, and another and another. Practice until you know without thinking what to do and until design has become yet another tool in your kit that you can take for granted—background knowledge that will let you focus your energy on creating.

EARLY SPRING IN THE CITY
Watercolor on Arches 140-lb. cold-pressed paper, 28¾ x 19½" (73 x 49.5 cm). Private collection.

This composition posed an interesting design problem. The strong diagonal of the roadway going down right to left had to be stopped from running the viewer's eye off the page. I solved it by using the dimensions and confines of the little park, making a pocket for the eye to reenter the picture. Placing the people helped, and I also made the tree trunks into strong verticals. The blue snowbanks in the center also hold the eye.

REDESIGNING A FINISHED PAINTING

I thought you might find it helpful to see a few examples of the painful thinking that goes on in my studio when paintings are half-finished or sometimes even when I thought they were completely finished—and times when it seems I'll never resolve them. For me it's not, say, how to make a tree look like a tree; what takes all the time is usually a design problem having to do with directing the viewer's eye, with making the painting flow.

A flawed painting makes a strong statement about the primary importance of composition: No matter how passionate you are about a scene or how well you render its individual elements, a painting must have underlying bones, a solidly built structure that is strong enough to support everything you want to convey about your subject. The following two examples illustrate how to analyze and then repair some basic structural flaws.

Creating a Sense of Depth

My publisher rejected the original finished version of *Wild Rose Point,* and I didn't notice the design mistakes until the painting was returned to me. When I first approached this subject—the shores of Lake Superior, the wild roses of early summer,

when the mists are rising and the sun is just beginning to reach into the dense woods and gleam on the water—I was very caught up in the emotions the scene evoked in me. All I knew at the time was that it had to be a painting.

I don't know how I missed the obvious here, something that goes against the first rule of composition! The largest shape, the tree roots and the small section of beach, are located in the center of the painting vertically, and the mass of tree shapes ends in the center horizontally. Nothing tempers this structure to lead the eye around the space.

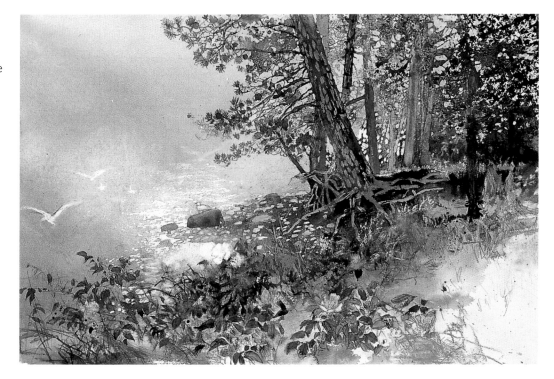

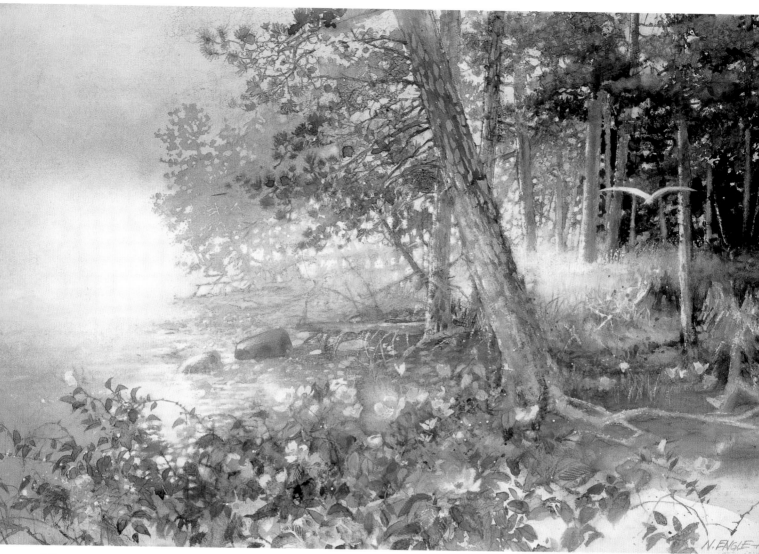

WILD ROSE POINT

Watercolor on Arches 140-lb. cold-pressed
paper, 19½ x 29" (49.5 x 74 cm).
Collection of Dr. David G. Dvorak.

Extensive work was done to repair these problems. First I needed to extend the tree mass so it didn't end in the middle of the composition. In one approach, I used an overlay of acetate that would take watercolor paint. I do this rarely—only when there's a large design problem to correct. I painted directly on the acetate, extending the branches of the foreground trees, since it's anatomically possible for them to be larger and more sweeping in character. I could even have made the main tree larger, but this would only have made the design worse: Imagine the white space at left cutting like an arrow into the shore, going nowhere. So I made up a different perspective, creating the point off in the distance in the mist. This enabled me to open up the grass area inland, emphasize the light reaching into the woods, and add interest by introducing the seagull. This more or less solved the vertical problem, but I needed to bring the tree trunk and roots down—and in doing this, I saw I could create an inviting pathway to invite the viewer's eye into the composition, to follow along the shore on this June morning.

Leading the Eye into a Painting

Like many artists, at any given time I have at least eight or ten paintings going on at once in my studio. This allows me to put away those with problems I can't solve at the moment but that, with time and a fresh eye, I might be able to complete later. I also live with half-finished paintings, ones I'm not sure how to proceed with. These I prop up against a wall in the living room or bedroom, sometimes opposite a mirror. A random glance at any one of them while I'm reading a book—or when there's a different light on it—can suddenly make solutions appear!

Bittersweet Cottage was such a painting, one that I had begun working on more than fifteen years ago. At the time, I'd brought the painting to the point where I was very pleased with the bittersweet berries and various textures in the foreground, but couldn't find anything I wanted to add to the rest of the composition, even after trying different possibilities with pencil and gray and white chalk.

Years later, my publisher saw what I had begun and loved the idea of adding a Victorian house to the scene. Here you can see how I revised my work after taking into account various valid criticisms.

This is the second stage, a finished painting. After my publisher and I discussed the work, we concluded that neither of us was very happy with it. If you look carefully, you'll see that there's a void from the center to the right of the composition, and an L-shaped scheme that lacks inviting depth; there's no way "into" the painting.

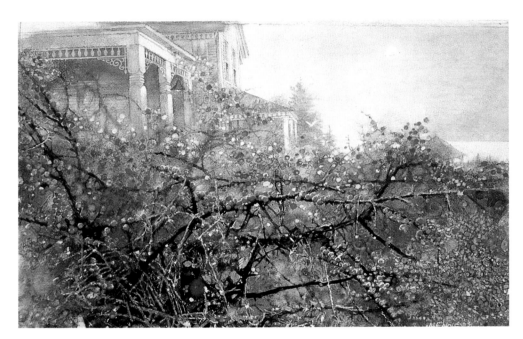

In this close-up you can see the detail of the berries and textures, which I created using a combination of techniques: throwing paint, masking, making highlights with a razor blade, and applying salt to still-wet washes.

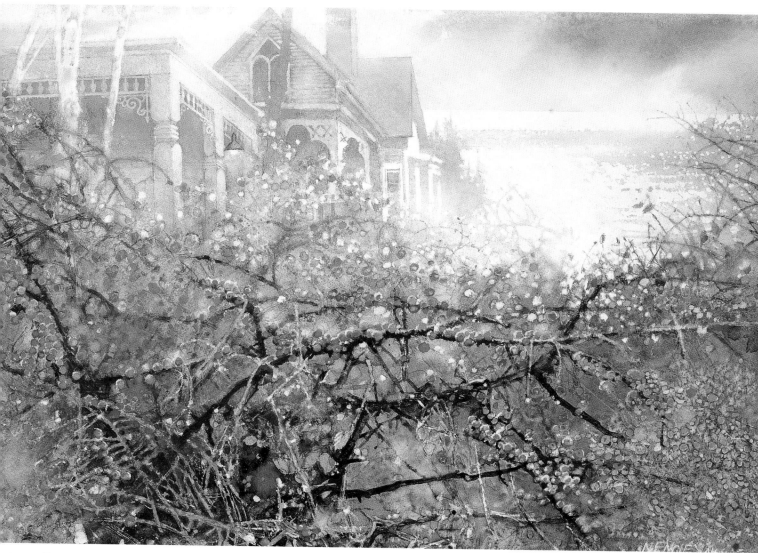

BITTERSWEET COTTAGE
Watercolor on Arches 140-lb. cold-pressed paper, 14 x 20" (35.5 x 51 cm). Collection of Patricia Winton.

Here is the redone version of *Bittersweet Cottage,* with the addition of a "new and improved" Victorian cottage; it was ultimately published as a limited-edition print. Some of the bittersweet's top profile was altered to lead the viewer's eye back into the composition, because the former direction, or thrust, was no longer a large mass leaning toward the right; instead, there was a new center of interest, the light on the sea, which had to be more or less surrounded by other shapes.

PAINTING WITH LIGHT
Illumination Through Exaggeration

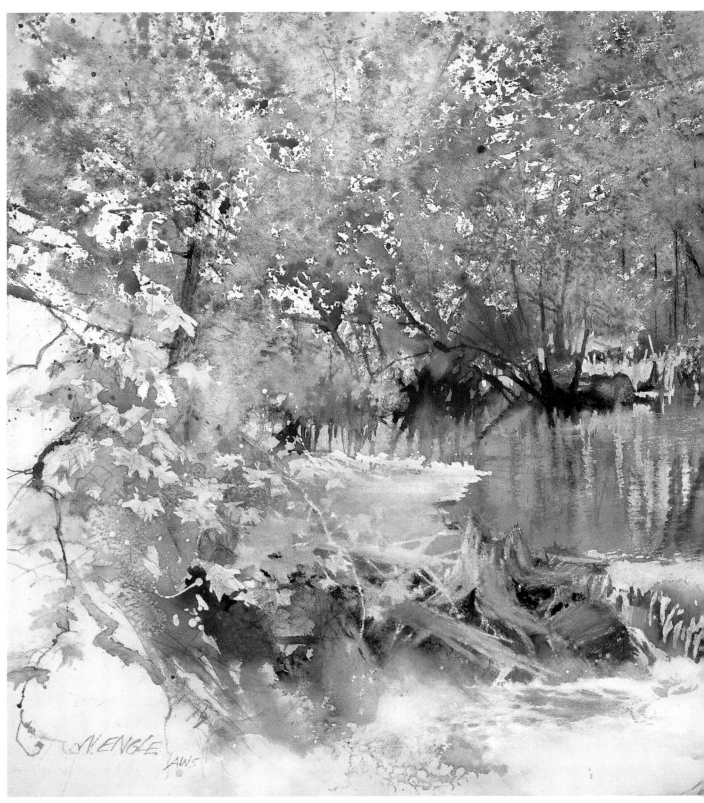

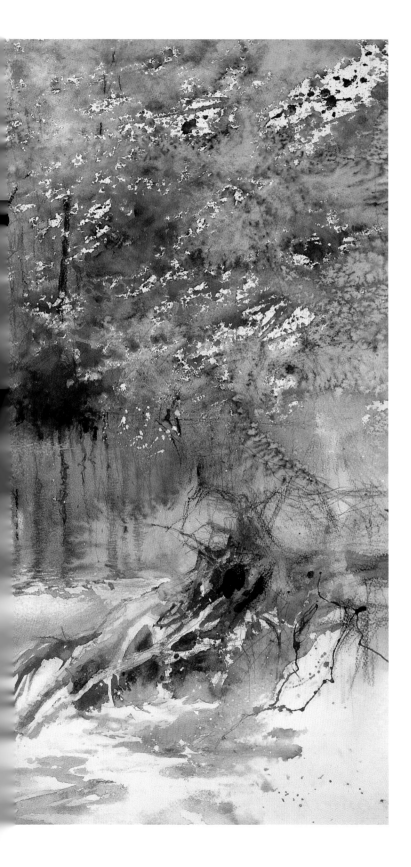

HAVE YOU EVER made a painting that was well designed, with good drawing and brush handling, so that almost all the elements check out, but it is totally boring? The reason can be the absence of light in the work, for light gives it life. I sometimes play a flashlight over the fields and rivers and woods of my paintings, and at once it becomes possible to see the very great difference the light would make. The light of the flashlight on the painting seems like the sun coming out. This tells you what to do and gives you a preview of how it will look after you do it. To make light happen in a painting, you lift paint from a given area to go lighter, then darken the tones around it to create a value contrast that will emphasize the light area. In a sense, this chapter is actually about handling edges, form, line, direction, and patterns in practical ways that make it possible to create paintings that say "light."

I will show you by example some of the ways you can introduce light into your own work in progress—or how to design it in at the drawing stage. My intention here is to show you not so much the techniques used to create the paintings, but rather the strategies behind controlling light. Thus, this chapter is more about thinking than technique.

FEEDER STREAM
Watercolor on Arches 140-lb. cold-pressed paper,
20 x 28" (51 x 71 cm). Collection of Taylor Ikin.

STUDYING LIGHT

How you gather information for your landscape paintings is crucial for a successful outcome. Not much is ever written about this part of making paintings, but it can mean the difference between a superficial painting and one with depth. How you record the light, especially—and the atmosphere, the mood, and the emotion you feel at the scene—helps to preserve the first excitement. This is all part of your desire to make the painting. How you record with your camera and sketchbook can jar your mind into new thinking, so that you begin creating as you are recording.

Light is never an isolated factor, but an integral part of the whole scene. Gathering information is the start of your painting. Try to get into the scene—not to just walk around and snap pictures, or look at the sky and take a few notes. Get under the waterfall, slog around in the swamp, put on waders and step into the river, dive into the surf when you swim. Experience the scene, don't just look at it. You should hear, feel, and smell it all. Some of my favorite paintings started with living, at least for a day, in the environment that became the subject of a painting. *Morning on the Yellow Dog River* (page 73)? I had been trout fishing and wading in the river all day, taking in the sounds and piney scents. *Quiet Waters* (page 94)? I gathered all of that material drifting around in a canoe. Floating over the almost motionless reflections in the silence of this north country, I felt I was part of the painting.

But none of the things you see, hear, and feel as you explore your subject will make it into the painting unless you plan them in.

Recording with a Camera

Create the light with your camera. Make deliberate mistakes. Perhaps you are photographing a tree. The instructions all say put the sun at your back to do this, but then you're only recording the tree as a lighted object, you are not capturing the light itself. You are recording what the sun is shining on, not the sun.

Instead, go around the tree and point the camera directly into the sun. Immediately there is light everywhere—blurring edges, shining through branches, creating lost shapes, reflections. Alter the camera's settings. Do everything differently. Climb a tree and shoot, get down on the ground and shoot, shoot with the camera moving. Try anything. (Also shoot some normal photos to record the facts of the scene.)

I don't mean you should copy these photos back in your studio. Rather, I have found that all of this activity will stimulate your creative instincts. You have the facts, so now look at your experimental shots, especially the light experiments. Can you use any of this material to explore what you felt when you were at the scene? All else should be subordinated in your painting.

Recording with a Sketchbook

If you prefer a sketchbook, describe the light with words also. Arming yourself with a sketchbook instead of a camera in a way forces ingenuity and creativity—you tend to note only the things that are exciting to you. I suggest you do this not only in your sketches, however, but also with words. When you are forced to make notes in words, you are setting the stage to illustrate them. I don't mean notes like "use cobalt blue here"; I mean that when you are describing the scene to go along with your sketch, try to behave like a writer—to be original in your choice of words. Try to write descriptive passages. Working between words and images can have a powerful result. Consider fragments like these—like Japanese haiku poetry—and think of the images that form in your mind: "Midnight—snowy streets, echoing dog bark"; "Golden room—frightened quick calligraphy—escaping swallow"; "Scooped up the moon in the water bucket and spilled it on the grass"; "Supper in autumn—flat light through an open door"; "Solid mist—people shouting between the boat and the hill."

When you are actually there at the scene, you may miss these particulars. Your notes, your words, will remind you of not only what you saw, but also what you heard, sensed, and felt. These words help you to isolate the essence—as haiku is about essence, as a sketch is about essence.

SIX STEPS TO LIGHT

When you have gathered all the information you need about your subject and are back in the studio, ready to work, concentrate your efforts toward designing light into your painting from the very beginning. The examples that follow here illustrate six elements that will help you do that: paint the shapes, the light's path, the values, the edges, the patterns, and the light itself.

Paint the Shapes

The shapes in *Winter Brook II* (below) were made by Mother Nature, and the big shapes were ideal for my goals that day—to try to make the painting as absolutely fresh and glowing as I found this scene. The small stream had been open for a time, until we had a three-day April blizzard, leaving pristine snow in the woods. On the fourth day the sun came blazing out, and all was normal again. The water level of the stream had been rising and falling, leaving layer-cake edges on the snow banks. The ice had

been breaking off; there was light everywhere, and a special light shining through the ice.

I painted it all with resist, even the light between the trees and branches. I also designed the deep, dark V near the center of the painting to offset the diagonal thrust of the river. But the real design is in the light shapes leading into the woods, all made possible by painting with mask. When you paint with mask, you are painting light.

Paint the Path

I knew we were climbing up and up when driving around the Ring of Kerry in Ireland, but I had no idea, until we drove around the final curve, what a spectacular view this would be from the top. That alone inspired me to make the painting *Ireland and the Sea* (next page). However, as I painted it, I began to be more interested in the light than in the view. I couldn't believe it, but it really is true—the light is different in Ireland.

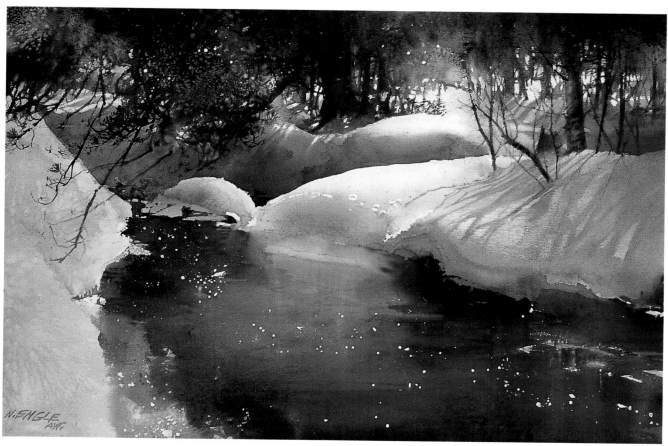

WINTER BROOK II
Watercolor on Arches 140-lb. cold-pressed paper,
20 x 28½" (51 x 72 cm). Collection of the artist.

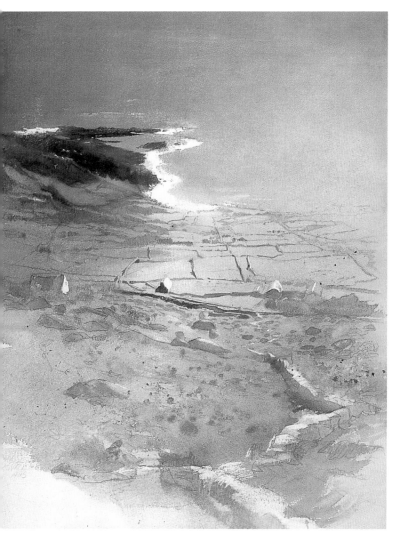

When the painting was more or less finished, I turned a flashlight on it, because I knew I wanted more light in the composition. I determined where I wanted the path of light, then I removed paint along that path with a large, spongelike tool from a paint store. I then misted the area with my water bottle and floated in more dark paints, especially deeper greens and olive, on both sides of the light path in the lower fields. The light path there was designed to travel across the rooftop, making it shine, then travel along the upper fields to the wall. Here the colors were deep enough, and I had the wall to lead the eye; I needed to lift paint only for the light path.

Take care when lifting large areas of color in a subtle way, because the idea is to keep all of the detail established in your previous washes. You just want to lighten things.

The lighting of the scene that inspired *New Snow* (below) intrigued me because on the other side of the band of trees, there was an open field; all the brilliant light was shining from there through the woods.

I painted the path of light for the eye to follow, first with a careful drawing of the critical area and then with a lot of mask, since it was so detailed. That way I could freely paint all the rest of the woods. The brilliant sunlight on the snow was also masked. I added the darkest values at an early stage—I always want to see the value range as soon as possible. The trees in the foreground were carefully observed, but the snow and tree branches and brilliant light in the background were designed specifically to pull the viewer's eye in that direction.

IRELAND AND THE SEA
Watercolor on Arches 140-lb. cold-pressed paper, 29 x 19 ½" (74 x 49.5 cm). Collection of Mr. and Mrs. Alf Jacobsson.

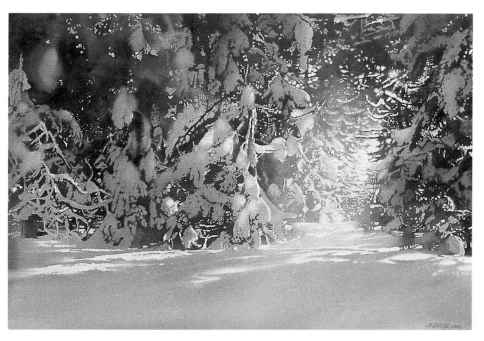

NEW SNOW
Watercolor on Arches 140-lb. cold-pressed paper, 19¾ x 29¼" (50 x 74 cm). Collection of Dr. and Mrs. D. Elzinga.

Paint the Values

Every painting has a range of values—darks, lights, and middle tones—and value is the first way to express light in paintings, but I like to use exaggerations within this system and explore the ways the light affects everything else. Sometimes it is a specific light, sometimes a general one; the light source should be determined, then the designing can begin.

Wharf Lights originally had a single light source, the one on the left. This was the reason I made the painting; the way that light played over the buildings and the water captivated me, and there seemed to be a mysterious light behind the sheds. As I went on to develop the painting, however, I began to feel that all the attention was focused on the left side of the composition. The values on the right, disappearing into the mist, needed help. I shone my flashlight on the painting, and then established a secondary light source by lifting paint with a toothbrush and other tools.

Last Light on the Marshes was inspired by the swamps and wetlands near where I live. At dusk they have a mysterious quality and, as the sun sets, become a little threatening. The thought of getting lost and having to spend the night there is unsettling; these marshes are trackless and still remain true wilderness areas. Then there are the sounds— I've heard blood-curdling cries coming from there as the dark settles in! I wanted this painting to convey some of these emotions, including a bit of menace.

To gather information, I played with the settings on my camera and again shot into the sun, and the results gave me ideas on how to proceed. I decided that dramatic contrast between very light and very dark values would work best to express the mysteriousness of the wetlands at this time of day. I used

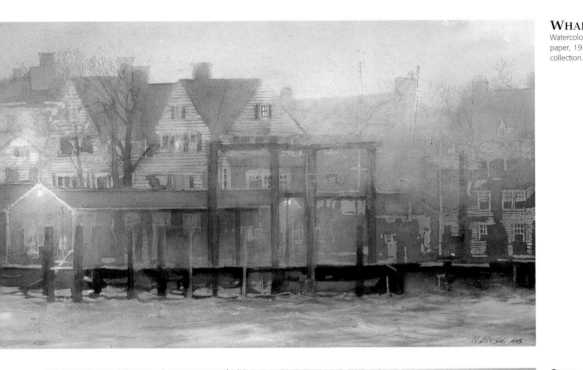

WHARF LIGHTS
Watercolor on Arches 140-lb. cold-pressed paper, 19⁷⁄₈ x 29¹⁄₄" (50.5 x 74 cm). Private collection.

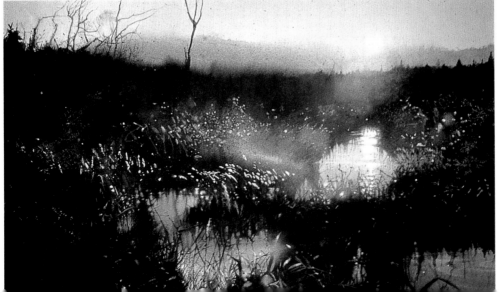

LAST LIGHT ON THE MARSHES
Watercolor on Arches 140-lb. cold-pressed paper, 19 x 29" (48 x 74 cm). Private collection.

mask to create the hard edges in the bushes and the sun's path. No black was used, just a combination of my dark colors. When I lifted paint from selected areas, they glowed.

Paint the Edges

An efficient way to lead the viewer's eye through a painting is to create sharp contrasts between the edges of shapes, using light against dark. You not only lead the eye *to* the light, you lead it *with* light. In *Bright River*, I did this by painting the crisp edges of the snow and ice on the water, as well as the edges of the foliage, with mask—in other words, painting with light. After the washes were finished and the mask removed, I used a toothbrush to make the light invading the painting from the top more extreme.

The center of interest in my work is usually a light rather than some object, because I want to lead the viewer's eye not just into the painting, but through it into another world. To be successful, my work should furnish a path into the viewer's imagination—in the way the old radio dramas let the listener imagine the world of characters as his own! In *Bright River*, that other world is just beyond the bend in the river.

In *Autumn Blueberries*, the edges leading to the distant light are mostly dark shapes, and the viewer's eye has many obstacles to overcome to get there. I love painting multiple planes going back and back and back . . . Depicting space this way sets up some semblance of a time frame, instead of the painting being seen all at once.

Still another example of working with edges to express light is *Dorset Fisherman*. Here I used the design and detail of all the linear shapes to create white edges, which I preserved by covering them with mask. These edges, combined with the vignetting at the bottom of the painting, lead the eye through the very bright light on the water to the diffused, soft light on the hills, making a contrast of many edges.

BRIGHT RIVER
Watercolor on Arches 140-lb. cold-pressed paper, 26 1/4 x 19 3/8" (67 x 49 cm). Collection of Debbie and Tony Vicario.

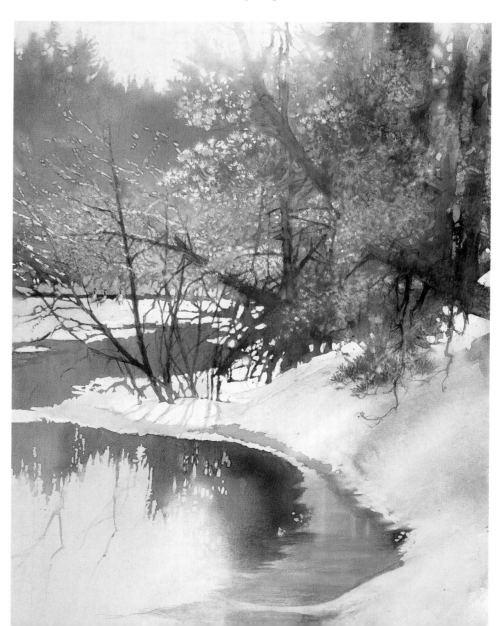

AUTUMN BLUEBERRIES
Watercolor on Arches 140-lb. cold-pressed paper,
14 x 21" (35.5 x 53 cm). Private collection.

DORSET FISHERMAN
Watercolor on Arches 140-lb. cold-pressed
paper, 19½ x 29½" (49.5 x 75 cm).
Collection of the artist.

Paint the Patterns

The spring breakup on the rivers and streams of the north and the patterns they form are of endless fascination to me every year. *Open Waters* (below) is a good example of my explorations of this subject. Here I painted the pattern of sun and shadow on the river ice with mask so that it would lead back into the painting step by step. This was combined with the pattern of banks, tree trunks, and bushes all leaning into the river. Covering all these white areas with mask allowed me to paint a high-contrast wash over all.

I wanted the patterns here, each in its own way, to lead to the most important light in the distance, the mysterious light. Notice by looking at the shadows that this light is not the light source, which is off to the right. This demonstrates the importance of patterns.

End of Winter (left) depicts the spring of the year, a time of receding snow banks and, for most north-country people, a thrilling sight! It's a time of sodden earth and cloudy skies: a time, as I remember from my childhood, to finally run free outdoors, to dig your heel in the ground to make a depression for playing marbles, to get ready for baseball and climbing trees and roller-skating!

There is no obvious light source here, just a glow in the air. I have painted the patterns in the ice with mask, retrieved the glare on the ice with a toothbrush, painted the patterns of the snow banks, and vignetted here and there, all to add to the subdued light of this day in the last month of winter.

END OF WINTER
Watercolor on Arches 140-lb. cold-pressed paper, 28 x 19⅞" (71 x 50.5 cm). Collection of Grace Engle.

OPEN WATERS
Watercolor on Arches 300-lb. cold-pressed paper, 20¼ x 29½" (51 x 75 cm). Collection of Bob and Sally Brebner.

Paint the Light Itself

When I was painting *Into the Sun*, what interested me most about this harbor in Alaska—a port not for boats but for seaplanes—was the amazing light. I knew I had to paint the light itself! I also was fascinated with the dots of islands, and the mountains and bays and peninsulas.

I painted the great areas of sun on the water with mask. I also decided on a hard-edged white for the cloud edges, which I masked to be sure I had control. I didn't want a "watercolor" sky; I tried that in a sketch, but it diminished the effect I was after. Although the dark silhouettes in the foreground seem almost not to be there, they are very important for contrast. Note how the clouds that the sun is shining on, in, or behind are brighter than the sky itself.

As I stared at the scene before me, a plane took off from the harbor, flew over the water, and disap- peared into the sun. I wanted the viewer of this painting, like the seaplane, to look from the bottom across the sun's path, rise up over the horizon, and lift up into the clouds and, finally, into the sun.

Light in the Willows depicts the scene I spoke of when I discussed photography earlier in this chapter. I gathered material for this painting with a camera and used my research files for the great white heron. I shot right into the sun through this willow tree and was rewarded with a world of light shining through the branches and creating a place beneath them that was literally bathed in sun, an ideal place to position the heron. The majority of the willow foliage was painted with a Chinese brush (so ideally shaped to make a willow leaf!); I covered the lighter leaves and the heron with mask, using the resist as a positive tool, the way you would use a paintbrush.

INTO THE SUN
Watercolor on Arches 140-lb. cold-pressed paper, 20 x 28" (51 x 71 cm). Private collection.

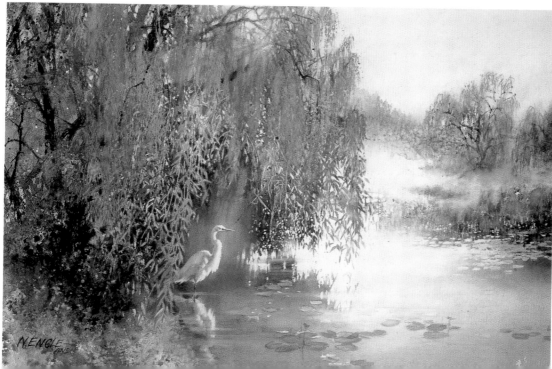

LIGHT IN THE WILLOWS
Watercolor on Arches 140-lb. cold-pressed paper, 19³/₈ x 27" (49 x 69 cm). Private collection.

WORKING OUTDOORS AND IN
Combining Two Concepts

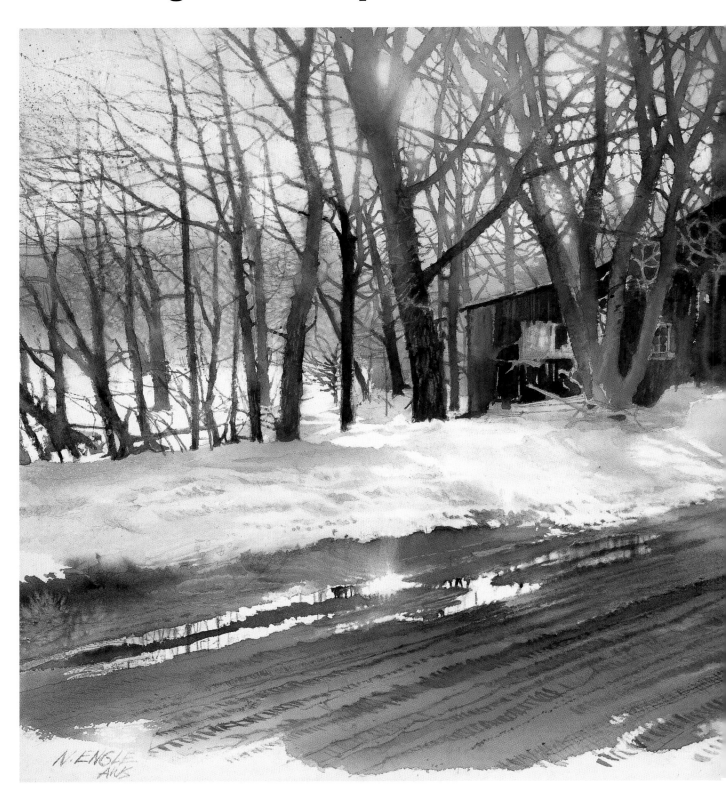

THIS CHAPTER is about combining painting in the field, with all of its exuberance, its wonderful benefits and emotions of the moment, with the discipline, intellect, and precision of studio painting. It is really about judgment, going to the core of what you are all about as an artist, because of the decisions you will make back in the studio about how to proceed with work you've started outdoors.

All in all, I think the benefits of experiencing the reality of a scene, being outdoors and painting there, outweigh all the disadvantages—the discomforts of weather, the blinding sun, the bugs (and, in my case, even bears)—because the whole scenario sometimes yields a painting you could not have produced any other way. I have come around to thinking it is an important part of a painter's growth to work on-site, and we should all occasionally plan to at least begin a painting outdoors. You can work both directly and then indirectly; when you can have it both ways, why not?

Some of the examples included in this chapter are finished products, started in the field and completed in the studio, while others were painted entirely on location.

MARCH THAW
Watercolor on Arches 140-lb. cold-pressed paper,
19 1/2 x 27 1/2" (49.5 x 70 cm). Private collection.

EQUIPMENT FOR WORKING OUTDOORS

First a word about the mechanics of traveling and painting at the scene. I do not use easels or stools of any kind, because when I am giving a demonstration, I need all of my equipment within easy reach, which for me means on the ground. There is usually a log or rock or wall or something similar to sit on. I find folding stools too high for me to be able to reach everything, and also kind of rickety, especially since I do some forceful moves when I paint, increasing the chances that such "furniture" will tip over.

The traveler's kit shown here was sewn for me; it is made of a heavy denim and measures 20 x 28 x 5" (51 x 71 x 13 cm). It has two full-size zippered compartments—one to hold illustration boards and paper, the other to hold my palette and half-sheet support boards (plywood or Gator board)—plus three zippered pockets to hold my paints and one long zippered pocket for my brushes and Windex spray bottle. I also take along a backpack for Kleenex, a water container, garbage bags, camera, and anything else that won't fit in the portfolio.

Why a cloth portfolio? Because you can fold it up in your suitcase. When I travel by air, I put my plywood board, illustration boards, and sheets of 140-lb. Arches watercolor paper in the bottom of my suitcase, along with my palette (wrapped in a plastic bag), then the portfolio containing my paints and brushes.

I love this system; it works well. One more advantage to it is that when you spread out your equipment to paint, it acts as a tarp, with all of your paints and brushes within easy reach.

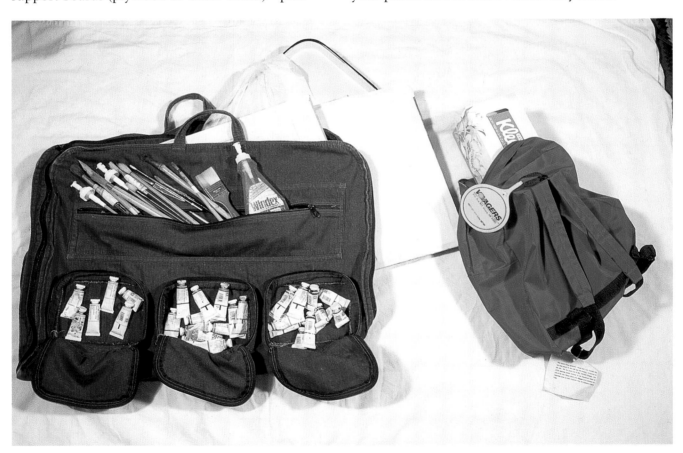

Here you can see my basic equipment for working in the field.

GENERAL APPROACH

When I conduct traveling workshops, I always try to have my drawing finished, based on research material, before we arrive at the location so I can devote my whole attention to the students and give the painting demonstration without wasting time. As a bonus, I have found this to benefit my work in the field, because I can still, in a limited way, use my indirect methods of drawing and masking.

In the field, my first concept is always that I am painting a watercolor that will run its course under my guidance. But it is also the time when emotions are in the forefront: What are my feelings about the scene; what is moving me, touching me, to paint this? What is the ambience, the light, the mood, the atmosphere? Let the watercolor express these feelings, because this is the only time—the beginning—when it is loose enough to be vulnerable to all of these impulses. Nowhere does this happen as easily as in the field, when you have primary access to your emotions about the scene. Being there seems to set the stage for the attitude you need to approach the painting. This is not a time for thinking; it's a time for reacting to the paint and your feelings toward the specific moment and place.

Being on-site also seems to increase the adrenaline flow. Away from the confines of the studio, you can be larger than life. One tends to be more reckless, a bit more flamboyant, more authoritative, to exaggerate or magnify the scene. This almost always is a good influence on the painting. But you have to do a lot of squinting to reduce the positively undisciplined look of nature so you can create a design that will be manageable on paper.

How do you translate your fieldwork into finished paintings? What parts should you keep, and which should you remove? How far should you go with details? How in the world can you transform something wild, begun in the field, into a painting that makes sense as a landscape? You can't have two radically different styles in the same painting; this is where the judgment comes in.

The best way for me to explain this is to show you paintings I began on location and describe their progress in the studio.

Retaining the Character of a Scene

The setting was Bali, the scene a serene mountain lake in the interior of the island, with a temple. I was somewhat overwhelmed by the peace, the tranquility, the dreamy quality of the scene.

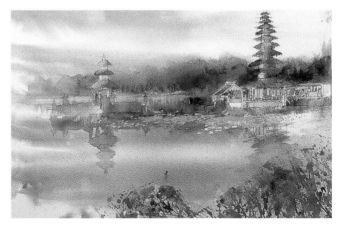

MOUNTAIN TEMPLE, BALI
Watercolor on Arches 140-lb. cold-pressed paper,
16 x 23¾" (41 x 60 cm). Collection of the artist.

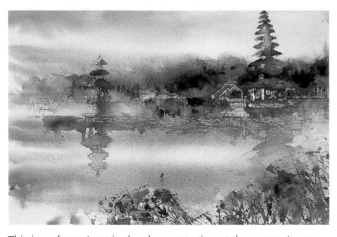

This is as far as I got in the demonstration at the scene. It was most important to me to keep this dreamy quality in the finish. You can see the mask and a lot of free application of paint, including in the foreground flowers. I must be careful not to destroy the essence of this painting with detail.

Here you see the decisions I have made so far. I removed the mask and made the lily pads on the water clearer and more believable. I have also begun to correct the structure of the temple a bit—a compromise between watercolor and architecture! More work should be done in the reflections, but to make these believable, I must not sacrifice the overall character of the work. The same criterion applies to the flowers; I will make only a few of them more realistic so I can retain the spirit of the rendering.

Editing for Impact

Italy is so mind-boggling that it is easy to go crazy with the paint. The setting here is an ancient town in the Tuscan hills, whose walls are a hodge-podge of old brick, large quarry stone, small pebbles, the lot—an excitement of texture! And there are vines everywhere, on all the walls.

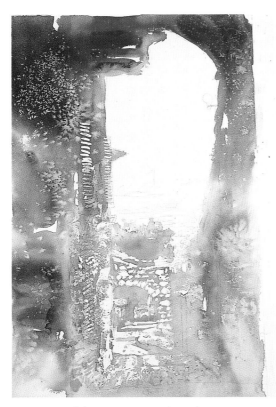

There is much here to retain and much to remove. I love some of the color, the strong rendering at the top of the arch, and the watercolor runs. But in the end, I want a powerful arch, a three-dimensional feeling of looking through a series of three arches, and your eye escaping to infinity beyond!

ANCIENT HILL TOWN, TUSCANY
Watercolor on Arches 140-lb. cold-pressed paper, 21 x 13 ¼" (53 x 34 cm). Collection of the artist.

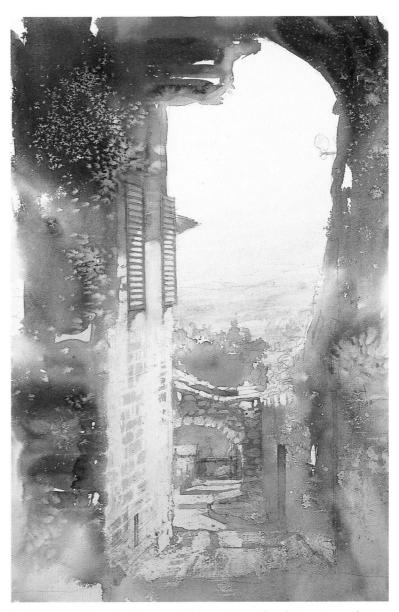

Back in my studio, when I removed the mask from the shutters, I saw that their structure was sloppy and awkward. However, I did try to keep a casual effect by not making them totally mechanical-looking. I've kept the salt effects at the top left for now by making a barely discernible flower box with vines. I've made the second arch darker, looking through to the light, and adjusted other values also. Because the sunshine was very strong on the left side of the arch, I lifted color there while working on the brick texture. For the same reason, I washed in a darker value on the sides of the first and second arches to emphasize the sun and shadow pattern. I've aimed to make the structure more believable without losing the spirit of my first impression—a delicate balance.

Proceeding with Care

This demonstration, which came out of a workshop trip to Tahiti, Moorea, and Bora-Bora, was great fun. I was teaching a method of showing heavy clouds and mist coming over the mountains, the very setting surrounding us. Every time I picked up a paintbrush, it started to rain!

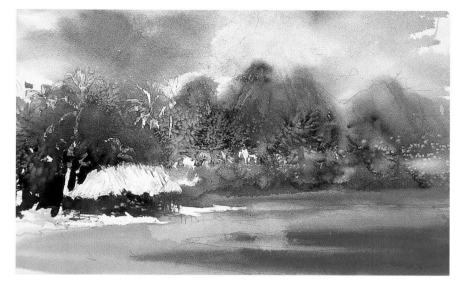

I made my drawing first and applied mask to the grass roof, some of the white sand beach, and the palm trees. I proceeded by painting the whole mountain. I then mixed paint with a lot of water to create a fog color and dumped it over the mountain. This had to be done immediately, while the paint on the mountain was still wet. I steered the watery fog color in the direction I wanted it to go. The jewel colors of the water in the South Pacific are incredible. I used cerulean blue with Winsor yellow, contrasting this hue with a darker blue, here French ultramarine.

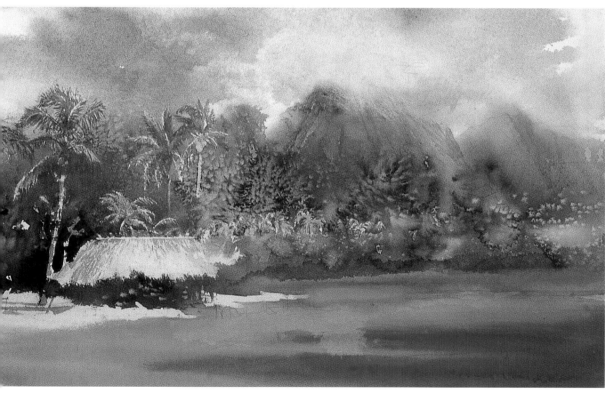

MOUNTAINS OF MOOREA
Watercolor on Arches 140-lb. cold-pressed paper, 14 x 22" (35.5 x 56 cm). Collection of the artist.

Later, in my studio, I decided to redesign the mountains slightly; I didn't like the four peaks. I certainly didn't want to undo the luck I'd had with the fog and mist while painting on-site, so I proceeded with care, designing in chalk first. I also painted the roof and the palm trees, adjusting the values. In that humidity the salt went wild, taking on the shapes of foliage and palm trees! I put this away for a few weeks before seeing what else needed to be detailed.

MAKING THE BEST OF BOTH WORLDS

I lived in England for almost a year and spent ime painting outdoors. Both paintings shown here resulted from trips to Scotland during that stay.

Ardvrech Castle, Scotland began with two visits to the scene, where I painted the basics (mostly the sky) on-site. A good stopping place for the painting was the silver band across the lake. I drew in the castle,

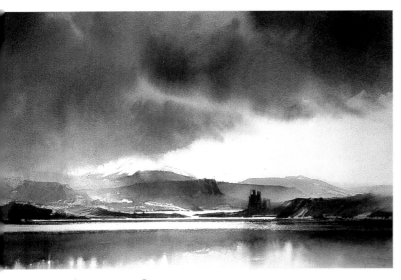

ARDVRECH CASTLE, SCOTLAND
Watercolor on Arches 140-lb. cold-pressed paper, 20 x 28½" (51 x 72 cm). Private collection.

finishing it and the bottom of the painting in my studio in London, working from photos I had taken. I needed to control the water and reflections more carefully than I could do in the field, and the details needed close work. My goal was to preserve the vitality of the clouds. An advantage of studio painting is that it gives you the opportunity to find a good happening and emphasize the effect. In this case, I observed a bit of light coming down from the sky on the left, seized on that as a good dramatic and design device, and so made it all happen in the studio.

I began *Bridge at Skye* by making a rough drawing of the bridge and creek, or burn, and then painted the big landmass and the sky on-site with great enthusiasm. It was important to be on the scene to observe all the subtleties of the colors; they were wonderful. This was in late October.

I did not attempt the bridge at the scene, because I knew I did not want it to have the look of direct painting, so I photographed it and added it later by using mask. The snow traces on the mountain were also added later, in the design phase of my work.

First the immediacy and realness of being there— then the comforts of home for details and design!

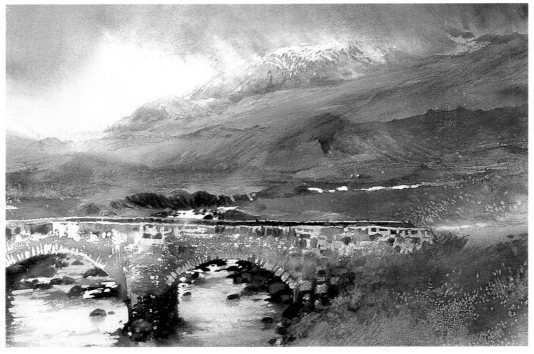

BRIDGE AT SKYE
Watercolor on Arches 300-lb. cold-pressed paper, 19 x 28" (48 x 71 cm). Collection of the artist.

PURELY PLEIN-AIR WORK

The two paintings shown here, *Fog over Superior* and *Quiet Morning in the Stumps,* were designed, drawn, and painted completely on the scene. I used no mask in either; all of the whites were either painted around or lifted later.

I was fishing for coasters—brook trout gone to sea—in Lake Superior and nothing was happening, so on this day I painted instead, because the fog was so intriguing. The result was *Fog over Superior.* When I returned to my studio, I lifted the roses and some whites on the figure but saw nothing else I wanted to change.

On a visit home in the early 1970s, I painted *Quiet Morning in the Stumps* from the front yard of my family's cottage on this lake in the wilderness. We spent entire summers here—my brother and I grew up in the lake as much as out of it, boating and swimming. This end of the lake was flooded a hundred years ago, so that the dense forest that once stood on land here is now underwater. It became a wonderful fishing place called "the stumps." A lot of my childhood is in this painting; I include it because I created the image totally *en plein-air.* Sometimes that's all you need.

QUIET MORNING IN THE STUMPS
Watercolor on Arches 140-lb. cold-pressed paper, 13 1/2 x 21" (34 x 53 cm). Private collection.

FOG OVER SUPERIOR
Watercolor on Arches 140-lb. cold-pressed paper, 21 x 13 1/2" (53 x 34 cm). Private collection.

EXPERIMENTAL TECHNIQUES
Seeking New Ways to Depict Reality

PEACEFUL MORNING, CANADAS
Watercolor on Arches 140-lb. cold-pressed paper, 19 x 27"
(48 x 68.5 cm). Private collection.

O F ALL THE JOYS of painting, experimenting is the most like play. It's a matter of letting curiosity lead to discovery, trying new ideas just to see what will happen. But when you experiment, it is essential to keep in mind that whatever you do is an end in itself and that you can't expect a finished product—a viable painting—to result. Instead, just go wherever an idea takes you and explore what you see happening on the paper. Above all, do not fall into the trap of thinking every one of your experiments counts. They don't. You can avoid this by preparing so many painting surfaces in advance that the supply seems endless and expendable. Be prepared to accept before you start that nine ideas out of ten fail! But the one that does succeed is worth all the dismay you might've felt about the others, because then you can apply it in a serious painting. Incorporating an original discovery in your work makes you, without fail, a better painter.

What I show you in this chapter are simply explorations I've conducted in my own quest to find ever more ways to create illusions of reality in my painting. The resulting effects cannot just suggest shapes and textures in nature; they need in my mind to *be* those objects. I will use anything that increases that feeling. An abstract painter stops when the composition at a certain stage constitutes a satisfying finish. I, on the other hand, can't stop until all of the abstract elements combine to form a representation of reality.

WORKING WITH UNUSUAL MATERIALS

Basically, I will try anything that makes a mark or creates a textural effect on my painting surface to achieve my ultimate goals. As you'll see, this has included such materials as gravel, pine needles, Chinese white opaque watercolor, Dr. Ph. Martin's Hydrus liquid watercolors, powdered pigment, soap, weird brushes, twigs, and more.

Using Gravel and Sand

For this experiment, I worked on Strathmore hot-pressed paper. My first step was to squeeze the colors appropriate to my subject from the paint tubes into two cups, warm hues in one, cool in the other. I diluted these with water and poured each mixture into its own Windex spray bottle. Next I taped the paper to a board. Then I went down to the beach and grabbed a handful of wet gravel and sand, dumped this onto the paper, sprayed the whole thing with the colors in my two Windex bottles,

GRAVEL AND SAND

and went away, leaving the painting flat. When the paper was totally dry, I removed the gravel and sand and was amazed to see the effects I got. You can be sure I will try this on a major painting.

Texturing with Pine Needles and Grass

I was very excited about this experiment, because it used natural forms and thus was, for me, a part of nature. For the first example (opposite), which I call "Beach in Winter I," I worked on 140-lb. Arches cold-pressed paper; my other materials consisted of my trusty Windex spray bottle, Pebeo liquid mask, and Winsor & Newton tube watercolors, plus pine needles, grass, and small leaves collected from my yard. When the painting was finished, nothing was left on it to injure the paint or the paper, so I could remain a purist!

To begin, I taped the paper to a board and prepared the mask by diluting it with water in a proportion that would let me spray the mixture on with my Windex bottle without clogging up the nozzle—about three parts masking fluid to one part water. I poured this mix into the spray bottle but, to minimize the time the spraying apparatus was in contact with the latex, did not put the top on until the last minute. Immediately after using a spray bottle to apply a mask-and-water solution to a painting, you need to rinse out the bottle thoroughly to rid it of any traces of the liquid-latex resist.

I spread the pine-needle mixture on the paper (artistically!) and, working from the top downward, sprayed the mask solution over everything. (It's a good idea to try this on sample paper first.)

When all was dry, I painted the beach colors conventionally with my usual palette. After that was dry, I removed the mask and debris, and what I found you see in "Beach in Winter I"! This first try made me decide to develop the technique further.

For my second attempt, "Beach in Winter II," I worked on medium-weight cold-pressed illustration board, and in addition to the materials in the preceding example, I used Winsor & Newton Chinese white tube watercolor.

In this case, instead of the mask solution, I prepared a mixture of Chinese white and water in a cup, adding just enough water to make a spray, and filled the Windex bottle with it. I painted the beach conventionally, making the colors quite dark, and then arranged the pine-needle mix on the illustration board while the paint was still wet, which helped hold the debris in place. When this was dry, I sprayed the whole area with the Chinese white mixture, working from the top downward;

BEACH IN WINTER I

BEACH IN WINTER II

then I left the board to dry. When the painting was completely dry, I removed the debris and discovered a bonus. I had expected dark shapes where the pine needles prevented the white from hitting the surface, but what I didn't expect was the effect of twigs (or whatever) coated with ice or snow. I can't explain that, but it gives me ideas! The only disadvantage to this technique is that I really dislike using white paint.

Experimenting with Powdered Pigment

While watering my plants in the tub, I was impressed with the random earth patterns I saw and decided to try to imitate them with paint. Among the materials I used for this experiment was powdered pigment (the color was sepia, the brand Winsor & Newton). When working with powdered pigments, you must wear something like a surgical mask to avoid inhalation. I also used beach sand, garden earth, a sheet of Strathmore hot-pressed paper stapled to my plywood board, a Windex bottle, and squirt bottles.

First I sprinkled water in a texture pattern on my paper with the Windex bottle, then threw on the sand, earth, and powdered pigment in random fashion. The reason I used the sand and earth is that the powdered pigment is so fine that it doesn't make for much texture. I propped the painting on a slant in the tub and sprayed and squirted water at the top, allowing it to run down the page. The result was "Earth Landscape I," shown at right. I think I have a long way to go with this experiment before I can use it in a real painting.

EARTH LANDSCAPE I

I've included a photograph of my palette here to show you how the paint—in this case, sepia powdered pigment and Hydrus liquid watercolors—formed its own patterns as it dried on the porcelain surface. I get many inspirations like this one from my palette, which often prompt me to say, "Why oh why can't I do this on paper!" Maybe someday.

Creating Effects with Soap Bubbles

I was given the seed of this idea—to create texture by letting paint interact with soap bubbles—by an artist friend, R. Jamielkowski, but I had to try many, many approaches before I figured out how to get it right.

I tried liquid dishwashing detergent, but the foam it produced was too fine for my purposes. I tried bubble bath, really working up a lather in the bathtub, but it didn't work. I even tried a bottle of kids' bubble solution, blowing bubbles through the ring in the "wand." That was quite a sight, me chasing the bubbles around, trying to get them to land on the paper—and needless to say, a failure. Finally I tried shampoo, mixing it with water in the kitchen sink. I whipped up a thin layer of bubbles, immersed the paper (in this case, a sheet of Strathmore hot-pressed) in this "bath," and brought it up gently, picking up bubbles. Using an eye dropper and liquid watercolor, I dropped paint into the foam in various places. Look at the image below to see what happened when the paper dried!

SEA FOAM

Working with a Heat Gun

The heat gun is comparatively new to me, but it's already become an important tool; I can see it taking me in a few new directions. My students find using a heat gun exciting as well.

This experiment was an attempt to control my usual pouring and squirting of paint by applying heat. It was inspired by a demonstration conducted by Maxine Masterfield, the author of *Painting the Spirit of Nature* and *In Harmony with Nature* (both Watson-Guptill). This was a great idea, but of course, when trying to do what she did, I totally failed. But what I got instead was "Fishes in the Deep" (above, right). I taped a sheet of Strathmore hot-pressed paper to my board and squirted on water, liquid watercolors, and diluted tube paints, tilting the board and letting the paint run in various ways and basically just watching what happened. I knew what I was after: the eddies and swirls and whirlpools of the water's action around reefs and rocks. As this was happening, I aimed the heat gun at my painting; this tool dries the water and paint very quickly, which gives you a lot of control (although in this case, the random fish shapes I ended up with evolved mostly from a loss of control!). Because the heat gun forces uneven drying, you get effects that aren't possible by any other means.

Experimenting with "Creepy Cobwebs"

In her excellent book *Creative Watercolor* (North Light), Mary Ann Beckwith shows how she experiments with a decorative Halloween product called Creepy Cobwebs in her fascinating abstract paintings. These "cobwebs" look like ordinary cotton batting but can be stretched into long, wispy strings that resemble spiders' webs (unlike real cotton batting, which just breaks into clumps when stretched). They can be found in dime stores or wherever party favors are sold. I could not resist trying to adapt her methods to painting a realist landscape. I spread the cobwebs out on a sheet of Strathmore hot-pressed paper and taped them into place. I sprayed the paper with water, and then dropped Hydrus liquid watercolors into the mix. I paid no attention to the actual hues; I was just looking for tree forms. Although that's what I had in mind, what I got instead were the dragonflies you see at right. Still, I remain excited about the possibilities of this technique. I know I will use it sometime in a landscape I'm thinking about.

FISHES IN THE DEEP

DRAGONFLIES

DEEP SNOW

Using an Impasto Medium

Winsor & Newton's Aquapasto is a translucent gel medium that, when mixed with watercolor paint, makes it possible to achieve a three-dimensional impasto effect. In my first experiment, I used it in conjunction with Chinese white and a palette knife.

I taped a piece of cold-pressed illustration board to my plywood support, then mixed Aquapasto with the white paint on a palette separate from my usual one, adding no water to keep it thick. (Aquapasto is yellowish white, which is why I had to add the white paint to it.) With my palette knife I applied this mixture to depict snowy hills, let the paint dry, then sprayed the sky with water and floated in the colors from my regular palette. Trees were added last. You can see the result at left; I loved slapping the paint on with a knife, but I'm not sure I want my watercolors to have this impasto look.

For my next experiment, I thought it would be fun to see what would happen if I used Aquapasto to create obstacles for the running watercolor to find its way around; the possibilities fascinated me.

After taping a piece of illustration board to my plywood support, I mixed the Aquapasto with dark colors and knifed in the rocks, placing them so the stream would be able to run before and after it hit the rocks. When this was dry I introduced the stream's colors, squirting, tilting, and spraying to steer the paint as if it were a real river (see below). I discovered that I had a little more control over the paint's flow here than with pure watercolor, but increasing the slant still made the stream run right through the rock. I'm reserving judgment.

RIVER FLOW

Chinese White Resist Technique

I developed this method in another life, when I was a graphic designer, and I am delighted it can be used in painting watercolors. However, the watercolor you use must be the permanent kind, such as Dr. Ph. Martin's Hydrus liquid watercolors, which are transparent, luminous, and can be mixed with any tube watercolor. The technique works because the white paint is water-soluble, while the liquid watercolor, once dry, is not. Shown here are two examples, "Elephant Hide" and "Cottage in Killarney."

For the elephant painting, I worked on medium-weight cold-pressed illustration board. First I drew the elephant, and then, with my palette knife, applied Chinese white opaque watercolor all around him, defining his outline with the paint and also covering the background totally. I then knifed white paint on the elephant's hide and also applied some of it using the drybrush technique. When this was dry, I mixed Payne's gray and burnt umber liquid watercolors and poured this all over everything. Remember, the opaque Chinese white serves as a resist! Once everything was completely dry, I hosed off all of the white paint, using my fingers to make sure every bit of it was gone, then hosed the board again. Once the white was removed, what remained was the elephant with a textured hide.

The advantage of this technique is that it gives you a chance to create texture with white paint, using palette-knife work, with its casual, slap-dash appearance, without leaving a trace of white paint on the paper! You still have the glow of the paper's own whiteness, without the deadening, chalky look of white paint. You could never achieve textures like this with liquid mask.

To paint "Cottage in Killarney"—a sketch that is only about 10" wide—I taped a piece of cold-pressed illustration board to my plywood support board, drew the cottage, and applied the opaque white paint using my palette knife as a trowel, trying to knife the paint onto the cottage walls the way you would apply plaster to a real wall. I also applied white to the grass area by dragging my knife through it. I was looking for textures here, not complete coverage.

When that was dry, I painted the landscape conventionally with liquid watercolors. The third step, once everything was again dry, was to put masking tape around the roofs so I could brush on the darkest values. I let the painting dry overnight, then removed the masking tape and hosed off the white, leaving only the color.

ELEPHANT HIDE

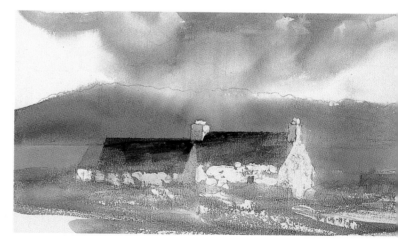

COTTAGE IN KILLARNEY

Working on Toned Paper

I became interested in this because I'd read that my hero J. M. W. Turner sometimes worked on toned paper. For both examples shown here, I mounted a sheet of toned, striated Japanese paper (not stretched) on my board and mixed some darks, again using the liquid watercolors because they are intense and would allow me to maintain a more uniform dark. I needed a very dark mixture to paint these scenes, because the paper itself was fairly dark.

I think it's worth exploring how toned paper might be used for landscape painting. I see advantages—for instance, the overall, continuous tone automatically unifies the scene from the start, allowing me to use all my techniques later. In "World War I Scenario," I was particularly fascinated with the grass effects and saw possibilities for foliage.

Although I just used whatever toned paper I had handy, I think preparing my own tone would give me more flexibility.

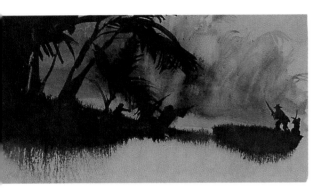

IN THE TROPICS (PRELIMINARY SKETCH FOR A PAINTING)

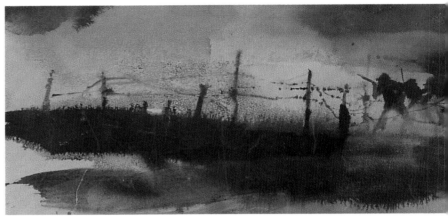

WORLD WAR I SCENARIO

Unconventional Brushes and Other Tools

As I've said before, I do not want obvious brush-strokes in my landscapes, however much I admire them in other artists' work. This is what has led me to search constantly for new and different ways to apply paint to paper. The examples shown here are explorations into some of the alternative methods and tools I have discovered and used over the years.

Strange Japanese brush. This is one of my very favorite brushes; I bought it at a Japanese art supply store in Chicago. It's not made the usual way, with hairs inserted into a ferrule. Instead it is actually a piece of bamboo that has been placed in a machine to chew up one end—so what you see here are not hairs but shredded bamboo. My strange brush painted this tree trunk, not I!

Chinese brush. I squeezed some Aquapasto into the hairs of a Chinese brush, making sure to get it in the heel, to make the brush stiff and spiky. I shaped the hairs with my fingers, then let the brush dry out. I mixed some paint on my palette and painted this driftwood in one stroke. The brush did it all.

Strange brass tool. I dimly remember some student giving me this tool in the far-off past. It is metal mounted on a lovely wood handle. The metal part is hollow, with a hole for filling with paint, which is delivered to the paper (here, illustration board) through the short, narrow tube that serves as a nib. Using it takes some juggling, but it works. Can anyone who reads this enlighten me about where this tool came from?

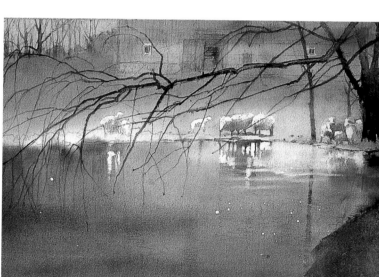

Split cedar twig. This twig was split at the end so it made a double line, which I didn't notice until after I'd started drawing with it. You can make a split deliberately, of course, with your knife. The advantage of making tree branches this way is that they retain a stiff look, the way wood really is, instead of wavering all over the place as a paintbrush does. This is important because most of us are not that precise with a normal brush.

Cedar twigs. I collected some cedar twigs, pulling them off the tree rather than the ground, since they can't be dead and dried out for this technique. Cedar seems to have more spring to it than other kinds of twigs. I try for a diameter about the size of a pencil and a length of about a foot. I strip off the leaves and small branches, select one end for a point, sharpen it with a knife, and cut a slit in the end to make it like a pen nib. I then break the branch in several places, although because the wood is green, it doesn't really break all the way through. If your branch is extremely springy, you don't need to do this at all. What is the purpose of all this? To give you a tool that you have almost no control over! I spread paint over the tip liberally several times and use the twig like a pen, with this difference: When you point the tip at the paper and hold the other end a foot away, whatever stroke you make certainly doesn't look contrived or timid! When you twitch the end you are holding, it twitches on the end that's touching the paper, like a seismograph needle. The cedar twig reproduces itself on the paper.

BARN WITH SHEEP
Watercolor on Arches 140-lb. cold-pressed paper, 19½ x 28" (49.5 x 71 cm).
Collection of Ed and Edith Nelson.

This is simply to show you how experiments can be applied in an actual painting. I created all these branches with the tools discussed in this chapter, mostly cedar twigs; it was easier to make them look real that way than with a conventional brush.

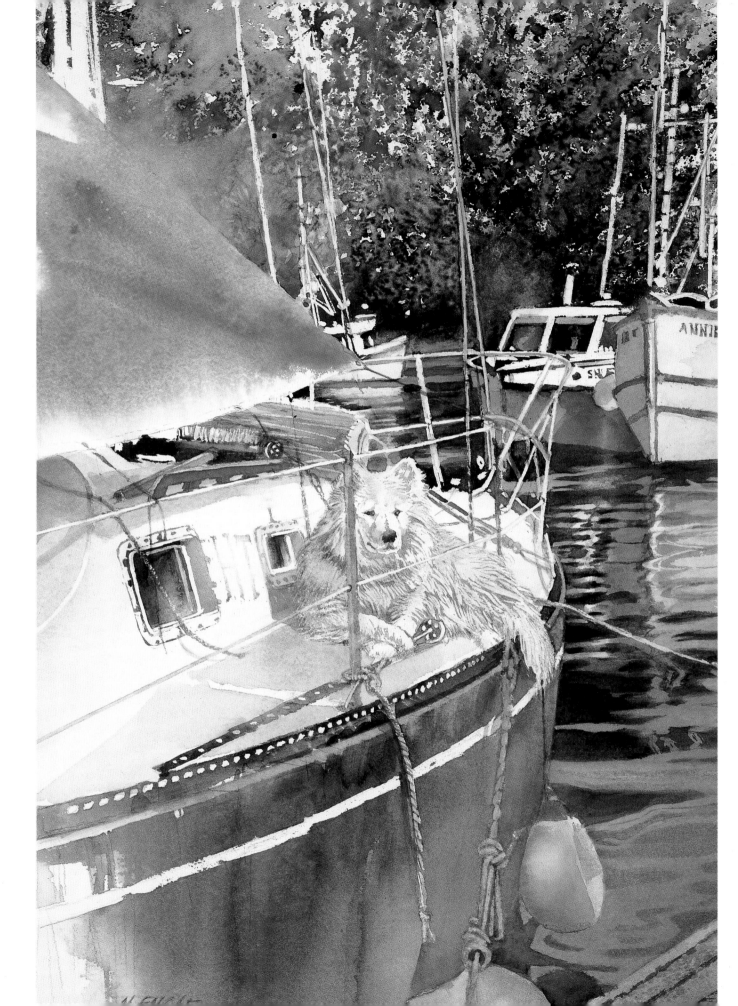

LAST WORD

I have found that being free with your experiments may help you to be more free in your serious painting. Experimenting teaches us that painting a watercolor is not a one-sided activity; the watercolor must have a chance to speak. This is why I create a dialogue with the watercolor while I am painting. Many of the strokes I make while guiding the paint are tentative and questioning. In fact, my rule is "proceed tentatively with authority." This sounds like a contradiction in terms, but it is how I paint. To me, it is like rock climbing: As you gain one threshold, you see the way to the next.

Experimenting also helps you to be freer in your attitude. And the more free your attitude, the more authority your paint handling will have. An attitude of confidence will produce graceful work. I myself will not release a painting or consider it finished until it has two elements above all else: authority and grace.

After you have read and studied and absorbed other artists' words, taken workshops, and tried other artists' discoveries, you can find your own voice again through experimentation. It should lead you to where your own interests lie.

Many students have asked me about overcoming painter's block. This often happens because you are expecting a product, perhaps under the pressure of painting something for a show or a deadline. Remember when you couldn't wait to play with the paints and colors? Return to your passions, to the reasons that led you to paint in the first place. And experiment!

And if you are a landscape painter, get outdoors. The growth of my own work depends on it—I always find new ideas out there. While wandering around in the landscape, I have come to realize that although, as I have stated, I want to take the viewer into my paintings, what I really want to do is take him not only into the reality of a scene but out again, beyond it—always, always beyond.

I read something the great nineteenth-century art critic and teacher John Ruskin wrote that so impressed me that I present part of it here. The passage was quoted by Gary Wihl in his book *Ruskin and the Rhetoric of Infallibility* (Yale University Press) and cited in the November 3, 1985, issue of *The New York Times Book Review:*

> To form a judgment of the truth of painting, perhaps the very first thing we should look for, whether in . . . foliage, or clouds, or waves— should be the expression of *infinity* . . . For we may be quite sure that what is not infinite cannot be true. It does not, indeed, follow that what is infinite is always true, but it cannot be altogether false; for this simple reason, that it is impossible for mortal mind to compose an infinity of any kind for itself, or to form an idea of perpetual variation, and to avoid all repetition, merely by its own combining resources. The moment that we trust to ourselves, we repeat ourselves, and therefore the moment we see in a work of any kind whatsoever the expression of infinity, we may be certain the workman has gone to nature for it.

SALTY DOG
Watercolor on Arches 140-lb. cold-pressed paper, 27 x 19" (68.5 x 48 cm). Private collection.

INDEX